Bridging the Mississippi

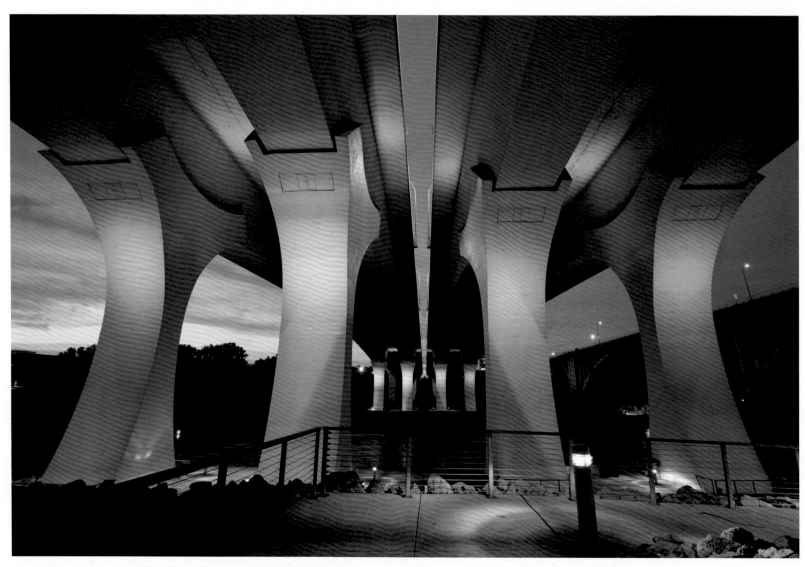

Substructure of the St. Anthony Falls I-35 Bridge in Minneapolis

Bridging the Mississippi

SPANS ACROSS THE FATHER OF WATERS

Photographs by **PHILIP GOULD**

Text by **MARGOT HASHA** and **PHILIP GOULD**

Foreword by **BENJAMIN HICKEY**

LOUISIANA STATE UNIVERSITY PRESS ▮▮▮ BATON ROUGE

Publication of this book is made possible with support from the Paul and
Lulu Hilliard University Art Museum, organizer of the companion exhibit
Bridging the Mississippi: Spans across the Father of Waters.

Published by Louisiana State University Press
Copyright © 2020 by Margot Hasha and Philip Gould
LSU Press Paperback Original

Photographs © 2020 by Philip Gould
All rights reserved
Manufactured in the United States of America
First printing
Foreword copyright © Louisiana State University Press
Map created by Susan A. Gottardi

DESIGNER: Mandy McDonald Scallan
TYPEFACE: Arno Pro
PRINTER AND BINDER: Shenzhen Caimei Printing through
 Four Colour Print Group, Louisville, Kentucky

Cataloging-in-Publication Data are available at the Library of Congress.
ISBN 978-0-8071-7222-3 (pbk. : alk. paper)

To Avery, Annika, Colin, and Daniel

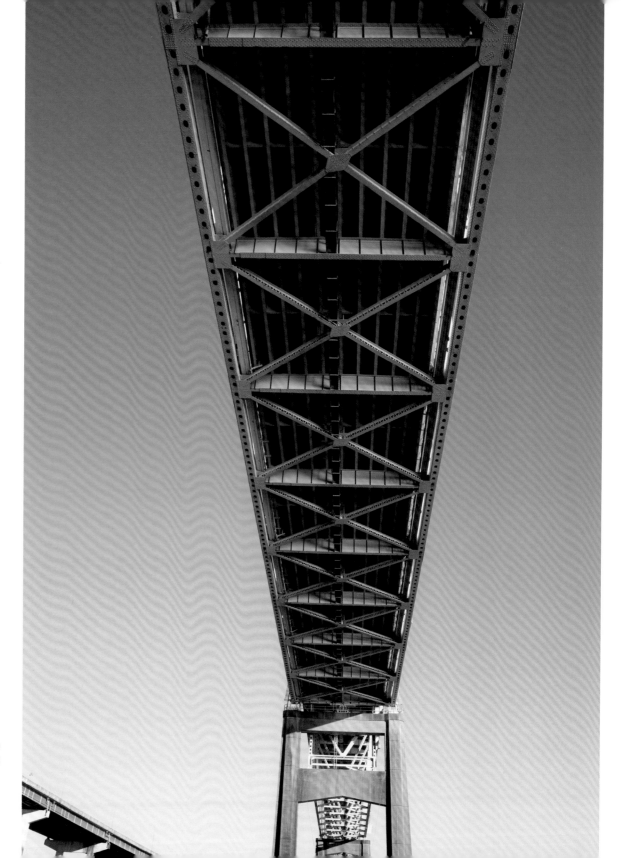

The original Greater New Orleans Bridge (CCC) substructure built in 1958

CONTENTS

FOREWORD, BY BENJAMIN HICKEY ~ xi

PREFACE ~ xiii

Introduction ~ 3

New Orleans, Louisiana

Essay
"Crescent City Connections,
 Gumbo Soil, and the Huey P." ~ 17

Photographs
Crescent City Connection ~ 19
Huey P. Long Bridge ~ 21
Hale Boggs Bridge ~ 29

Gramercy, Louisiana

Photographs
Veterans Memorial Bridge ~ 30

Donaldsonville, Louisiana

Essay
"Building a Span to Nowhere" ~ 33

Photographs
Sunshine Bridge ~ 35

Baton Rouge, Louisiana

Essay
"Traffic Jams and the Riverwalk" ~ 39

Photographs
Horace Wilkerson I-10 Bridge ~ 41
Huey P. Long Bridge ~ 43

St. Francisville, Louisiana

Photographs
John Jay Audubon Bridge ~ 44

Natchez, Mississippi–Vidalia, Louisiana

Photographs
Natchez–Vidalia Bridges ~ 46

Vicksburg, Mississippi

Photographs
I-20 Bridge ~ 50
U.S. 80 Bridge ~ 50

Greenville, Mississippi

Photograph
Jesse Brent Memorial Bridge ~ 51

Memphis, Tennessee

Essay
"A New Day for the Queen City" ~ 53

Photographs
Arkansas–Memphis I-55 Bridge ~ 52
Frisco Bridge ~ 52
Hernando de Soto Bridge ~ 55
Harahan Bridge ~ 58

Cairo, Illinois

Photograph
Cairo Mississippi River Bridge ~ 61

Cape Girardeau, Missouri

Photograph
Bill Emerson Memorial Bridge ~ 63

St. Louis, Missouri

Essay
"Faith in Eads and Steel" ~ 65

Photographs
Eads Bridge ~ 65
MacArthur Bridge ~ 68
Martin Luther King Bridge ~ 70
Stan Musial Veterans Memorial Bridge ~ 71
Chain of Rocks Bridge ~ 72

Alton, Illinois

Photograph
Clark Super Bridge ~ 74

Louisiana, Missouri

Photographs
Louisiana Rail Bridge ~ 76
Old Champ Clark Bridge ~ 77

Quincy, Illinois

Photographs
Soldier's Memorial Bridge ~ 78
Bayview Bridge ~ 78

Keokuk, Iowa

Photographs
Keokuk Municipal Bridge ~ 80

Ft. Madison, Iowa

Photographs
Fort Madison/Niota Toll Bridge ~ 82

Burlington, Iowa

Photographs
Great River Bridge ~ 84

The Quad Cities of Iowa and Illinois

Essay
"A Little Less Opinion, a Little More Fact" ~ 87

Photographs
Government Bridge ~ 89
Iowa–Illinois Memorial Bridge ~ 90
Centennial Bridge ~ 91

Clinton, Iowa

Photographs
Gateway Bridge ~ 92
Chicago and North Western Mississippi
River Crossing ~ 93

Savanna, Illinois

Essay
"A Tale of Two Bridges" ~ 95

Photographs
Savanna–Sabula Bridge ~ 98
Dale Gardner Veterans Memorial
Bridge ~ 100

Dubuque, Iowa

Photographs
Julien Dubuque Bridge ~ 102
Canadian National Railroad Bridge ~ 103

Marquette, Iowa–
Prairie du Chien, Wisconsin

Photograph
Marquette–Jolliet Bridge ~ 104

Lansing, Iowa

Essay
"A Town and Its Bridge" ~ 107

Photographs
Black Hawk Bridge ~ 108

La Crosse, Wisconsin

Photographs
Canadian Pacific Rail Bridge ~ 112
Mississippi River Bridges ~ 113

Winona, Minnesota

Photographs
Chicago and North Western Rail Bridge ~ 114
Winona Main Channel Bridges ~ 115

Red Wing, Minnesota

Photographs
Eisenhower Bridge ~ 116

Hastings, Minnesota

Photographs
Milwaukee Railroad Bridge ~ 118
Hastings Bridge ~ 118
Hastings Spiral Bridge ~ 119

St. Paul, Minnesota

Essay
"St. Paul and the Mississippi River Gorge" ~ 123

Photographs
Robert Street Bridge ~ 122
Great Western Railroad Bridge ~ 122
Wabasha Street Bridge ~ 125
Smith Avenue High Bridge ~ 126
Intercity Bridge (Minneapolis) ~ 128
Lake Street Bridge (Minneapolis) ~ 129

Minneapolis, Minnesota

Essay
"Calamity, Beauty, and Innovation" ~ 131

Photographs
Washington Avenue Bridge ~ 132
Tenth Street Bridge ~ 132
St. Anthony Falls I-35 Bridge ~ 132
Stone Arch Bridge ~ 134
Father Hennepin Bridge ~ 136
Third Avenue Bridge ~ 138
Lowry Avenue Bridge ~ 140

Anoka, Minnesota

Photograph
Ferry Street Bridge ~ 142

St. Cloud, Minnesota

Photographs
Veterans Bridge ~ 143
BNSF Bridge ~ 143

Sauk Rapids, Minnesota

Photograph
Sauk Rapids Bridge ~ 144

Little Falls, Minnesota

Photograph
Broadway Bridge ~ 145

Bemidji, Minnesota

Photograph
Bemidji Bridge ~ 146

Lake Itasca, Minnesota

Essay
"The Mississippi River Headwaters" ~ 151

Photographs
Log-bridge Crossing ~ 152
Headwaters Crossing ~ 153

ACKNOWLEDGMENTS ~ 155

SELECTED BIBLIOGRAPHY ~ 157

FOREWORD

Bridging the Mississippi: Spans across the Father of Waters is an expansive account of America's greatest waterway. Philip Gould and Margot Hasha have populated the pages of their book with a variety of transportation innovations, including barges, trains, paddle steamers, and, of course, bridges. The impetus for this project, bridges frequently do not receive their due as architectural wonders although they speak to American ingenuity and can-do attitude as few other structures do. Gould and Hasha offer a thorough historical narrative that is offset with intensely human stories. The resulting push and pull between grand narrative and singularly lived experience hints at the complexity of creating a work that represents, as much as possible, the entirety of the Mississippi River.

Gould's photographs capture the connectedness between the river and our shared history. Whether it is Raymond Manson praying under the Crescent City Connection each morning or a statue depicting a young Abraham Lincoln fighting in court for railroads' right to cross the Missis-

sippi, each image reflects the movement of time intertwined with the lives of people of all backgrounds. In Gould's dramatic shot of the bridges in Cairo, Illinois, where the Mississippi and Ohio rivers converge, the waterways and bridges seem to cut back diagonally against each other as though the whole arrangement is held together with a zigzag stitch. It strikes me that our communal understanding of the Mississippi holds us together in a manner similar to that of seams in garments. Taken from a chartered plane, the Cairo photograph subtly points to humans' role in the development of transportation along the banks of the Mississippi. That moment echoes other technological innovations that have taken, or are taking, place and are shown within these pages.

Bridging the Mississippi enhances our understanding of what the Mississippi River is. Through images and text, it offers readers the opportunity to see themselves as part of a larger historical continuum. This book is sure to delight.

Benjamin Hickey
Curator of Exhibitions
Paul and Lulu Hilliard University Art Museum
May 2019

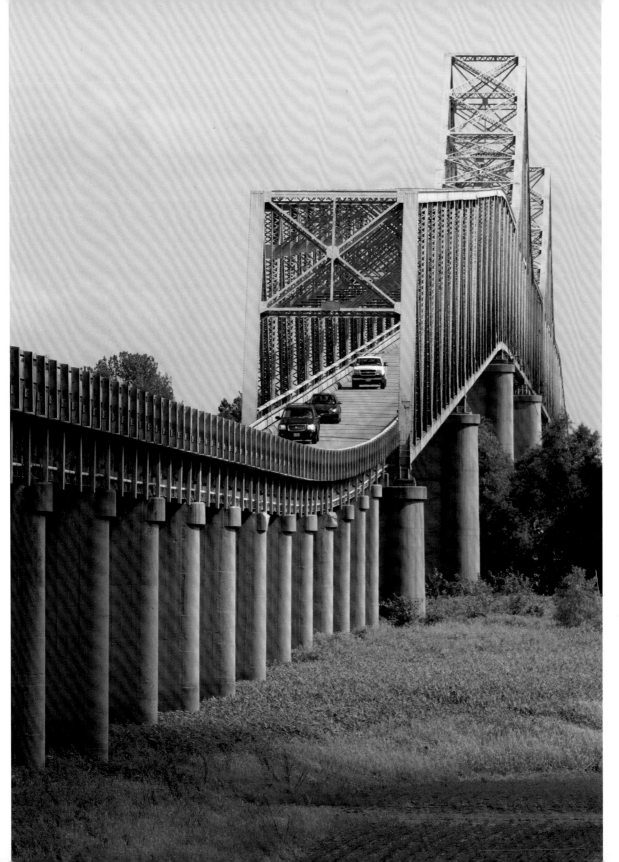

Traffic on the Mississippi River
Bridge near Cairo, Illinois

PREFACE

The vintage bridge we were approaching seemed grand and fitting for a Mississippi River crossing, yet the span actually was narrow, barely wide enough for two vehicles meeting from opposite directions. As we carefully drove across the old bridge on that very cold night, we could see piercing beams of truck lights ricocheting off the span's metal superstructure and into the misty, frozen air. On this remote bridge near Cairo, Illinois, where the Mississippi and Ohio rivers merge, this compelling scene was something I had not witnessed in my lifetime of travel.

I was headed to Paducah, Kentucky, with Robert Dafford, a fellow artist and friend from Lafayette, Louisiana. After a long day's drive, we reached the Mississippi River crossing at Cairo well after sundown. While crossing the bridge, I debated with myself about whether to ask Robert to stop the car so I could set up the tripod and photograph what I was seeing. I said nothing though, and the moment passed. As we drove on, I could see the opportunity receding in the rearview mirror.

It was easy to rationalize my decision at the time. Exhausted from traveling all day, I thought it best to hold my tongue and continue, yet my choice gnawed at me for weeks. In time, however, my regret morphed into the seed of an idea. If that one bridge in Cairo was so intriguing, what about all the other spans over the Mississippi River? Why not document crossings up and down the entire 2,350-mile length of the Father of Waters? I imagined photographs of visually compelling bridges in large cities, small towns, and rural farmland. Surely each would have its own distinctive identity.

Simultaneously, and to my amusement, I was often thinking about an old Jimmie Rogers song, "Miss the Mississippi and You," a heartfelt tune covered by numerous country-music icons, including Merle Haggard and Emmylou Harris. The song tells of America's great river far from the "big city lights," whose shores offer refuge to a weary soul and the comforting embrace of the singer's beloved. It didn't take much of a mental leap to replace *miss* in the song title with *bridge* and after changing *bridge* to *bridging* for grammatical clarity, I had a workable book title, *Bridging the Mississippi,* as well as a potential romantic subtheme for the project.

I also thought of the countless times I have crossed the Mississippi since first moving to Louisiana in 1974. When traveling from Lafayette to Baton Rouge or New Orleans, I crossed the older bridges whenever possible. Louisiana children once called these older spans "Huey Longs," a reference to the plaques hanging over their entrances that state "Built under the administration of GOVERNOR HUEY LONG." It was during his brief tenure as governor and United States senator, from 1928 to 1935, that Long modernized Louisiana's transportation grid, constructing thousands of miles of roads and over one hundred bridges throughout the state.

With ideas for the project taking shape, I began my research. I knew precious little about Mississippi River bridges outside of Louisiana, so I tried to learn as much as possible about these crossings. At one point early in my research I even attempted a virtual tour from a map on my cellphone, viewing bridges in 3D mode, without much success.

Jon Donlon, another friend and colleague, heard about the project

The Jesse Brent Memorial Bridge near Greenville, Mississippi

and sent me an intriguing e-mail in which he wrote, "I have long admired bridges as improbable objects and as unifying devices and have visited them all over, from the great grey Limpopo to the sluggish Father of Waters. When I went to St. Louis, I hoofed over to look at Eads Bridge—crowds were at the nearby Arch. However, a little knot of guys was at the foot of the bridge; young Malaysian engineer geeks, visiting America and doing a pilgrimage to sites from their textbooks (interview, May 28, 2016).

Ben Sandmel, an old friend, writer, and folklorist who, in his youth, worked as a deck hand on several riverboats, including the *Delta Queen,* strongly encouraged me as well. Ben had seen every bridge along the Mississippi in good weather and bad, and he recommended several as essential for the project.

The website of Minnesota resident John A. Weeks III, www.johnweeks.com, was particularly helpful. It features information about bridges across various midwestern rivers, including the Mississippi. After reviewing Weeks's site, bridge by bridge, and reading additional accounts of travel and commerce on the river, I began to grasp the remarkable narrative suggested by these spans.

Over the next two years, I made three extended trips upriver—in summer, fall, and winter—plus numerous ventures closer to home. My approach was simple: focus on the spans with historic significance, as well as the bridges which are architecturally intriguing, or simply dramatic, if not beautiful. In my photography I concentrated on three factors pertaining to the bridges: architecture, landscape, and humanity. Photographing the humanity aspect was often most rewarding as the photographic sub-jects would suddenly appear, creating numerous, serendipitous moments. I was seeing people in situations I never anticipated when planning the book. In most instances, each photo's relevance to the greater story was immediately clear.

In organizing the book, I had to decide how to sequence the bridges, whether to head upstream or down. After much consideration, I chose to head upriver in my portrayal. From a Louisiana vantage point, I knew the river best at its lowest latitudes. Heading upstream to photograph would be my voyage of discovery, something akin to an explorer's quest to find a river's source.

I also feel the river's modest beginnings, where the Mississippi is little more than a narrow stream with a famous name, lack the visual impact of the mega spans further downstream. The final crossings featured in the book, a thirty-foot log and a group of large boulders at the headwaters on Lake Itasca in Minnesota, have more resonance as crossings after we have seen everything downstream.

Finally, after three years photographing for the project, I have come to appreciate the importance of Mississippi River bridges. Practically, they provide essential national links for transportation and commerce. Figuratively, they are the stitches in America's fabric, connecting regions as well as local communities. What also became abundantly clear is that bridges across the Mississippi and elsewhere often provide the aesthetic framing of life-affirming settings, such as parks, riverwalks, and levee trails in towns and cities alike, places where people can gather and engage with, as the Jimmie Rodgers song says, "that old river shore."

Philip Gould

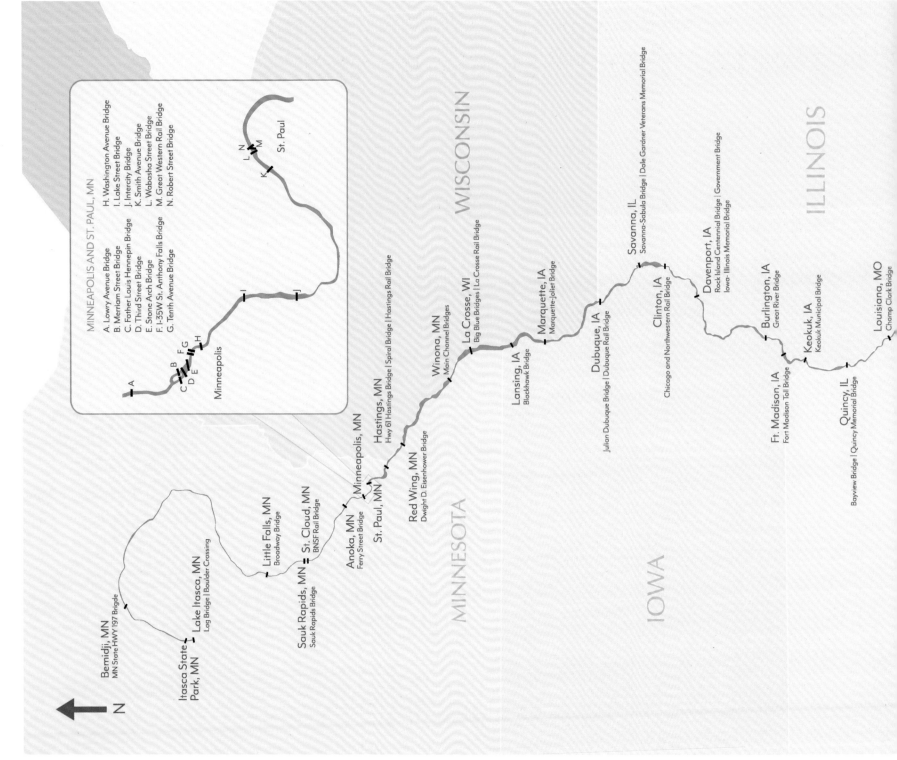

MINNEAPOLIS AND ST. PAUL, MN

A. Lowry Avenue Bridge
B. Merriam Street Bridge
C. Father Louis Hennepin Bridge
D. Third Street Bridge
E. Stone Arch Bridge
F. I-35W St. Anthony Falls Bridge
G. Tenth Avenue Bridge
H. Washington Avenue Bridge
I. Lake Street Bridge
J. Intercity Bridge
K. Smith Avenue Bridge
L. Wabasha Street Bridge
M. Great Western Rail Bridge
N. Robert Street Bridge

St. Paul

Minneapolis

N

Bemidji, MN
MN State HWY 197 Bridge

Itasca State
Park, MN

Lake Itasca, MN
Log Bridge | Boulder Crossing

Little Falls, MN
Broadway Bridge

St. Cloud, MN
BNSF Rail Bridge

Sauk Rapids, MN
Sauk Rapids Bridge

Anoka, MN
Ferry Street Bridge

Minneapolis, MN

St. Paul, MN

Hastings, MN
Hwy 61 Hastings Bridge | Spiral Bridge | Hastings Rail Bridge

Red Wing, MN
Dwight D. Eisenhower Bridge

Winona, MN
Main Channel Bridges

La Crosse, WI
Big Blue Bridges | La Crosse Rail Bridge

Lansing, IA
Blackhawk Bridge

Marquette, IA
Marquette-Joliet Bridge

Dubuque, IA
Julian Dubuque Bridge | Dubuque Rail Bridge

Savanna, IL
Savanna-Sabula Bridge | Dale Gardner Veterans Memorial Bridge

Clinton, IA
Chicago and Northwestern Rail Bridge

Davenport, IA
Rock Island Centennial Bridge | Government Bridge
Iowa- Illinois Memorial Bridge

Burlington, IA
Great River Bridge

Ft. Madison, IA
Fort Madison Toll Bridge

Keokuk, IA
Keokuk Municipal Bridge

Quincy, IL
Bayview Bridge | Quincy Memorial Bridge

Louisiana, MO
Champ Clark Bridge

MINNESOTA

WISCONSIN

IOWA

ILLINOIS

MISSISSIPPI RIVER BRIDGES

MISSOURI

Alton, IL
Clark Bridge

St. Louis, MO

KENTUCKY

Cape Girardeau, IL
Bill Emerson Memorial Bridge

Thebes, IL
Thebes Bridge

Cairo, IL
Cairo Mississippi River Bridge

TENNESSEE

Memphis, TN

MEMPHIS, TN
A. Memphis-Arkansas Bridge
B. Frisco Bridge
C. Harahan Bridge
D. Hernando de Soto Bridge

MISSISSIPPI

Greenville, MS
Jesse Brent Bridge

Vicksburg, MS
I-20 Vicksburg Bridge | U.S. 80 Old Vicksburg Bridge

NEW ORLEANS, LA
A. Hale Boggs Memorial Bridge
B. Huey P. Long Bridge
C. Crescent City Connection

Natchez, MS
Natchez-Vidalia Bridge

St. Francisville, LA
John James Audubon Bridge

Baton Rouge, LA
Horace Wilkinson Bridge | Huey P. Long - OK Allen Bridge

Gramercy, LA
Veteran's Memorial Bridge

New Orleans, LA

Donaldsonville, LA
Sunshine Bridge

ST. LOUIS, MO
A. Mac Arthur Bridge
B. James B. Eads Bridge
C. Martin Luther King Bridge
D. Stan Musial Veteran's Memorial Bridge
E. Chain of Rocks Bridge

ARKANSAS

LOUISIANA

location of bridge crossings

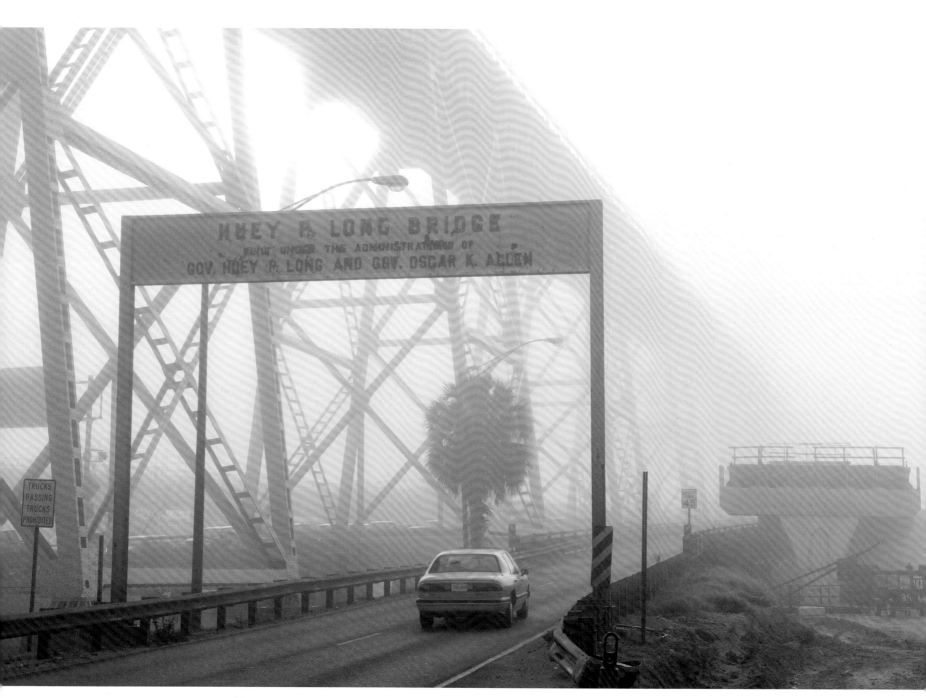

A car drives onto the original roadbed of the Huey P. Long Bridge in 2011 during its expansion project from 2006 to 2013. The sign above the entryway, long since removed, had greeted vehicles entering the bridge since it opened in 1935.

Introduction

Early Challenges to Railroad Bridges

During the first half of the nineteenth century, riverboats dominated America's transportation grid, boosting the nation's economy and directly contributing to the rise of trade settlements and towns along the Mississippi River. Centralized in St. Louis and New Orleans, cities located in slave-holding states, steamboat operations were oriented to north-south commerce, much of it in cotton. The Civil War temporarily halted these riverboat operations; it was not until the end of the conflict, in 1865, that they were reestablished. By then, only the bridge in Davenport, Iowa, spanned the Mississippi, but this was soon to change.

Development in the steel industry shortly after the Civil War contributed to a transition toward railroad operations and away from riverboat commerce. While this transformation did not occur overnight, rail bridges constructed of steel soon would be built at numerous points across the heretofore formidable Mississippi River, and in the coming years connect the Midwest and West to the industrial East. Chicago would quickly emerge as the center of the Midwest's new rail industry. By the turn of the twentieth century, railroads would dominate travel, trade, and commerce, effectively ending the riverboat era while simultaneously encouraging westward expansion.

In spite of the rapid growth of rail lines, railroad owners faced monumental opposition in their early efforts to expand, especially along the Mississippi. Prescient steamboat-company owners, anticipating railroad encroachment, had lobbied for laws securing their monopoly on the great river. In addition, they effectively garnered broad public support for river commerce, further impeding rail interests.

According to historian Howard S. Miller, the prevailing thinking at the time was that "bridges across navigable waters were public nuisances, navigational hazards, and unconstitutional restraints on interstate commerce. Even worse, they were crimes against nature" (71). However, after years of frustrating battles against the railroads, riverboat owners finally conceded the importance of the burgeoning infrastructure, and a newspaper article about the Eads Bridge in the *St. Louis Daily Missouri Democrat* acknowledged "the undeniable trend favoring trains, that geography had been undone by technology. . . . Rivers run only where nature pleases. Railroads run wherever man pleases" (72).

Geological and Geographic Factors

As the primary artery of the massive waterway flowing down from Minnesota through the Midwest to the Gulf of Mexico, the Mississippi River and its tributaries comprise the third-largest river system in the world. Draining 1.25 million square miles of watershed from thirty-one states, ranging from the Rocky Mountains to the Appalachians.

During the early Pleistocene epoch 2.6 million years ago, Ice Age glaciers crept southward through the Midwest, churning the landscape and

leaving a wake of broad river channels. This glacial drift carried a mixture of ice, silt, clay, sand, gravel, and boulders, reshaping the geography along the way. However, parts of present-day Wisconsin, Minnesota, northeastern Iowa, and northwestern Illinois escaped this slow-moving elemental force and were left as dramatic bluffs, with elevations ranging from 600 to 1,700 feet along the Mississippi riverbank.

The source of the Father of Waters lies within a vast network of tiny glacial lakes in northern Minnesota, and the search for the river's headwaters drew many early nineteenth-century explorers to the area. For example, in 1832, the Ojibwe tribe chief Ozawindib guided Henry Rowe Schoolcraft to what is today called Lake Itasca. Schoolcraft was commissioned by the United States government to negotiate a treaty between the Dakota and Ojibwe Indians, and he saw his assignment as an opportunity to explore the region.

Prior to Schoolcraft's expedition, native peoples knew the lake as Omushkos.

Bemidji Bridge tower, Bemidji, Minnesota

Early French explorers translated the Indian word to Lac La Biche, or Elk Lake. Schoolcraft renamed the lake, partly to reinforce his claim that he had found the true Mississippi River headwaters. He combined two Latin words—*veritas* (truth) and *caput* (head). The new name caught on, and sixty years later, in 1891, the Minnesota legislature officially voted to make Lake Itasca and the area surrounding it the first Minnesota state park. The bill passed by only one vote. However, that narrow margin allowed the legislature to successfully protect the pine-forested area from the politically powerful logging industry.

From Lake Itasca, which lies 1,475 feet above sea level, lake water flows

over a line of boulders, into a shallow creek, beginning its 2,350-mile journey to the Gulf of Mexico. The shallow stream widens from a few feet at its headwaters to nearly two miles across near its mouth south of New Orleans. From Lake Itasca, the river flows north to Lake Bemidji, then winds its way eastward and arcs south in the shape of a question mark toward Minneapolis and St. Paul. At St. Anthony Falls in Minneapolis, the Mississippi's water level drops fifty feet or more. From there the river widens and continues to St. Paul, flowing through the only gorge along its path.

From St. Paul to Savanna, Illinois, the Mississippi flows through narrow stretches and massive lakes. For example, sixty miles downriver from St. Paul lies Lake Pepin, the widest naturally occurring part of the river. With a surface area of 45.7 square miles and averaging 1.7 miles wide, it is the largest lake on the Mississippi. Downriver from Lake Pepin, the Mississippi meanders between bluffs and through flatlands until it is joined by the Missouri River in St. Louis. From this point, the Mississippi wanders through a vast, open delta to eventually converge with the Ohio River at the southernmost tip of Illinois, between Cairo and Wickliffe, Kentucky.

South of Kentucky, in regions where the landscape is relatively flat, the Mississippi winds and curves dramatically. In cities such as Memphis, Vicksburg, Natchez, and St. Francisville, bluffs on the eastern side of the mighty waterway function as overlooks for visitors. The last of these are in Baton Rouge at Scott's Bluff on the Southern University campus and downtown, where the Old State Capitol is located.

Over thousands of years, especially during high-water periods, the

Mississippi occasionally changed course, its rushing waters cutting deeply into riverbanks and carving out new paths. Oxbow lakes formed over time when these meandering parts of the river separated from the main channel. Examples of oxbow lakes, or false rivers, along the Mississippi River include Horseshoe Lake in Madison County, Illinois, and Lake Providence in northeastern Louisiana.

One hundred miles upriver from Baton Rouge, the Mississippi connects with the smaller Atchafalaya River. If unimpeded, the Mississippi would force its way into the narrow channel. However, the river is prevented from flowing into the Atchafalaya and changing course by numerous flood-control structures. The most significant of these is the Old River Control Structure, a multicomponent floodgate system regulating Mississippi River water flow and diverting approximately 30 percent of it into the Atchafalaya River.

South of New Orleans, near the mouth of the Mississippi, the river continues through a vast, marshy delta comprising a complex network of channels. One of these, the twenty-mile-long Southwest Pass, provides ocean-going vessels access to the Mississippi River and New Orleans.

Exploration and Early Trade

The earliest-known native settlement along the Mississippi River dates back to 1,000 BCE during the Woodland period. The Hopewell Indians of Illinois and Ohio used stone and bone tools, built shelters, crafted leather, and engaged in early cultivation. Their pottery, which was used for grain storage, cooking, and burial decoration, allowed them to build villages and develop a more sedentary existence. However, hunting, fishing, and gathering remained important to their survival, and their use of spears later was replaced by bows and arrows. The Hopewell also traded furs, weapons, and pottery within a loosely defined network that extended across much of the Mississippi River watershed.

Cahokia, the most advanced settlement among the Mississippian cultures, was located in present-day Illinois, directly across the river from St. Louis. With a population that peaked at 20,000, Cahokia was the largest native-built city north of the Rio Grande and served as the base of the Mississippian Indian trade network.

Hernando de Soto, a Spanish explorer and conquistador born in 1500, was the first European to explore the Mississippi River in search of gold, a passage to China, or even a route to the Pacific coast. In 1539, de Soto landed on the west coast of present-day Florida with 600 troops. He traveled through Georgia, Alabama, Mississippi, Tennessee, and Arkansas, leading his party up the Mississippi River to Memphis, then heading west. In 1542, he died of fever along the banks of the river, possibly in Lake Village, Arkansas, or Ferriday, Louisiana.

French explorers Father Jacques Marquette, a Jesuit missionary, and Louis Jolliet, a fur trapper, were the first Europeans who attempted to travel to the Great Lakes via the Mississippi River. Setting off from Arkansas in 1673 with several men in two bark canoes, Marquette and Jolliet intended to document this largely unknown region for French and Canadian officials. They hoped to realize France's dream of an all-water route from the Great Lakes to the Gulf of Mexico, where the French could build forts, create a barrier between themselves and the English, and expand their Catholic faith. The two men were unsuccessful.

However, Marquette and Jolliet did pave the way for other European explorers to travel the regions along the Mississippi River. Robert de la Salle, a Jesuit, was the first French European to explore the Mississippi from the Ohio River to the Gulf of Mexico. On April 8, 1682, upon arriving at the mouth of the Mississippi, he claimed the entire river basin for France and named the region "Louisiana" after Louis XIV and his wife Anne.

During the the eighteenth century, American settlers began to trade extensively, building rafts and floating goods along the Ohio River to the Mississippi and down to the rapidly growing city of New Orleans. Once unloaded, the rafts were scrapped for lumber. The traders, known as Kaintucks, then made the long trek back to Kentucky on foot, following the path now known as the Natchez Trace. Once back home, the traders began their journey again.

Nicholas James Roosevelt, inventor, investor in upstate New York land, and member of the famous Roosevelt family, was known for designing vertical paddle wheels for steamboats. He traveled the Kaintuck route by flat-bottom boat to explore and familiarize himself with the Ohio and Mississippi rivers. In 1809, Roosevelt joined interests with Robert Fulton,

who had introduced steamboats to western waters. In 1811, their vessel, *New Orleans,* became the first powered vessel to travel the Ohio and Mississippi rivers from Pittsburgh to New Orleans, a trip taking fourteen days.

Following the success of the *New Orleans,* countless steamboats began hauling goods and travelers up and down the Mississippi and Ohio rivers. The commerce generated by steamboat interests quickly transformed trade areas into thriving communities. But the sovereignty of steamboats would be short lived, as the need for faster methods of transportation and the push for westward expansion would introduce a rival—the railroad.

Railroads

With the advent of railroads, river travel and trade gradually declined. Because railroads were limited less by geography and topography, they could be built across prairies, over mountain ranges, and across waterways. People's desire to settle the West required easier access than wagon trains could provide, and railroads offered the solution if constructed in a suitable location. The area between Rock Island, Illinois, and Davenport, Iowa, seemed ideal for a rail bridge. Under the guidance of Henry Farnam and Joseph Sheffield, the Chicago and Rock Island Railroad completed the first rail bridge across the Mississippi River in 1856. Passengers from New York City could arrive in eastern Iowa within forty-two hours. Only thirteen years later, the 1,912-mile-long transcontinental railroad, built between 1863 and 1869, would connect the United States rail network from the Midwest to the Pacific coast at Oakland Long Wharf in San Francisco.

From the moment of its completion in 1856, the Rock Island Bridge symbolized larger issues affecting transcontinental commerce and regional interests. Railroad backers were divided in their opinions between those who favored a northern route for the transcontinental railroad and those who preferred one further south. Also, the Rock Island Bridge pitted steamboat interests against the railroads, a disagreement that finally was settled in the United States Supreme Court during the Lincoln administration.

Within weeks of its opening to rail traffic, the Chicago and Rock Island Bridge endured a fateful catastrophe. A side-wheel steamboat named the *Effie Afton,* having just cleared the rail crossing while heading up-

stream without incident, suddenly veered out of control when one of the wheels jammed. Crashing into a bridge pier, the vessel burst into flames. The *Effie Afton* was destroyed, as was the pier and much of the bridge, rendering the new span impassable. It has been said that witnesses along the riverbank thunderously cheered as the alien bridge was vanquished!

Soon thereafter, steamboat interests sued the railroad, claiming the bridge was a material obstruction to navigation. The rail bridge company assembled a legal defense team that included Abraham Lincoln, then an aspiring young attorney. Jefferson Davis, secretary of war, also was involved because of his active role in the debate over a northern or southern route for the transcontinental railroad. Lincoln's persuasive closing argument acknowledged that "one man has as good a right to cross the river as another to sail up or down it." He further noted that at stake was the "fate of the civilization of the west" (Pfeiffer, 2004).

No verdict was rendered in the case, but the highly publicized trial afforded the young lawyer national celebrity and boosted his political career. Later, during Lincoln's presidency and with the Civil War raging, the case was heard in the United States Supreme Court, which decided in favor of the railroad. Apart from Lincoln's political legacy, he laid the groundwork for a post–Civil War future when he signed the Pacific Railroad Act in 1862, opening the way for the transcontinental railroad, which was completed in 1869, four years after his assassination.

The Rock Island Bridge was rebuilt, and construction of new rail spans along the Mississippi and other rivers became a national priority. The Chicago press trumpeted this progressive policy, writing that railroads had overturned the sovereignty of the rivers and made Chicago "Queen of the West." Railroads quickly surpassed riverboats as the preeminent means of transportation for goods and passengers on the Mississippi River once Chicago became the hub of rail activity in the American Midwest.

James Eads His Bridge

By the 1860s, St. Louis business owners expressed escalating concerns about the decline of riverboat travel and commerce, especially during the Civil War when southern markets were unavailable. Competition for economic power had increased between rail and riverboat interests, and the

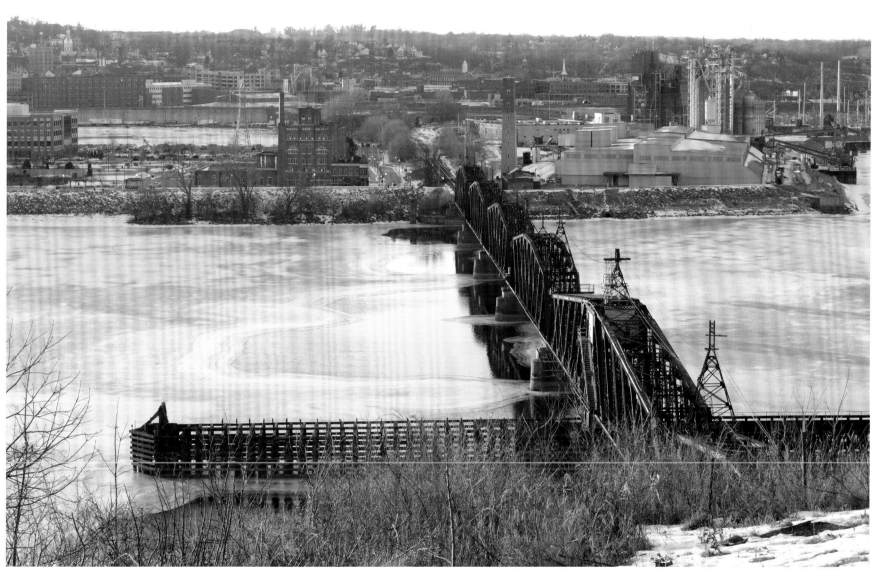

The Canadian National Railroad Bridge in Dubuque, Iowa. During the winter months, the river is closed to commercial traffic, allowing the swivel span to stay open for rail traffic.

construction of new bridges across the Mississippi had also opened new commercial networks. St. Louis business owners envisioned combining railroads and riverboats to form a complex transportation matrix that could compete with Chicago's formidable rail network. Accomplishing such a goal would be difficult, so St. Louis city fathers turned to well-known inventor and businessman James Eads.

Eads's résumé was impressive. He had already invented a pneumatic pressurized casing, or diving bell, which enabled him and other river-bottom explorers to extend their time under water. This device allowed Eads to walk much of the Mississippi River bottom in search of salvage from sunken steamboats, a lucrative business considering the frequent boat collisions along the river. During the Civil War, Eads also had designed and manufactured ironclad battle ships for the Union, enabling the North to maintain control of the Mississippi River.

In spite of his accomplishments, Eads had no formal engineering education, yet he was being charged with building a bridge that, for the times, seemed impossible to complete. Other American bridges had been constructed of iron and wood, materials not strong enough for the proposed span. So Eads turned to steel, a new metal alloy untested for bridge construction. He was aware of European developments in steel metallurgy and expected additional improvements would make construction of the St. Louis bridge possible. Eads hired top engineering professionals to work with him, and the new span was the first in the United States to utilize steel in large volume.

Eads's bridge project commenced in 1867 but not without enormous technical challenges. For example, the design plan required the piers to be set into bedrock 100 feet beneath the silt-laden river bottom. They

Sign on the original Savanna–Sabula Bridge between the Illinois and Iowa towns on the Mississippi River before the span's demolition

also had to be placed 500 feet apart to allow enough space and height for riverboats to safely navigate beneath the bridge. Everyone involved was clearly aware of the *Effie Afton* incident.

Through fits and starts, the Eads Bridge in St. Louis was finally completed, and it opened to much public fanfare on the Fourth of July in 1874. Eads was, however, unsuccessful at convincing the railroads to actually use the new bridge. The existing railroad networks on both sides of the Mississippi did not efficiently connect to the new span, making operations difficult. As a result, use of the expensive, state-of-the-art bridge declined, and its operations fell into bankruptcy in 1875.

The Eads Bridge languished until 1993, when it was converted into a cross-river line for the St. Louis metro system. The city then began a slow refurbishment of the entire structure to include a new vehicle and pedestrian crossing. In spite of its checkered history, the Eads Bridge attracts aficionados from around the world. In an article for the *New York Times,* architecture critic Ada Louise Huxtable described the Eads as "among the most beautiful works of man" on the occasion of its Centennial, July 4, 1974.

Footholds

By the close of the nineteenth century, numerous railroad bridges had been built along the Mississippi River, enabling rail operators to connect to various points south and west. These massive rail bridges were designed and constructed with lift or swing spans to allow riverboat traffic to navigate unencumbered. Architecturally, the goal was function over style, so many of the spans seem dark and heavy to modern eyes. Still, many contemporary admirers see great beauty in these imposing metal structures.

One exception to this function-first trend in rail spans was the Stone

Arch Bridge in Minneapolis. Built in 1883, it stood adjacent to downtown, just below St. Anthony Falls. Because river traffic could not navigate the falls, this was the stopping point for commercial boats. Consequently, height and space requirements, so important to the design of bridges over commercially navigable waters, were not a factor for the Stone Arch Bridge. Engineers were free to create a stylistically appealing span different from the typical lift or swing bridges downriver. The result was an evocative span featuring twenty-one arches, reminiscent of ancient Roman architecture.

The Stone Arch Bridge transformed Minneapolis from a sleepy town into a buzzing metropolis. It was now possible to transport materials by rail from the Pacific Northwest through Minneapolis and to the industrial Eastern Seaboard. In 1870, the city of St. Paul, with a population of 20,000, was the northernmost river port on the Mississippi and also served as Minnesota's state capitol. Simultaneously, 13,000 people resided in Minneapolis. Within a few short decades Minneapolis eclipsed St. Paul in economic growth, and by 1910 boasted over 300,000 residents compared to St. Paul's 214,000.

As affordable automobiles gained in popularity during the early twentieth century, new bridges were built to accommodate both rail and vehicle traffic. The first traffic lanes were attached to preexisting rail crossings and quickly became outmoded. To meet new demands, bridge builders erected distinctive, albeit quirky, structures specifically intended for cars and trucks. This trend continued through the 1930s until World War II, when many of these vehicle crossings were replaced by sturdier, more massive spans.

Huey P. Long Bridge in New Orleans

By 1930, the Mississippi River Bridge in Vicksburg, Mississippi, was the southernmost span on the river. There was no Mississippi River rail bridge in New Orleans, one of the most important port cities in the United States. The Crescent City desperately needed a railroad bridge to improve operations and commerce in the area, and residents enthusiastically supported the idea.

Rail transportation in New Orleans was inefficient and expensive. New Orleans railroad operators were forced to transport rail cars across the river on slow-moving ferries. However, building a rail bridge in New Orleans posed daunting challenges for engineers, particularly because of the river's width. Also, any new span had to be constructed at a height sufficient to allow clear passage of ocean-going freighters and passenger ships. Because trains required a grade of 1.25 percent, a New Orleans rail bridge would exceed four miles in length. Further complicating matters, builders would necessarily be required to dig through deep layers of silt to properly anchor the piers while wrestling a four-mile per hour current.

Building a rail bridge in New Orleans was not a new idea. As early as 1892, the Southern Pacific Railway proposed constructing a high-level bridge in or near the city. However, an economic depression prevented any work on the project. It was not until 1925 that railroad engineering firm Modjeski & Masters began its design. The Great Depression of 1929 once again delayed progress, but on December 31, 1932, construction resumed with a few minor interruptions. Louisiana's populist governor Huey P. Long avidly promoted the new bridge. Unfortunately, the "Kingfish" did not live to see its opening on December 16, 1935. He was assassinated three months earlier.

The original vehicle bridge featured a nine-foot-wide lane on both sides with no shoulders. While adequate for cars and trucks of the 1930s, the lanes were dangerously narrow for the large vehicles popular during later decades. In 2006, Louisiana Department of Transportation (LDOT) undertook a massive, multiyear widening project of the Huey P. Long Bridge. Piers and approaches were modernized and strengthened to accommodate three 11-foot-wide lanes on each side, plus shoulders. The transformed span beautifully incorporates the original four-mile rail crossing with its new, wider traffic lanes, while maintaining the structure's profile and architectural integrity.

The Long, Delicate Dance

Since 1856, when the *Effie Afton* struck the first rail crossing at Rock Island, Illinois, a costly, sometimes dangerous, and often tenuous relationship has existed between bridges and the vessels navigating beneath them. When collisions, or landings, do occur, the results can range from a few scrapes or dents to calamitous destruction of vessels and spans. Whether minor

or catastrophic, collisions on the Mississippi and other rivers are a fact of life. In his memoir, *My Life on the Mississippi: Or Why I Am Not Mark Twain*, Richard Bissell describes the modern dangers of working on the river, stating, "Due to wind, current, rudder trouble, engine failure, or the mysteries of fate, towboats nowadays, with tremendous power and magnificent steer systems, still manage sometimes to hit the piers, bust up the tow and fill the river with runaway or sunken barges, or even to sink the towboat itself" (87).

During the early hours of October 12, 2018, the towboat *Kristin Alexis* was pushing a crane barge upriver towards the Sunshine Bridge near Donaldsonville, Louisiana. Suddenly, the crane smashed into the bridge and lodged beneath it, rendering the towboat and barge immobile. The collision created an enormous dent in one of the bridge's support beams, forcing LDOT officials to close the span to vehicle traffic. Since the accident, contractors have worked around the clock to repair the Sunshine Bridge.

After inspecting the damaged span, project engineer Tim Thomas said, "Bridges and vessels are engaged in a long, delicate dance that neither party wants" (interview, Oct. 29, 2018). This dance becomes more challenging at night or when a heavy fog blankets the water. Sometimes the only reference a riverboat pilot has is the flagpole at the front of his barge grouping.

Another difficult crossing to navigate involves the U.S. 80 bridge in Vicksburg, Mississippi. Riverboat pilots consider this span the trickiest on the river to negotiate, and with good reason. According to Herman Smith, superintendent for the Mississippi Bridge Commission in Vicksburg, the bridge has been struck more than any other span on the river. In 2017, there were four strikes; in 2018 there were six (interview, Dec. 18, 2018).

What makes this site so treacherous is the ninety-degree hard right turn in the Mississippi just upriver from the U.S. 80 and I-20 bridges. To safely navigate this turn, towboats and massive barge groupings flowing downriver must maneuver through the 825-foot gap beneath the U.S. 80 bridge while navigating a river current of at least four miles per hour. The number four pier to the right of the gap is nicknamed "Scar" for the countless dents and scrapings caused by landings.

Jon Craiglow, a native of Cape Girardeau, Missouri, and a veteran riv-

Eddie Tarver inspects damage to the Sunshine Bridge during its repair. A towboat and crane barge struck the span on October 12, 2018.

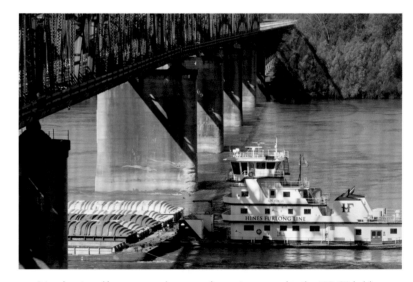

A towboat and barge grouping pass downstream under the U.S. 80 bridge at Vicksburg, Mississippi. The pier to the barge's upstream, starboard side are scarred by collisions from numerous vessels over the years. The bridge has endured more hits than any other on the Mississippi. Boat pilots also rate the bridge as one of the most difficult to navigate due to the ninety-degree bend in the river just upstream from the span.

erboat pilot who knows the lower Mississippi bridges quite well, stated, "Bridges are typically the toughest obstacles because there is very little room for error and the river is constantly throwing errors our way. That said, thus far, I've not personally hit a bridge" (interview, Sept. 24, 2018).

Infrastructure and Historic Preservation

The history of Mississippi River bridges is filled with stories of remarkable innovation, incredible successes, significant compromises, ongoing survival, and deep disappointments. As many of the stunningly beautiful older spans fall into disrepair, become unsafe, or no longer meet contemporary traffic demands, a heated debate has emerged between those who insist upon historical preservation and those who advocate for modernization of bridge infrastructure. In some cases, historic preservation wins out and failing spans are repurposed into pedestrian parks, as in the case of Minneapolis's Stone Arch Bridge. For others, including the Dale Gardner Veterans Memorial Bridge in Savanna, Illinois, the push for modern infrastructure has prevailed. However, in many cases, historic preservation and modern infrastructure form an easy partnership, resulting in the best both sides can offer, as seen with the widening project of the Huey P. Long Bridge. Sadly, as in the case of the Hastings Spiral Bridge in Hastings, Minnesota, efforts at preservation failed, and its demolition in 1951 led to deep regret within the community.

Perhaps the best-known tale of successful historic preservation involves the Eads Bridge, which has had its ups and downs since its opening in 1874. In 1875, it experienced bankruptcy, followed by years of neglect and closure. However, during the 1990s, it was improved and repurposed, with its architectural integrity intact.

The remarkable Black Hawk Bridge in Lansing, Iowa, built in 1931, is one of the last distinctive spans of its era. Its fate remains in question due to its advanced age and awkward location near a major bend in the Mississippi River. However, the structurally sound bridge is a tourist attraction and point of pride for residents of tiny Lansing.

The Harahan Bridge in Memphis, Tennessee, constructed with two rail lines, opened in 1916. The following year, a fourteen-foot-wide vehicle lane built of timbers was added to each side of the bridge. These timbers

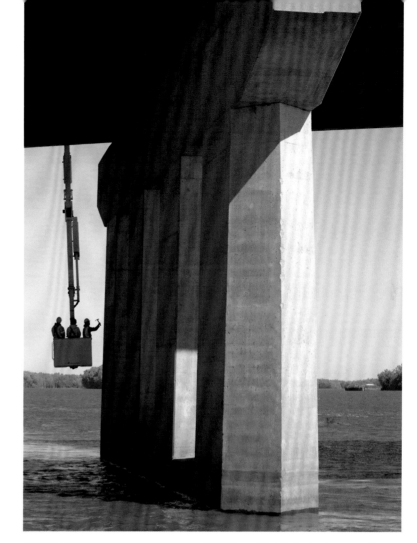

Iowa Department of Transportation bridge inspectors in Burlington use a hammer to test for cracks in the Great River Bridge's reinforced concrete piers.

were removed in 1949, but the support girders remained, even when the new Memphis–Arkansas Bridge opened nearby. In 2016, the metal girders were repurposed for use as the base for a pedestrian and bicycle path. Today, LED lights illuminate the entire 100-year-old Harahan Bridge, instilling a sense of vibrancy and aesthetic beauty.

In Minneapolis, the Merriam Street Bridge spans the small east channel of the Mississippi River near downtown, then connects to Nicollet Island. The original truss section of the bridge dates back to 1887, when it

Harahan Bridge pier (detail), Memphis

Integrating history and modernity through a somewhat different method, city planners in Quincy, Illinois, simply relieved the heavy two-way load on the Quincy Memorial Bridge by constructing a new span adjacent to the original. When two-direction traffic loads rendered the old span obsolete, the new Bayview Bridge was built in 1986, just north of the Quincy Memorial span. Once the Bayview was completed, the Illinois Department of Transportation reinforced the old bridge to carry all eastbound traffic, routing westbound traffic across the new span. Architecturally, the two bridges contrast, but there exists a touching harmony between the old and new.

In 2007, officials from Minnesota Department of Transportation (MDOT) initiated a statewide inspection of spans after the I-35 bridge calamity in Minneapolis and discovered that the pre-1946 cantilever through-truss crossing in Winona was dangerously deteriorated. It was closed immediately, and a temporary ferry service carried traffic until a new bridge could be completed nearby. After the new bridge opened, workers began restoring the old cantilever bridge. However, the project was controversial among locals, who felt that two adjacent bridges were unnecessary and a waste of their taxpayer dollars.

Mark Peterson, Winona mayor and executive director of the Winona Historical Society, countered residents' arguments, stating in an interview that the bridge possessed historic value as the only truss span of its kind in the state. In his view, the expensive repairs were worthwhile, even though the cost exceeded what was spent to construct the new bridge. "This community will be very happy seventy-five years from now that they kept the bridge," he explained. "By then the span will be a 150-year-old historic relic" (interview, Mar. 5, 2018).

Possibly the most significant cautionary tale for bridge preservationists is that of the regrettable decision made in Hastings, Minnesota, during the 1950s. In 1895, the Hastings Spiral Bridge was built across the Mississippi River at the foot of downtown. Motorists and pedestrians entered the bridge from street level and traveled up the spiral to the crossing level. The unusual bridge became legendary among locals. However, by the 1940s and 1950s, the winding span was suffering from metal fatigue and rust, and could no longer support the increased weight of traffic. A

was part of a much larger span that crossed the river at Broadway Avenue. When that antiquated bridge was removed in 1985, the one best-preserved truss was floated downriver and installed at its current location near the St. Anthony Main development. Wooden pedestrian lanes were added to both sides of the bridge, and new piers and supports were built on top of steel girders for added strength. The antique truss adds historical authenticity to the span, without providing any functional support. Through the successful partnership between modernization and historic preservation, the Merriam Street Bridge retains its vintage charm while meeting contemporary structural needs.

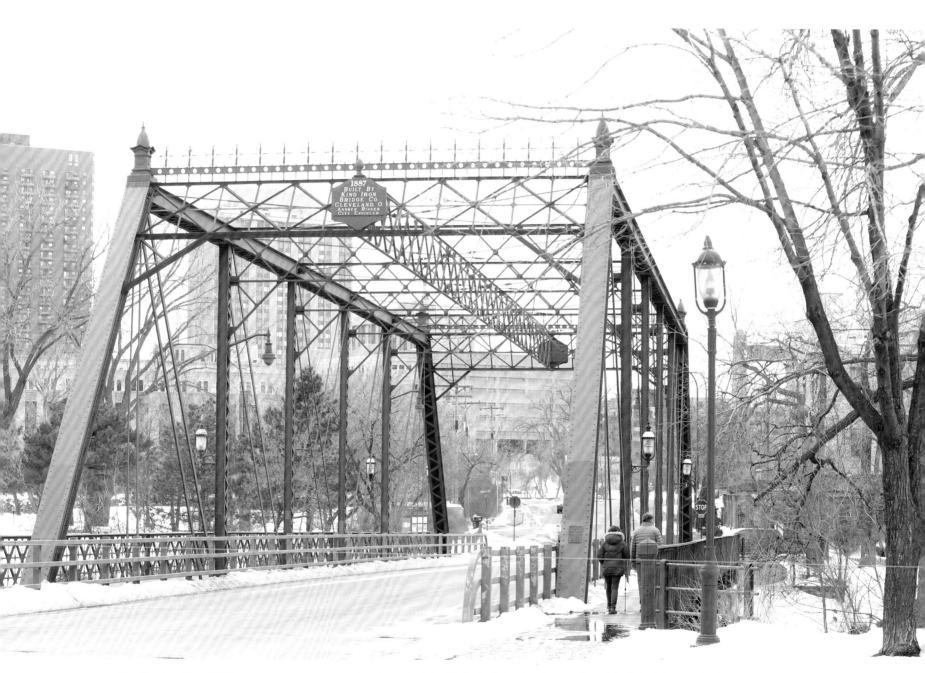

The Merriam Street Bridge crosses a narrower eastern branch of the Mississippi River in Minneapolis. Originally built in 1887, the bridge was once part of a longer span that crossed the entire river further upstream. The portion of the trestle pictured here was recovered during the demolition of the original and floated to this location. The bridge connects the city's east bank to Nicollet Island.

new bridge was built adjacent to the spiral span after World War II, and MDOT then gifted the old span to the town of Hastings. Unfortunately, the town could not afford the expensive maintenance costs, and the Hastings Spiral Bridge was torn down. According to John A. Weeks III, "As soon as it was torn down, the city realized its mistake. The Spiral Bridge was a symbol of the city for decades. Nowadays, when someone in Hastings wants to tear down a historic building, the cry goes out to remember what happened to the Spiral Bridge" (www .johnweeks.com). Weeks also notes that Steve and Sylvia Bauer took preservation matters in Hastings to heart and founded a collection of historical buildings called the Little Log House Pioneer Village, whose star attraction is a replica of the Hastings Spiral Bridge.

The Twenty-First Century

Modernization of Mississippi River bridge infrastructure has continued into the twenty-first century. When new spans are built, they tend to be fairly basic in design, with at least two exceptions—the Lowry Avenue and the I-35 St. Anthony Falls bridges. The latest Lowry Avenue Bridge, which was completed in downtown Minneapolis, features computerized multicolored lighting along its steel-tied arches, creating a dramatic nighttime display. The new I-35 St. Anthony Falls Bridge was built because of a catastrophe. During rush hour on August 1, 2007, the old I-35 Mississippi River bridge near downtown Minneapolis collapsed suddenly, killing thirteen people and injuring 145. The incident occurred when the spindly crossing, suffering from extreme metal fatigue, could no longer support heavy interstate traffic.

The new, state-of-the-art I-35 bridge has sleek lines and a comput-

Artist's rendition of the Hastings, Minnesota, Spiral Bridge, which was demolished in 1951

erized lighting panel that illuminates the span at night. Electronic stress sensors were installed throughout the bridge to serve as an early warning system. And on each end of the traffic deck, two blue wave sculptures were added as memorials to those who lost their lives in 2007.

The new I-35 bridge is a stunning visual attraction bisecting the St. Anthony Falls Riverside Park in downtown Minneapolis. The park is a peaceful, accessible refuge along the Mississippi River bank, drawing residents and visitors alike. Contemporary havens such as the St. Anthony Fall Riverside Park have sprung up in towns and cities along the river, where they weave together businesses and residential areas to enhance urban living.

Mississippi River bridges provide both source and setting for countless truly American stories of courage, disappointment, creativity, suffering, and triumph. Some tales celebrate human ingenuity in the face of seemingly insurmountable technical challenges posed by a river whose geographic and geological complexities inspire awe and resolve rather than fear and retreat. Other stories concentrate on the Mississippi River as a 2,300-mile-long museum, featuring spans that showcase the evolution of bridge architecture in the United States. Still others tell personal tales of inspired relationships between individuals and bridges in a tenuous balancing act between efforts to honor and preserve history with attempts to maintain modern, safe infrastructure.

What follows is an interpretation of the historical and evolving textural relationship between America and its Father of Waters, told through

Afternoon traffic on the Sunshine Bridge in Donaldsonville, Louisiana

stories and photographs of seventy-plus magnificent bridges that cross it. We began our journey in New Orleans, the final city through which the great river flows before emptying into the Gulf of Mexico. Working our way upriver, we stopped at both newly renovated spans and others in use for more than a century. From the original Hennepin Bridge, the first span constructed on the river in 1855, to the twenty-first-century expansion of the vintage Huey P. Long, each crossing forms a stitch joining East and West into one national fabric.

Evening rush-hour traffic crosses New Orleans's Crescent City Connection. An estimated 180,000 vehicles cross the bridge daily.

New Orleans, Louisiana

Crescent Connections, Gumbo Soil, and the Huey P.

The Mississippi River at New Orleans is a gateway for vessels from around the world and is also the southernmost city along the banks of America's Father of Waters. Compared to various points north, the river is particularly daunting around the Crescent City. Here, riverboat pilots must navigate barges and ocean-going vessels strategically to avoid both natural and man-made hazards along the riverbanks. For example, located along eight major river bends in Jefferson and Orleans parishes are a public aquarium, riverside shopping centers, ships, docks, and bridge piers. As elsewhere, the Mississippi is often fierce, with rapid currents and dangerous whirlpools challenging safe navigation. There are few kayaks and small boats in these waters along the riverbanks. The water is muddy and brown because of the tons of delta silt carried downriver. In New Orleans, bedrock lies beneath 1,000 feet of deltaic riverbed.

During the latter half of the nineteenth century, as rail commerce and travel became increasingly important to New Orleans, crossing the Mississippi was an expensive and time-consuming process. Because there was no rail bridge, trains were disassembled, loaded onto ferries three to five cars at a time, and finally transported across the river for reassembly, a tedious effort often taking days to complete.

New Orleans residents had advocated for a rail bridge since the early 1800s. Finally, in 1892, representatives of the Southern Pacific Railroad proposed a crossing, but a financial panic that year extinguished the idea. In spite of collective support for a new span, neither the will to build it nor the means to finance it existed, at least not yet.

During the early twentieth century, New Orleans grew and prospered, and rail traffic followed suit, along with increasing demand for a bridge. Finally, during the early 1920s, the New Orleans Public Belt Railroad hired renowned bridge architect Ralph Modjeski to design a span that could safely bridge the Mississippi.

The old rail and new highway approach piers on the expanded Huey P. Long Bridge

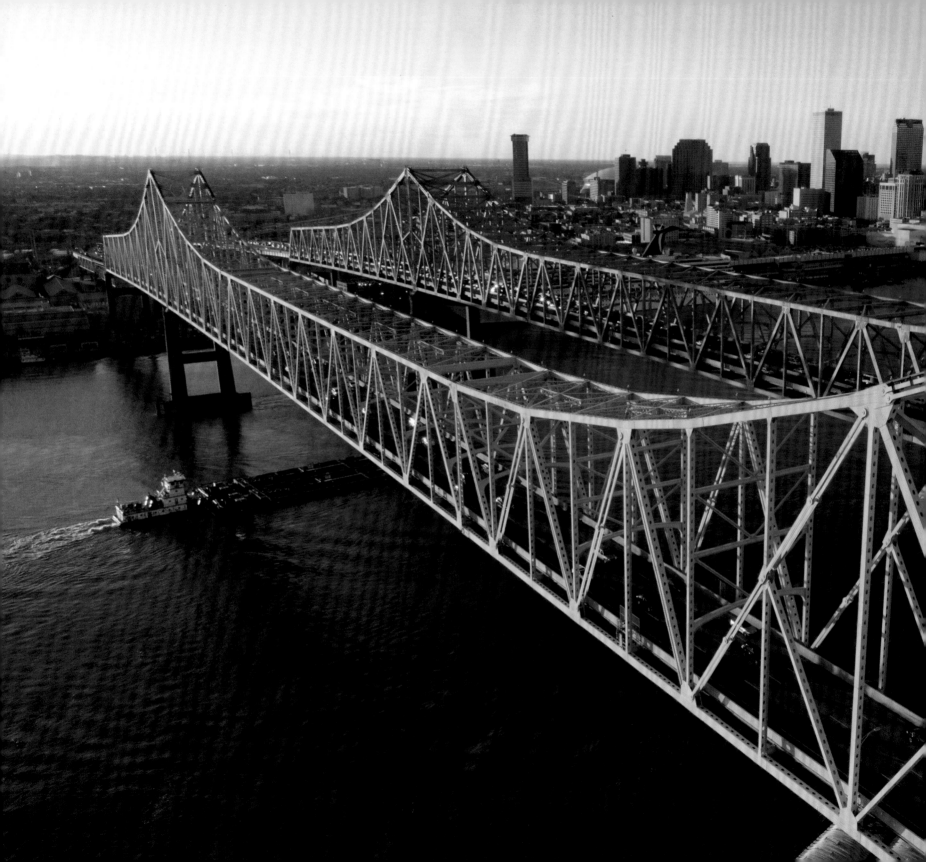

His firm, Modjeski & Masters, proposed a rail crossing that would meet the height requirement of 135 feet to accommodate freighters and passenger ships. The bridge design also specified a 1.25 percent grade for tracks, which would extend the approaches far beyond the riverbank. At the time, Modjeski's vision challenged the very limits of engineering capabilities and budgets.

Huey P. Long, who was elected governor of Louisiana in 1928, came to Modjeski's aid. The populist "Kingfish" had campaigned for expansion of the state's infrastructure, including the construction of new roads and bridges that would connect rural Louisianians to larger, more urban and populated areas. T. Harry Williams notes in his celebrated book *Huey Long*, "In the four years of his governorship the state had built 1,583 miles of concrete roads, 718 miles of asphalt roads, and 2,816 miles of gravel roads (just over 5,000 miles in total doubling the miles of roads in the state). It also constructed 111 bridges, many of them major structures spanning bigger streams" (546). Long's ambitious infrastructure initiatives, as well as his political muscle, propelled construction of Modjeski's New Orleans span.

According to the American Society of Civil Engineers (ASCE), "Many conditions, such as the 'gumbo soil' in and around the river, low land approaches, strong river currents, and the need for high navigation clearances required for ocean-going vessels, made the design and construction of this bridge difficult" (www.asce.org).

During opening-day celebrations on December 16, 1935, 1,200 people boarded a sixteen-car passenger train for the inaugural crossing. A procession of marching bands, bicyclists, and pedestrians accompanying the train also paraded across the bridge along its traffic lanes.

A special edition of the *New Orleans Times-Picayune* heralded the Huey P. Long Bridge as "the Mississippi's greatest feat of Engineering . . . gone are delays and inconvenience . . . traffic may now move unimpeded, toll-free for vehicles and pedestrians. The great structure, which generations of thoughtful men said could not be built . . . is characteristic of the

Afternoon sun illuminates the Crescent City Connection before rush-hour traffic fills the span.

indomitable spirit of the people of Louisiana and a symbol of their economic recovery" (Marking and Snape, 86–87). The Huey P. Long Bridge featured two rail lines at its center. With extended approaches on each side, the rail bridge measured 4.35 miles, the longest of its kind in the world at that time. It quickly became a vital connecting point for the nation's major southern rail lines. Since then, the Burlington-Northern-Santa-Fe, Union Pacific, CSX, Kansas City Southern, Canadian National, and Amtrak, all have crossed the Mississippi River on the Huey P.

At governor Long's insistence, builders added two traffic lanes on each side of the span. In later years, when automobiles and trucks increased in size and weight, the lanes became too narrow for safe driving. As the local joke went, on any given day people prayed more novenas crossing the Huey P. Long Bridge than in all New Orleans–area churches combined!

Tulane geographer Richard Campanella noted in the alternative weekly newspaper *Gambit:* "It is often said that the reason the Huey P. Long Bridge is located so far from downtown New Orleans was Long's disdain for the city in favor of rural Louisiana. While the outlying location of the bridge may well have pleased the governor, the real reason was the geography of railroads" (online edition, accessed Nov. 11, 2018). Building a four-mile-long rail bridge in Orleans Parish would have produced an unsightly scar on the cityscape. Also, it made more sense to construct the rail approaches away from downtown where there was ample space. Campanella continued, saying, "The 'Huey P' was indeed a boon to railroads and rural Jefferson Parish, but it sat too far from the urban core to affect the lives of most urban commuters. Thousands of New Orleanians continued to ferry across the river daily to shipbuilding jobs in Algiers or to industrial plants in Harvey and Westwego."

The Greater New Orleans Bridge ("GNO" in local parlance) was the first crossing in the city as well as the longest cantilever span in the world at the time it was built in 1958. Featuring four lanes, the GNO was routed away from downtown and across the Mississippi to Algiers on the west bank. As might be expected, the new bridge spurred population growth on the west bank so rapidly that the need for a second span quickly was apparent. In 1981, construction of a second bridge adjacent to the GNO commenced, finally opening to traffic in 1988.

Once the second bridge opened, Louisiana state senator Fritz Windhorst and the *Times-Picayune* organized a contest with students from area schools to name the two bridges. The twenty-five finalist names included Greater New Orleans Super Span, Creole Crossing, The Big Easy Twin Spans, and Mardi Gras Gateway. Jennifer Grodsky, a fourth grader at St. Clement of Rome School in Metairie, submitted the winning name—The Crescent City Connection (CCC). Judges thought that Jennifer's entry best articulated the nature and spirit of the city and its twin bridges. The Louisiana legislature officially adopted the new name for the two bridges not long after.

The CCC is a workhorse of a bridge in the Big Easy. In 2017, according to LDOT, 180,000 vehicles crossed it daily. Today the double span is an iconic element within the New Orleans cityscape, along with the downtown skyline, the French Quarter, and the Mississippi River itself. The city's horizon is defined by the CCC, which is visible from the tallest buildings.

New Orleans grew and more families left the city to settle in the suburbs, which further burdened the transportation network in and around the metropolitan area. In Jefferson Parish, traffic on the Huey P. Long Bridge increased beyond its intended capacity. The solution to this problem required two bridge projects. The first was the construction of the I-310 bypass, which crosses the Mississippi River just west of Kenner and connects to U.S. 90 traffic heading southwest. The new span, named the Hale Boggs Memorial Bridge, opened to traffic on October 6, 1983. It was the first major cable-stayed crossing built in the United States. Also known as the Luling Bridge, its two towers resemble massive A-frame structures looming over the horizon and are visible from I-10 several miles away.

The second project began in April 2006, with the widening of the Huey P. Long Bridge. Modjeski & Masters was the principal contractor for the conceptually ambitious undertaking. The plan involved widening the original cantilever structure to include new traffic lanes and wider shoulders. The refurbished Huey P. became a grander, more dramatic version of itself.

The completed renovation features larger encasements built around the five original piers. Massive W-shaped structures resting on the ex-

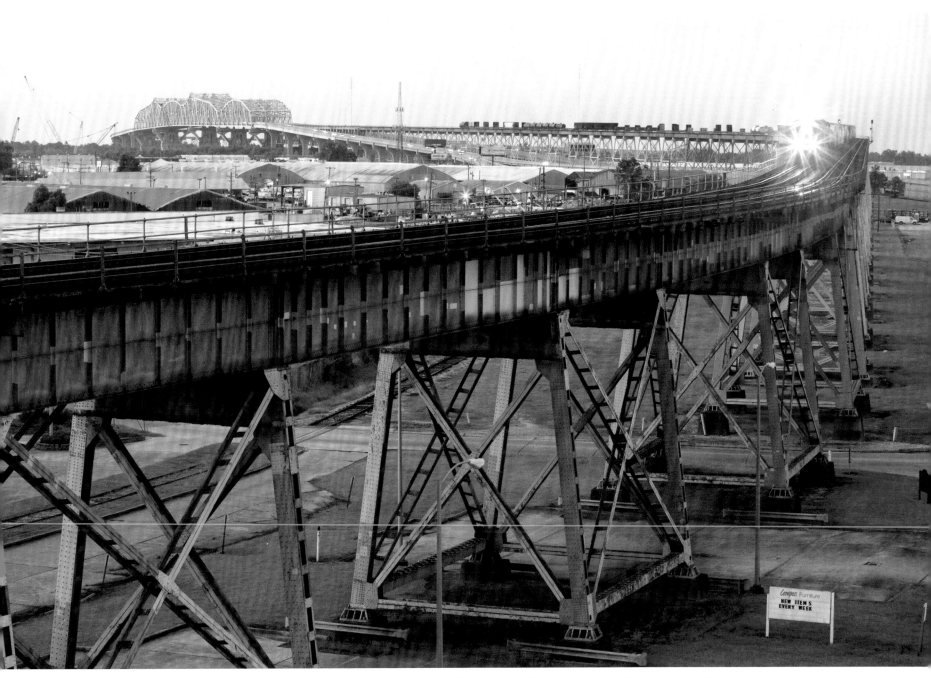

A freight train travels over the Huey P. Long Bridge. The rail portion of the bridge is more than four miles in length.

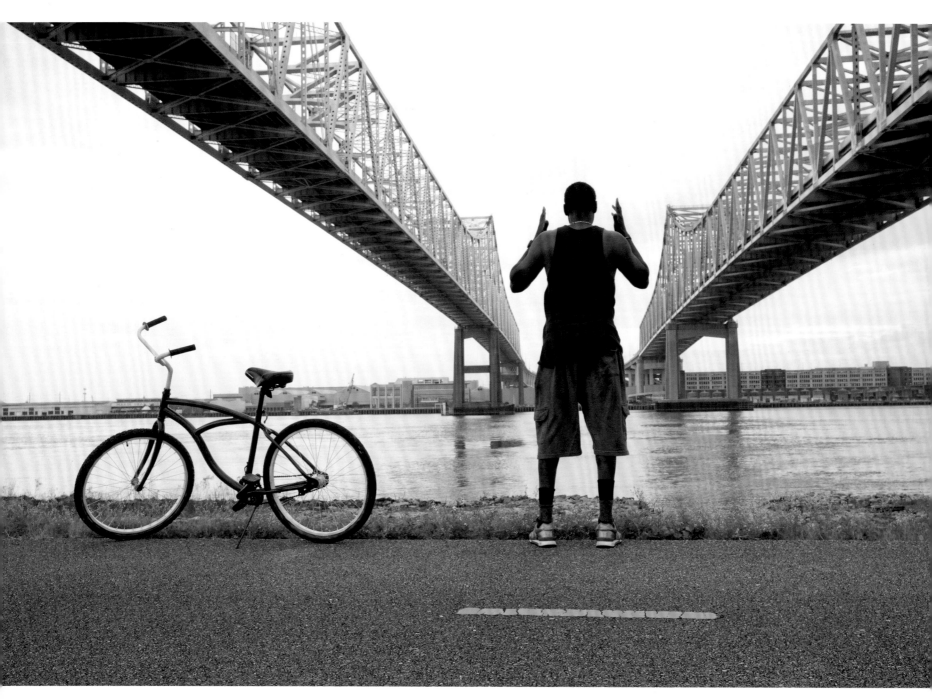

Raymond Manson prays under the Crescent City Connection. "Each morning I go to this spot and pray. By aligning myself in prayer with the bridges, I can align myself to God," he says.

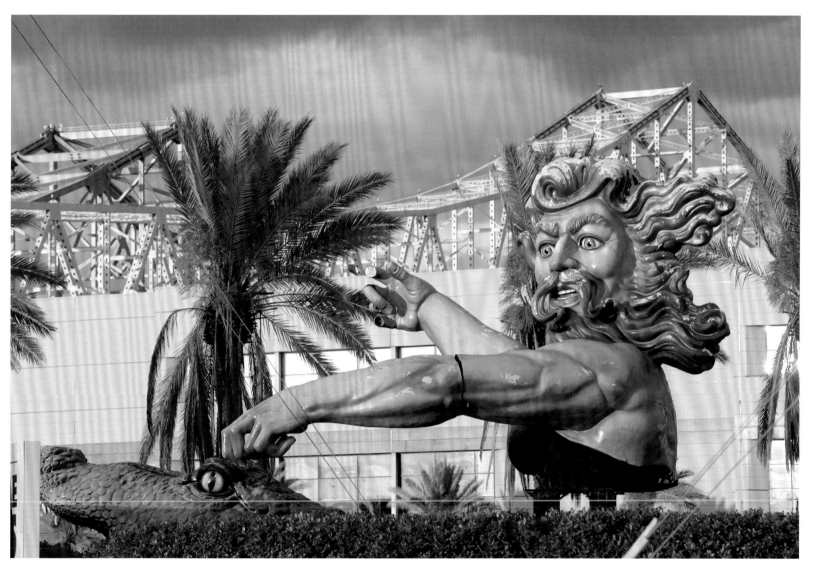

A statue of Neptune in front of Blaine Kern's Mardi Gras World with the Crescent City Connection in the background

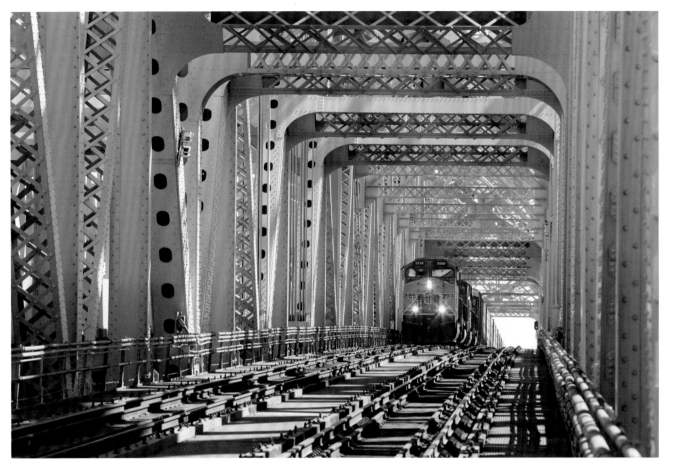

A freight train travels through the Huey P. Long Bridge's superstructure.

panded concrete piers support the heavier truss loads. Forty-foot concrete traffic lanes, an improvement over the originals, rest on the giant Ws. Framing these new additions is the span's superstructure, which is roughly four times wider than the original. The new, longer concrete approaches enable greater ease of traffic flow on and off the bridge.

Costing $1.2 billion to complete, the modernized bridge opened on June 16, 2013, to great fanfare. Today, the Huey P. Long Bridge carries, on average, 40,000 vehicles and eighteen class-one trains daily. The New Orleans Public Belt Railroad keeps a close eye on the eighty-five-year-old bridge. Towboats inspect the piers annually. Additionally, the Public

Belt maintains the bridge, periodically replacing the structure's rail ties as needed. Public Belt bridge supervisor Dean Giroir asserted, "The Huey P. Long is arguably the most maintained bridge in the U.S. It is here to stay" (interview, Nov. 15, 2018). This is great news for those brave souls who no longer need to pray their way across the Mississippi River.

In 2011, ASCE dedicated the original Huey P. Long Bridge as a National Historic Civil Engineering Landmark, an honor bestowed to fewer than three hundred structures worldwide. Other notable recipients of this honor include the Eiffel Tower, the Panama Canal, and the Stone Arch and Eads bridges across the Mississippi River.

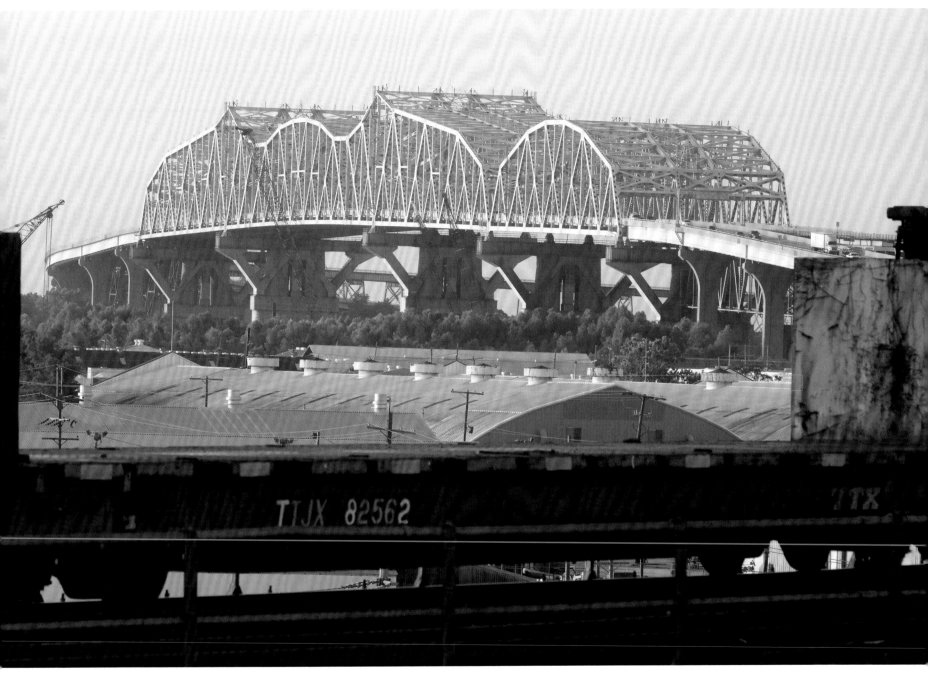

This view of the newly expanded Huey P. Long Bridge shows both the original substructure supports as well as the span's widened superstructure.

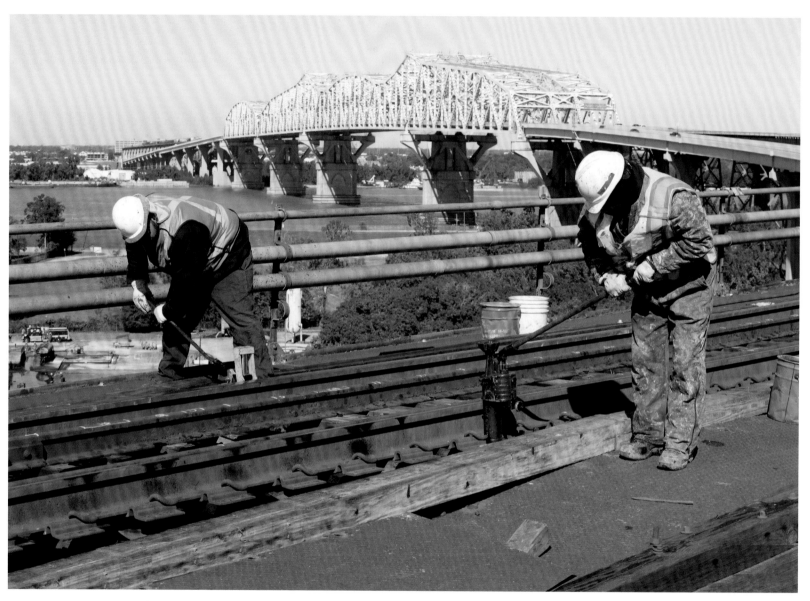

New Orleans Public Belt Railroad maintenance workers raise the rails on the Huey P. Long Bridge to make enough room for new rail ties to be inserted underneath.

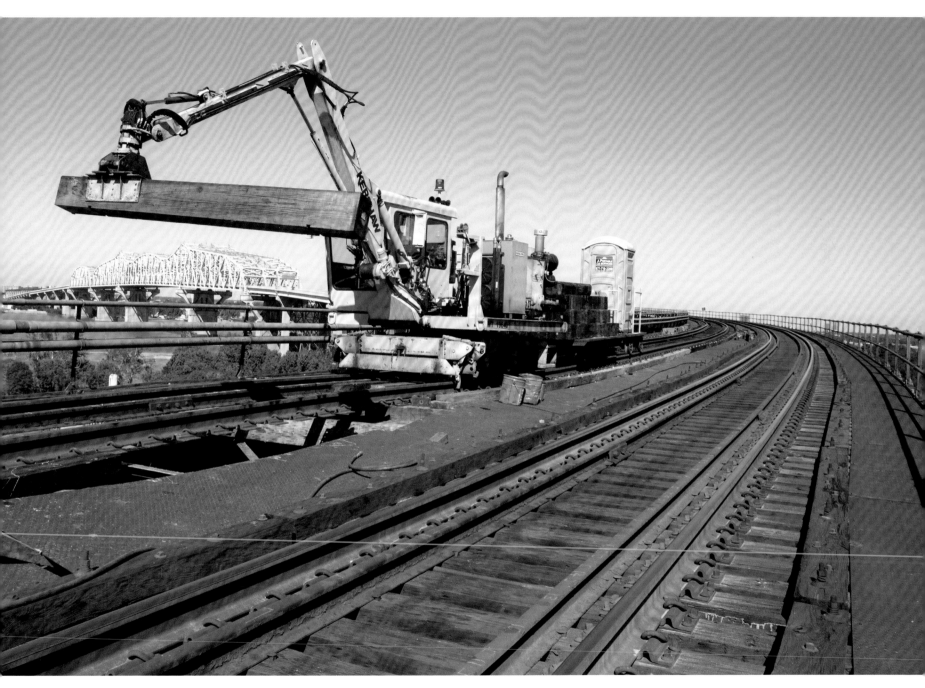

A small crane lifts a new rail tie into position under the tracks on the Huey P. Long Bridge. According to the New Orleans Public Belt Railroad, the span has 34,704 railroad ties from end to end.

Top, A cyclist passes under the Hale Boggs Memorial Bridge as he rides through a park along the river's levee. *Bottom,* An empty ocean-going freighter passes under the bridge located upstream from New Orleans.

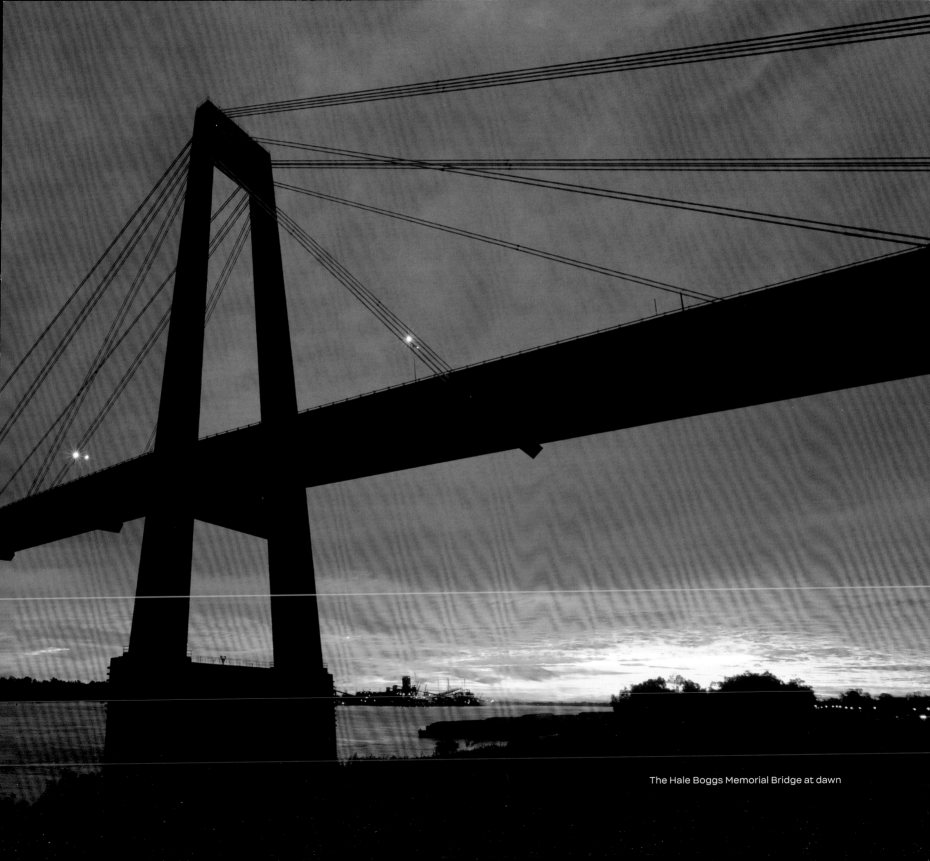

The Hale Boggs Memorial Bridge at dawn

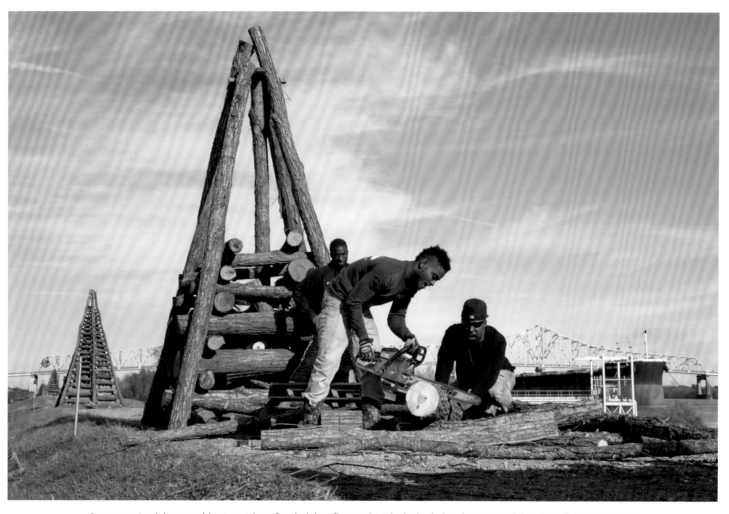

Gramercy, Louisiana, residents cut logs for their bonfire on the Mississippi River levee. In celebration of the Christmas season, hundreds are set ablaze on the levees each Christmas Eve along the Mississippi River between New Orleans and Baton Rouge. The Veterans Memorial Bridge is in the distance.

The Woodville Cemetery near Wallace, Louisiana, in front of the Veterans Memorial Bridge in Gramercy, Louisiana

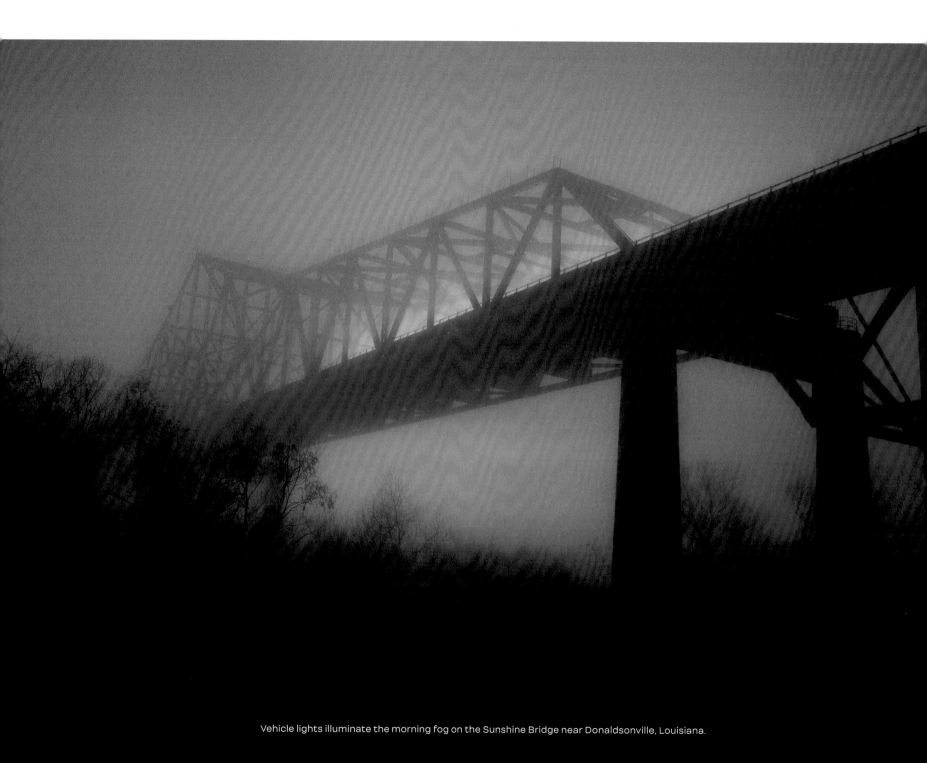

Vehicle lights illuminate the morning fog on the Sunshine Bridge near Donaldsonville, Louisiana.

Donaldsonville, Louisiana

Building a Span to Nowhere

To appreciate the Sunshine Bridge today, imagine south Louisiana along the Mississippi River during the late 1950s without it. Antebellum mansions, many in disrepair, and other simple vernacular-style structures stood juxtaposed with old country stores and the occasional gas station. Only a few chemical plants had sprung up along the river roads adjacent to the protective levees along the Mississippi River. Every twenty or thirty miles, ferries provided a way across the river. Economically underdeveloped, this area of Louisiana was primarily rural.

Louisiana governor Jimmie Davis was aware of the need for economic growth along the Mississippi. In his gubernatorial campaigns, he advocated for the rural poor, determining that a new bridge in this impoverished area would help to create a more prosperous Louisiana. The governor's enthusiasm for new bridge construction near the sleepy farm-

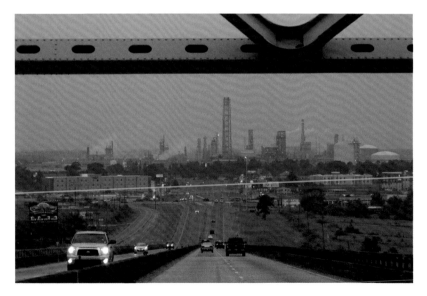

The Sunshine Bridge deck provides a view of the CF Industries plant on the west bank near Donaldsonville, Louisiana. It is one of numerous industrial facilities built in the area since the bridge was opened in 1964.

ing community of Donaldsonville, population 6,500 in the early 1960s, received support from most of Louisiana's business-community leaders. However, skeptics decried the governor's plan as "fantasy," a potential "financial boondoggle," and a "bridge to nowhere." Undaunted by public skepticism, Davis and the Louisiana legislature approved the new bridge proposal in 1960. The 8,236-foot cantilever crossing was completed on September 30, 1964.

So, what to name this splendid new span? The governor's supporters were united in their desire that it bear his name. Unfortunately for them, Louisiana law prohibited the naming of buildings and bridges for living persons. Davis, a popular singer and songwriter in his own right, suggested a clever compromise—the Sunshine Bridge—thus ensuring the legacy of his hit song, "You Are My Sunshine."

A widely held belief among older locals was that Davis rode

his horse across the Sunshine Bridge before it opened to the public. In reality, the governor, with similar fanfare, once rode his horse Sunshine into Louisiana's capitol rotunda but never over the new bridge. It turns out, however, that it was Mr. C. F. Chauvin, sitting astride his Tennessee Walker, Blaise, who crossed the unopened Sunshine Bridge. Throughout the construction process, Chauvin, proprietor of a local mercantile establishment, rode Blaise to the site regularly to observe the progress. Befriending the construction crew over time, Chauvin managed to secure permission to cross the bridge on horseback before vehicles were allowed. He and the crew kept their secret until a Baton Rouge newspaper broke the story on October 1, 1964.

Ten days later, on the eve of the official ribbon-cutting ceremony, a special Sunday edition of the *Baton Rouge Advocate/State Times* proclaimed, "In one swift leap across the Mississippi River, the shining new Sunshine Bridge . . . will now open the way to an even greater future for South Louisiana." The industry trade journal *Chemical Week* echoed the newspaper's prediction declaring in an article published on March 28, 1964, "A petrochemical spaghetti bowl is developing near the town of Geismar on the east bank of the Mississippi. And when the new $30 million bridge linking this area with the west bank opens this year, it may well spawn 'a new Ruhr Valley,'" a reference to the massive and lucrative industrial region in Germany.

The economic field of dreams promised by Governor Davis was realized once the Sunshine Bridge opened. Industrial plants sprang up on both sides of the Mississippi River, creating thousands of jobs and spawning a network of roads and interstate highways, which predictably contributed to a dramatic rise in local traffic. The first year the bridge was in operation, 2,130 vehicles crossed it daily. By 2017, that number had increased to 17,300.

In spite of its positive economic impact in South Louisiana, the Sunshine Bridge today appears tired and outdated, and it poses serious challenges for drivers. The narrow bridge is without shoulders, allowing for no margin of error. First-timers crossing the bridge are in for an adventure at the very least. While their passengers enjoy the pleasant view of the Mississippi River below, drivers have little choice but to clutch their steering wheels and stare straight ahead in an effort to maintain control of their vehicles as bigger trucks roar past. By contrast, for those viewing the Sunshine Bridge from a distance, it appears as a beautiful arc above the horizon.

Pedestrians standing below the bridge near the river's edge hear only the faint *thumpa thumpa* sound of traffic overhead. Here, a visitor might experience a moment of meditative calm as the Mississippi flows past. Occasionally interrupting this scene is a tugboat pushing its barge group or an ocean-going freighter heading up- or downriver.

Philip Gould: A Personal Reflection

On a recent walk along the riverbank just beneath the Sunshine Bridge, I gained a new appreciation for what I already understood was a special view. On that day, the Mississippi River appeared still, like a pond, its glasslike surface reflecting the clouds overhead. The calm of the moment was suddenly broken when an old, worn-out pickup drove right up to the bank near where I stood. Two grizzled, middle-age men wearing old jeans and t-shirts exited the truck carrying fishing poles and other mysterious objects. Introducing themselves as Larry Breaux and Terrence "Rosebud" Rose, they began pounding plastic tubes into the sand at the river's edge, explaining that these objects would hold their fishing poles in place. We continued our casual conversation, with Larry and Rosebud saying that since retirement they often spent afternoons fishing along the river. Occasionally punctuating their narratives with references to Jesus and God, they continued their preparations.

Moments later, one of the rods began jerking to and fro. Larry grabbed the pole and skillfully reeled in the catch. Ready to assist, Rosebud waded into the shallows, reaching down with his bare hands and grabbing the sizeable catfish by its mouth. On a nearby tree branch, the friends hung their catch, slowly skinning and gutting it. "That felt like a thirty pounder," remarked Rosebud, as he casually tossed the dressed fish into an ice chest. "It's okay, but I like bringing in the fifty pounders. That's when the fight gets fun!"

The Sunshine Bridge reveals the graceful ark of its bridge bed as seen from a nearby sugarcane field at dusk.

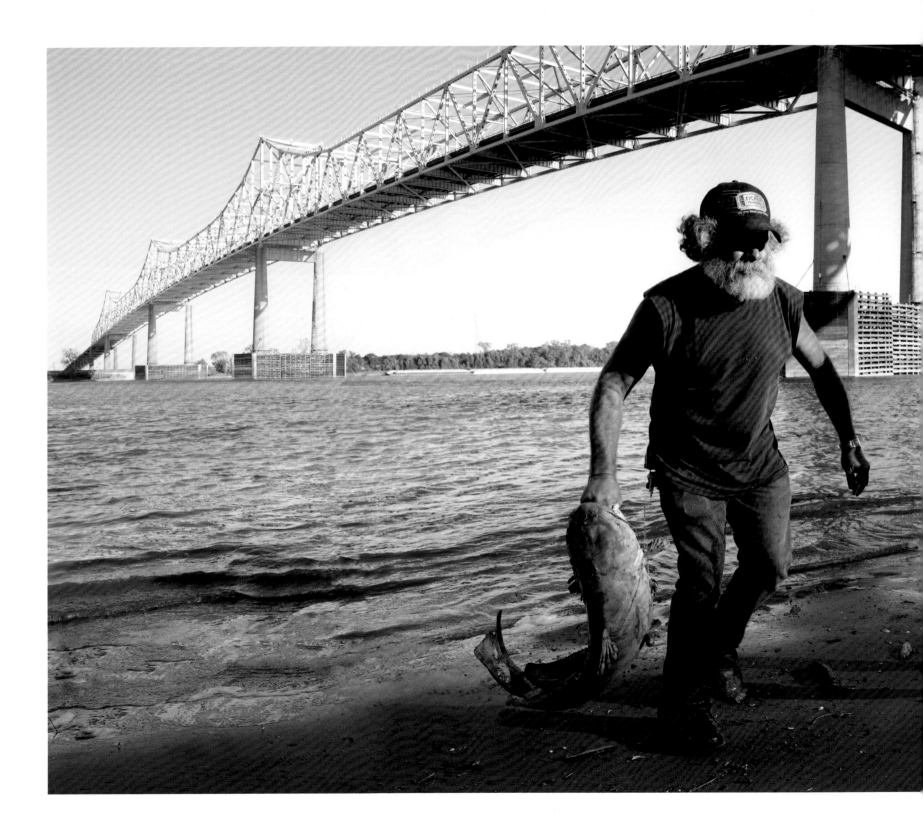

Under the Sunshine Bridge, Terrence "Rosebud" Rose carries a large catfish out of the Mississippi River that his friend Larry Breaux has just caught.

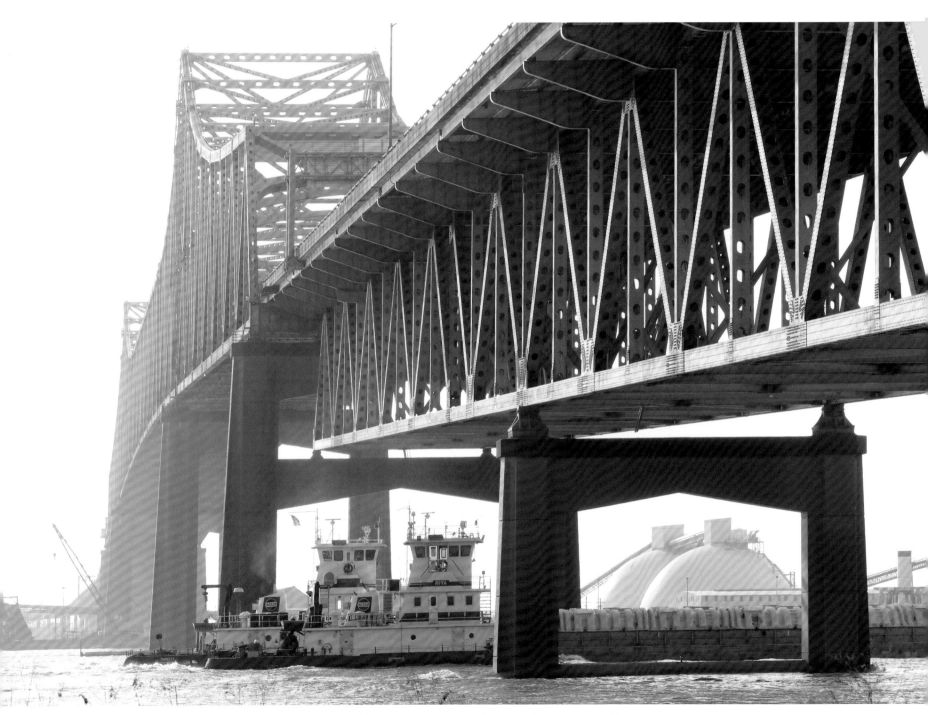

Parallel towboats push barges upstream under the Horace Wilkinson I-10 Bridge in Baton Rouge.

Baton Rouge, Louisiana

Traffic Jams and the Riverwalk

wo bridges cross the Mississippi River in Baton Rouge, Louisiana—the Huey P. Long, a smaller version of the New Orleans span bearing the same name, and downriver, the cantilever-style Horace Wilkinson I-10 crossing, known to locals as the "New Bridge." Designed by the engineering firm Modjeski & Masters and built at a cost of $46 million, the Horace Wilkinson Bridge opened to traffic on April 10, 1968. Named in honor of three generations of the Wilkinson family who served in the Louisiana legislature for a total of more than five decades, the span is the tallest on the Mississippi with a clearance of 175 feet. Over 100,000 vehicles cross the bridge daily from Port Allen on the west side of the Mississippi into Baton Rouge. South Louisiana residents are familiar with frequent traffic back-ups on the bridge and plan their travel accordingly. Traffic congestion on the Wilkinson Bridge occurs at the I-10/I-110 junction, at the base of the span on the east side of the Mississippi. Here,

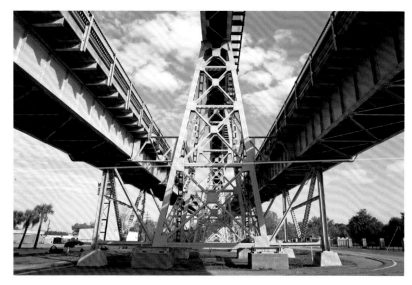

A cross-section trestle of the Huey P. Long–O. K. Allen Bridge in Baton Rouge after its renovation

two of the three eastbound lanes veer south toward New Orleans. The far right lane immediately exits at Washington Street, causing a choke point that slows and often halts traffic, compelling back-ups over the bridge for miles to the west. LDOT is addressing the problem, and plans are underway to relocate the current Washington Street exit and extend both I-10 lanes.

Along the east bank, residents and tourists enjoy downtown Baton Rouge's proximity to the Mississippi River. Located along the 4.31-mile-long levee path, or Riverwalk, are bike and river trails, museums, parks and green spaces, the North Boulevard Town Square, and the Belle of Baton Rouge Casino. At the Baton Rouge City Dock, thousands of tourists arrive annually on grand riverboats. Moored nearby is the *USS Kidd,* a World War II destroyer that now serves as a memorial to Louisiana veterans.

Just upriver from the Wilkinson span is the Huey P. Long–O. K. Allen Bridge, known to locals as

Tyquencia Azard poses along Baton Rouge's Mississippi Riverwalk before heading to her high school prom at Scotlandville Magnet High School.

the "Old Bridge," built in 1940 at a cost of $8.4 million. The Old Bridge is a cantilever-style span carrying U.S. 190 and one rail line, the Kansas City Southern, between East Baton Rouge Parish and West Baton Rouge Parish. The view from this bridge includes much of industrial Baton Rouge as well as marshland along the river. A major rehabilitation project in 1986 included widening the lanes from 19' 9" to 24' and replacing damaged trusses and piers. In 2013, proposals were submitted by several engineering firms to clean, paint, and repair the bridge once again. The project was completed in 2017. Traffic on the Old Bridge is fairly light, with approximately 18,000 vehicles crossing daily. In spite of its narrow lanes that sometimes ice over in cold winter weather, the vintage bridge is not nearly as much as a navigational nightmare as its old New Orleans cousin.

The Huey P. Long-O. K. Allen Bridge marks the endpoint of ocean-going navigation on the Mississippi River. The Army Corps of Engineers keeps the river dredged to forty feet here to accommodate freighters. Upriver from the bridge, the Corps maintains a twelve-foot-deep channel sufficient for the navigation of towboats, barges, and tourist riverboats.

A couple miles to the north, students, residents, and visitors can enjoy a stunning view of the Mississippi River and both Baton Rouge bridges from Scott's Bluff, located on the Southern University campus. Here, the scenery is rural, the breezes tranquil, and the sunsets among the most beautiful in Louisiana. For hundreds of miles north from this point, the landscape surrounding the Mississippi River is mostly rugged and undeveloped.

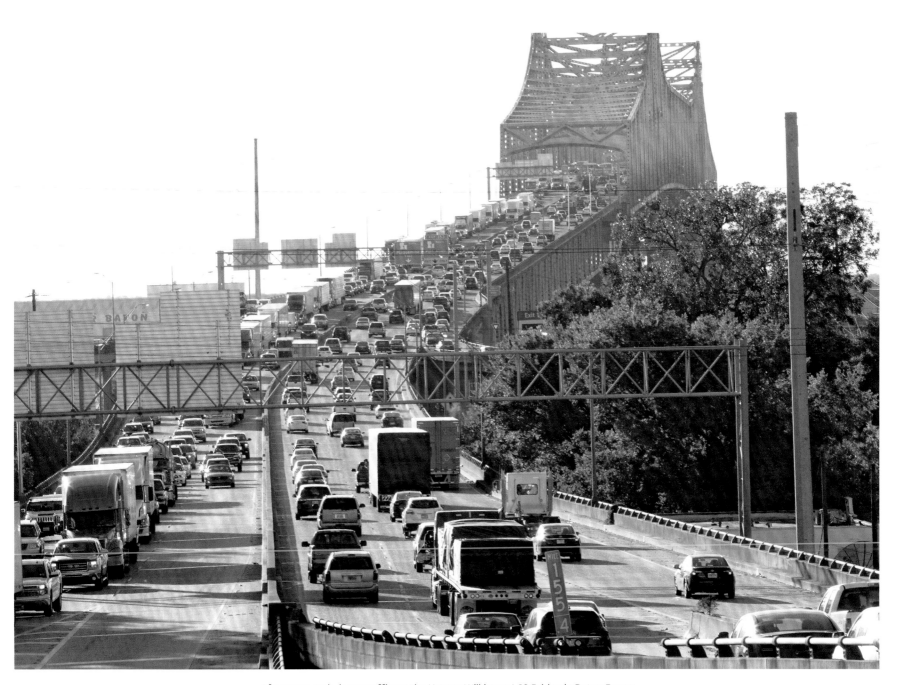

Afternoon rush-hour traffic on the Horace Wilkinson I-10 Bridge in Baton Rouge

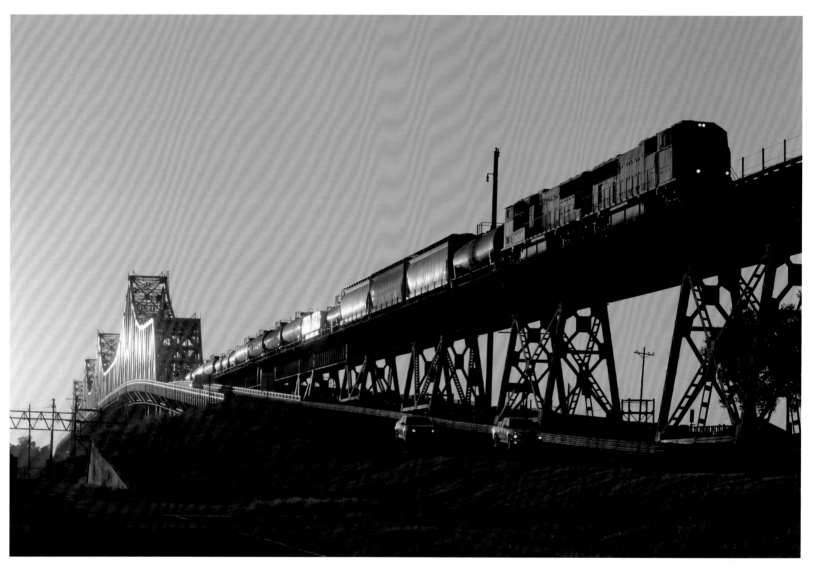

A freight train crosses the Huey P. Long-O. K. Allen Bridge in Baton Rouge. The span, built in 1940, features a single rail track and four lanes of bridge decks for vehicle traffic. The crossing also marks the northern-most point on the river that is dredged deep enough for ocean-going freighters. Only riverboats, towboats, and barges can travel upstream beyond this point.

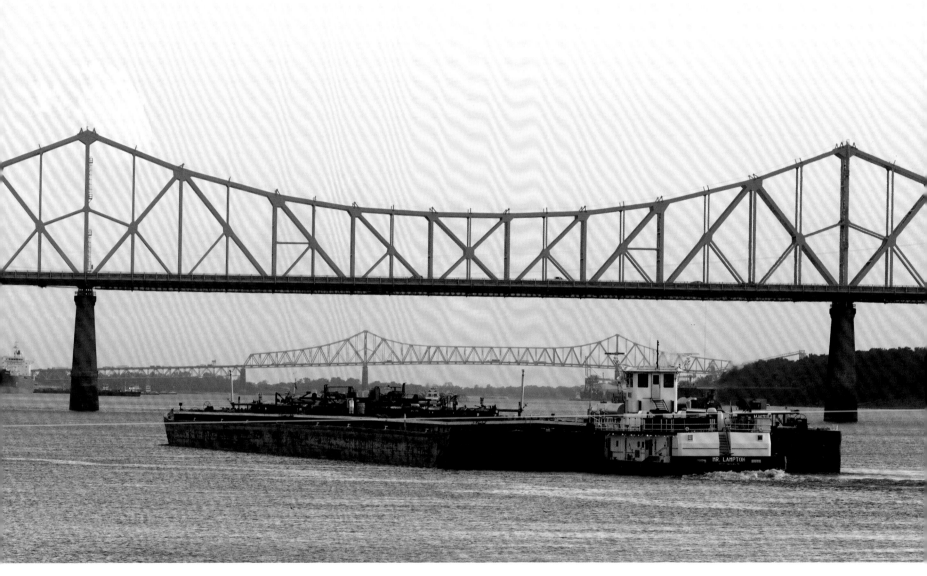

A towboat and barge configuration makes its way downstream under the Huey P. Long Bridge. The Horace Wilkinson I-10 Bridge is in the distance.

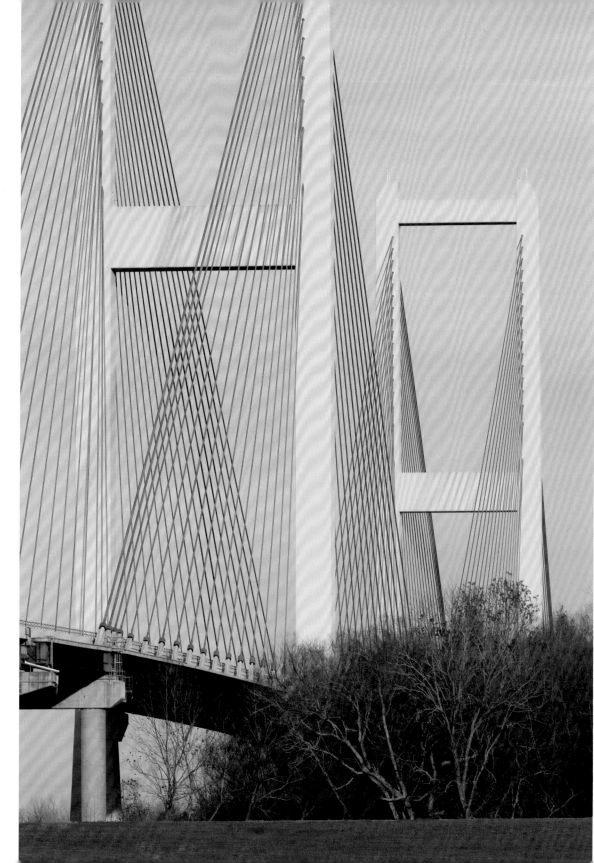

The John James Audubon Bridge
near St. Francisville, Louisiana

Jason El Koubi and Blake David kayak along the Mississippi River bank near the Audubon Bridge. Over the years, El Koubi has kayaked much of the lower Mississippi, ventures he enjoys immensely.

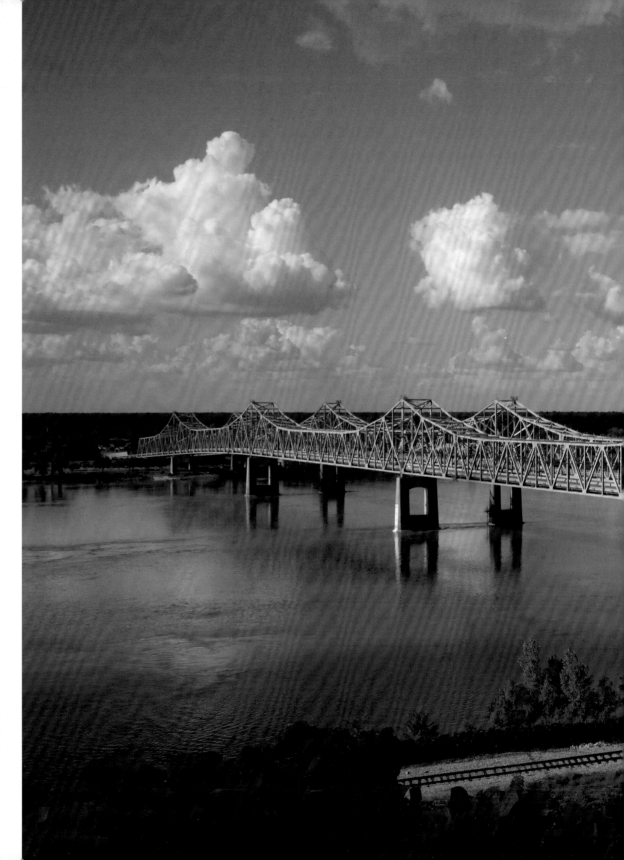

The Mississippi River Bridges seen from the bluffs in Natchez, Mississippi, crossing the river into Vidalia, Louisiana.

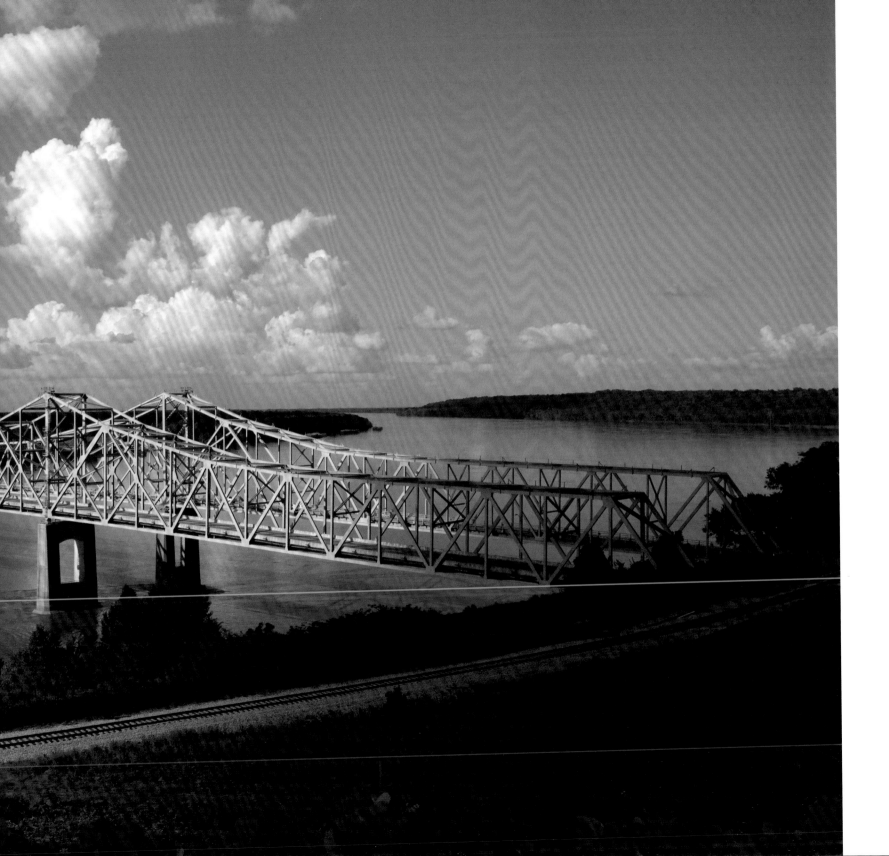

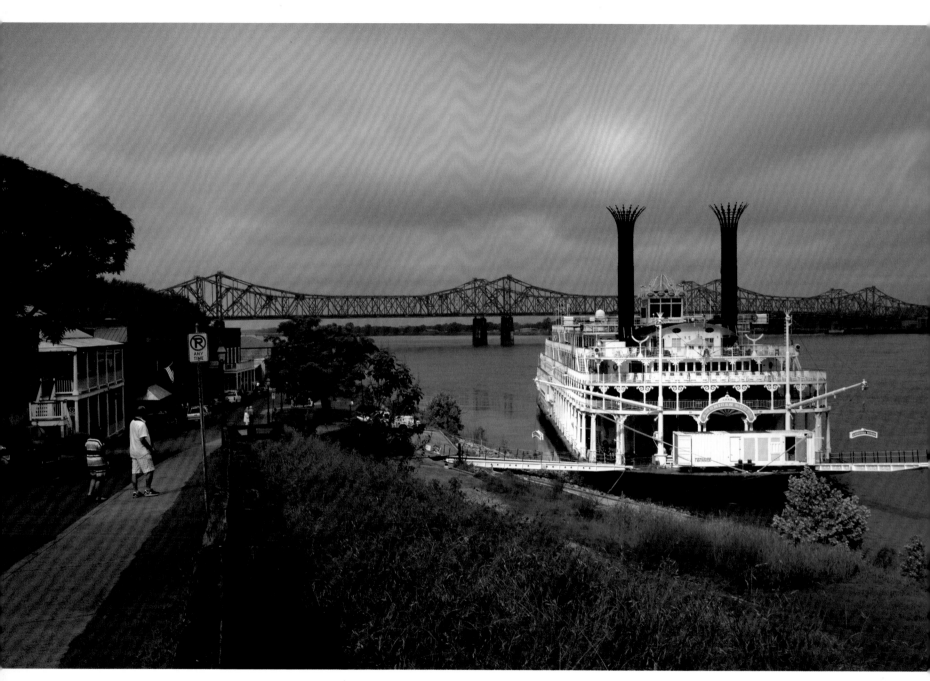

The *American Queen* docks along the riverside at the Under the Hill district in Natchez, Mississippi.

Riverboat tourists shop on the riverbank along the Under the Hill district in Natchez, Mississippi.

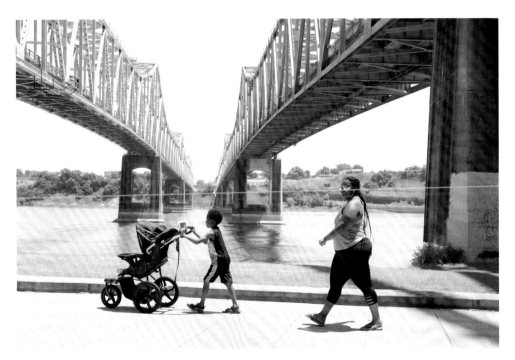

A young lady and her children walk along the riverfront in Vidalia, Louisiana.

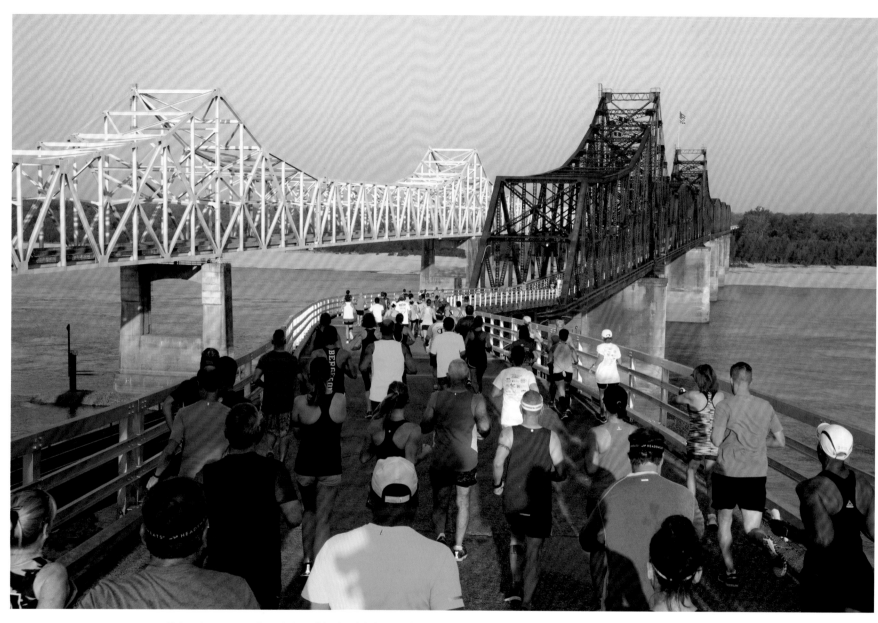

Entrants run onto the U.S. 80 Bridge in Vicksburg, Mississippi, during the city's annual Over the River Run. The charity event raises funds for the Southern Cultural Heritage Foundation. The vintage bridge is closed year-round and opens only for the event. The I-20 Bridge is to the left.

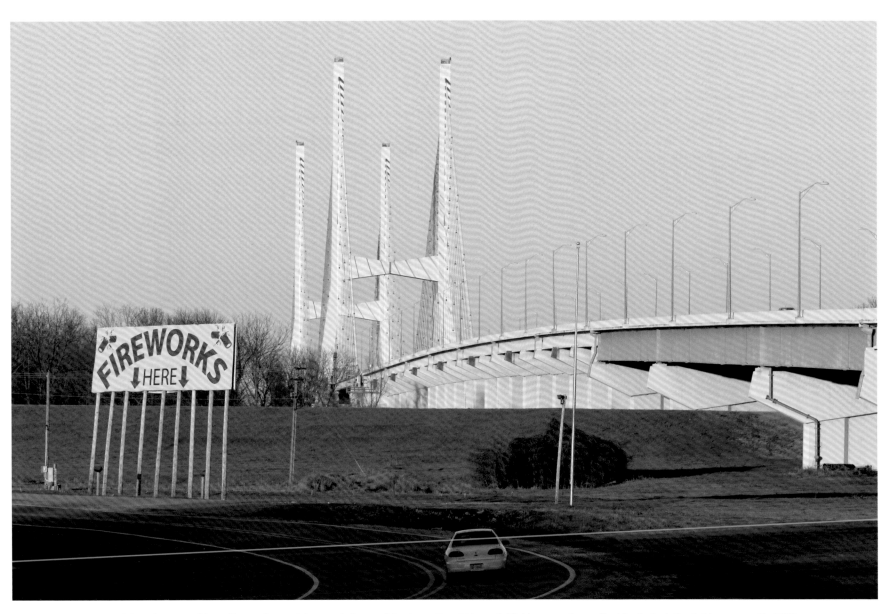

A car drives down an old road in northeast Arkansas in front of the Jesse Brent Memorial Bridge near Greenville, Mississippi. The bridge opened in 2010 and replaced an obsolete span that was poorly located with regard to river traffic. It was the most struck bridge on the river primarily due to its close proximity to a sharp bend upstream. Jesse Brent was a towboat operator and pioneer in Greenville. Starting his modest operation in 1941, he helped to make Greenville the "towboatingest" town on the Mississippi.

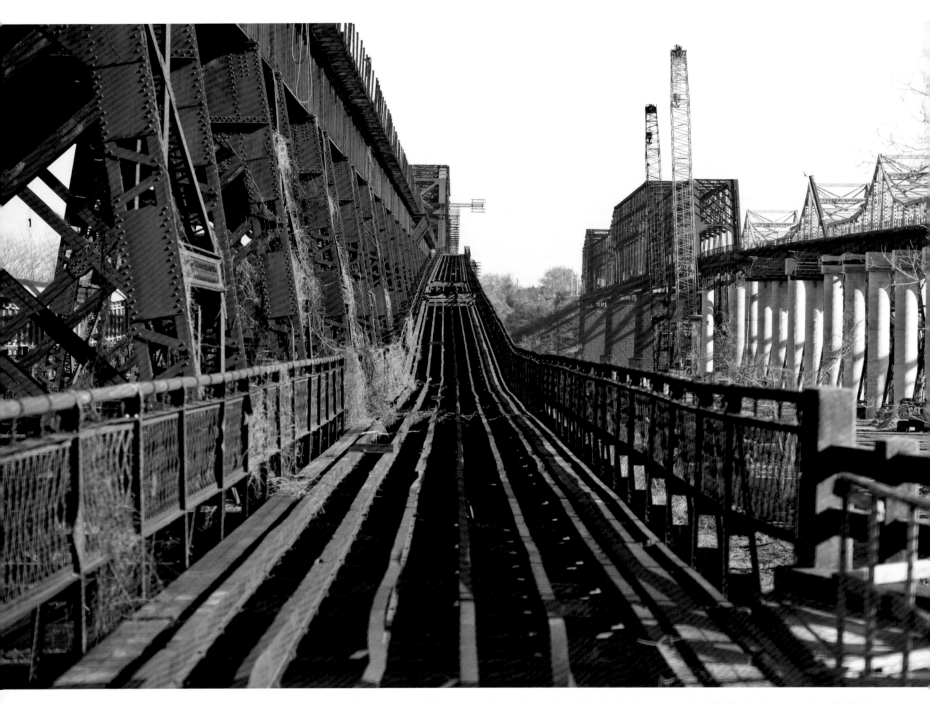

Supportive metal beams are all that remains of the traffic lanes straddling the Harahan Bridge in Memphis. The bridge opened in 1917. The timber road closed in 1948 when the Memphis–Arkansas Bridge *(far right)* was built. In the distance to the right, the Frisco Bridge is refitted with new supportive concrete posts and beams.

Memphis, Tennessee

A New Day for the Queen City

On May 12, 1892, fifty thousand excited citizens gathered along the banks of the Mississippi River to celebrate the opening of the Memphis Bridge. Also known as the "Iron Bridge," and later the "Frisco Bridge," it was the city's first rail span and the only one south of St. Louis, Missouri. With construction completed after just three and half years, proud Memphians came together to admire their new bridge linking Tennessee and Arkansas.

Kansas City and Memphis Railroad owners made the first ceremonial crossing that day, along with a line of eighteen locomotives linked together and festooned with banners and flowers. At the sound of a cannon blast, the 1,500-ton assemblage slowly rolled across the new rail span from Tennessee toward the Arkansas lowlands across the river, stopping where the span touched ground.

After a second blast, the lo-

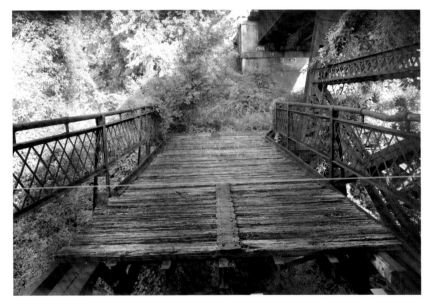

Creosote timbers are still attached to an abandoned portion of the old vehicle entryway to the Harahan Bridge in East Memphis.

comotives started back across the Mississippi toward the Tennessee bank. According to Paul Coppock of the *Memphis Commercial Appeal,* they were "roaring as fast as they could run, with every whistle at full voice and each bell ringing. Boats along the river responded to the noise with their own whistles. As the engines rolled off the bridge, thousands of voices along the banks responded with a chorus of cheers. It was more a release of tension than a tribute to bridge-building skill. It was that yell of the crowd that made the deepest impression on boys who as old men told of their experiences that day" (*Memphis Commercial Appeal,* May 13, 1892).

Far less dramatic but consistent with local political protocol, the next event included a retinue of governors and other dignitaries from both states, all dressed in silk hats and frocked coats. They boarded flat cars that were rolled out to the center of the bridge. From their platform,

each man touted the importance of the new rail bridge for securing a bright future for the Queen City of the Mississippi River Valley.

The day's celebration symbolized decades of effort by Memphis community officials to expand the city's economic viability. After the Civil war, Memphis residents faced important choices about their future. Would they remain a river port fueled by the antebellum agrarian economy of the past? Or would they find a way to successfully move forward with an industrialized economy linked to the North? Most Memphians were eager to turn a new page and participate in the nation's healing. They envisioned their future directly tied to their location on the Mississippi River and imagined Memphis as a river and rail hub. The opening of the Memphis Bridge in 1892 was a significant step in that direction.

In 1903, the Memphis Bridge was sold to the St. Louis and San Francisco Railway. By 1916, its name changed to the Frisco Bridge following the opening of the adjacent Harahan Bridge. The name stuck, even after the Burlington Northern Railroad purchased the span in the 1980s.

By the early twentieth century, rail traffic in Memphis had increased so significantly that an additional double-track railroad bridge was needed. Rock Island Railroad officials commissioned prominent bridge builder Ralph Modjeski to design the span. He selected a continuous steel-truss style for the 2,549-foot structure, which initially was named the Rock Island Bridge. Modjeski's original plan included a double-rail crossing only. However, freshman United States congressman Kenneth McKellar of Memphis threatened to block building permits unless vehicle roadbeds were included. After much squabbling, the railroad agreed to build "wagon ways" suspended on each side of the bridge, and Modjeski's new plan incorporated fourteen-foot-wide roadways as a result. Before the span was completed, Rock Island Railroad president J. T. Harahan was tragically (and ironically) killed in an automobile-train collision. In his honor, the new span was renamed the Harahan Bridge and opened on July 16, 1916. A plaque honoring McKellar and others was installed on the roadbed's side railing.

The narrow roadways, constructed of wooden planks over a steel bed, were inadequate for handling vehicular traffic, as long lines of slow-moving cars stressed the road. In September 1928, both eastbound and westbound highway lanes caught fire near the Memphis side, forcing officials to close the bridge for months. Ferries handled vehicle traffic while workers repaired and made improvements to the bridge. More than 950 tons of new structural steel were added, along with fire-resistant roadways. By 1941, 12,000 cars and trucks crossed the Harahan Bridge daily, and new discussions about construction of a separate vehicle-only span gained traction.

In the spring of 1939, the *Commercial Appeal* featured an article titled "Needed a New Bridge: Security of Trade and Life Itself Depends upon Uninterrupted Passage Over the Mississippi River Whenever Emergencies Exists or Catastrophe Threatens," reflecting the city's desire for a span that would exclusively carry cars and trucks. This new Memphis–Arkansas Bridge, a cantilevered-through truss span, was completed ten years later in December 1949. Referred to now as the "Old Bridge" to distinguishing it from the newer Hernando de Soto span upriver, it opened well before the new interstate highway system was built and lacked the standardized concrete dividers separating opposing lanes of traffic. These safety features were added later, along with walkways along the outside of the bridge. In 2001, the span was listed in the National Register of Historic Places.

Soon, Memphis required a second vehicle bridge. But before it could be built, a navigational problem on the Mississippi had to be addressed. Just north of the city, the Mississippi flowed east, then sharply turned right to flow south. A bridge constructed near this turn would pose a danger to riverboats. To solve this problem, in 1956 the Army Corps of Engineers embarked upon a multiyear dredging project to straighten the river and provide a direct route south past Memphis. Bridge construction commenced in 1967, and the Hernando de Soto Bridge opened six years later.

The idea for the de Soto Bridge's distinctive M-shaped design originated with Jerry O'Roark, assistant vice president for Holiday Inn. He introduced his idea in a letter to the editor of the *Commercial Appeal* dated May 2, 1967. In a drawing included with the letter, O'Roark depicted a large letter *M* attached to the span, on the scale of the St. Louis Arch. O'Roark's homage to the city gained the backing of Mayor Wyeth Chandler, and the concept was adopted and incorporated into the Hernando

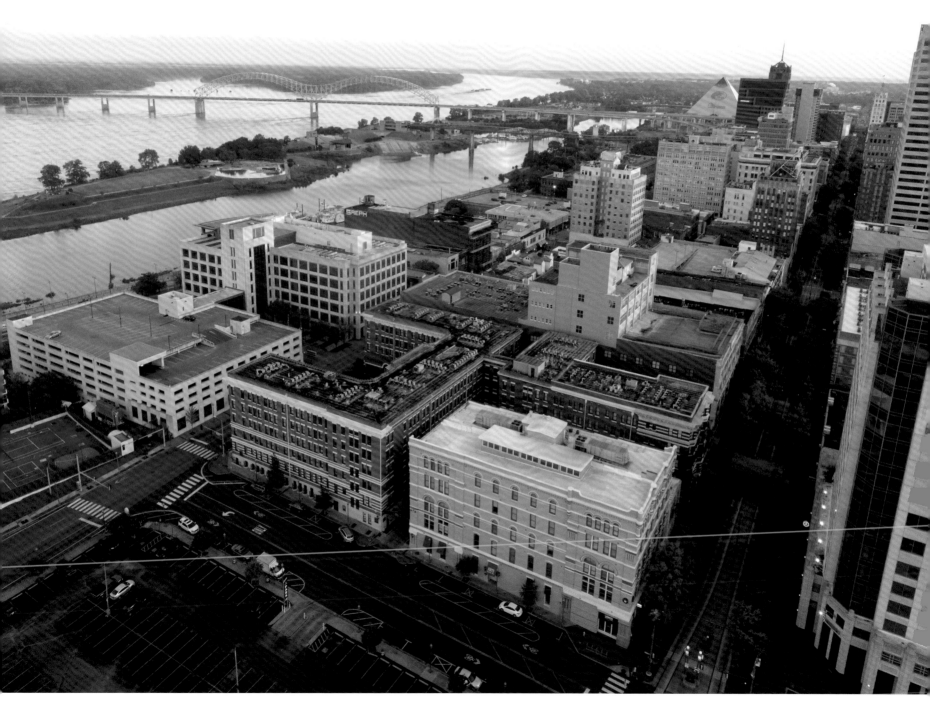

Memphis's downtown historic district with the Hernando de Soto Bridge in the distance

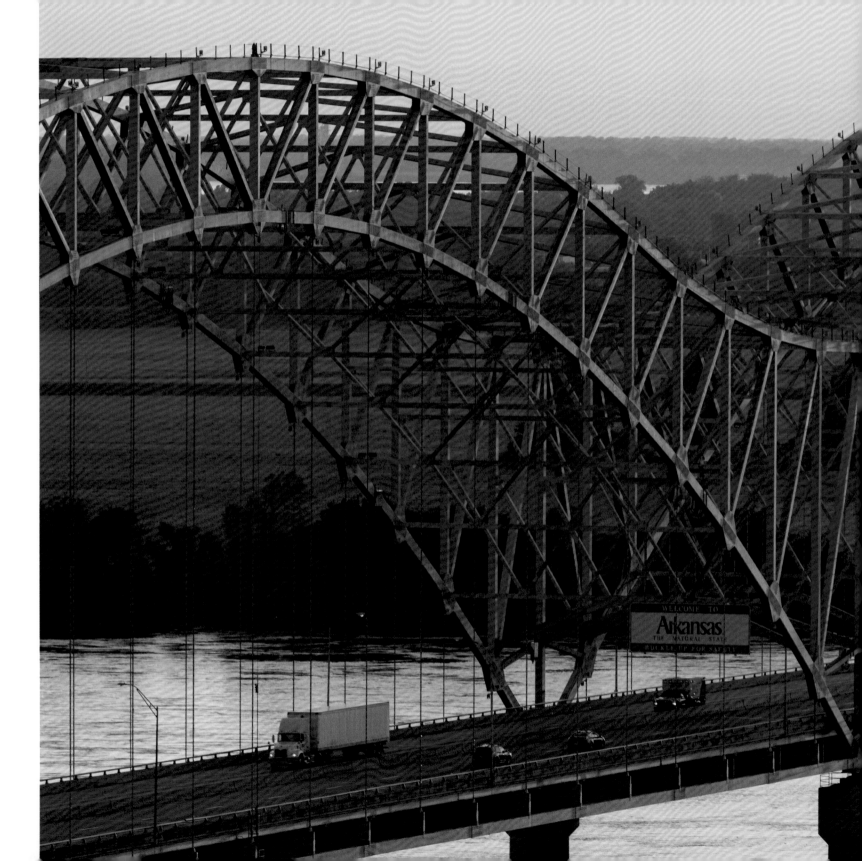

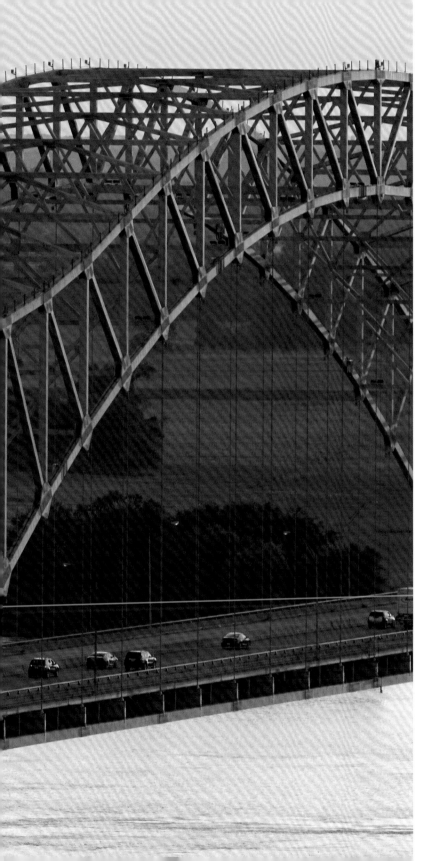

de Soto's design. In 1986, after sodium-vapor lights were installed on the span, the Memphis Symphony played for its nighttime unveiling, and the crowd gasped when the lights were turned on. The next day, an article in the *Commercial Appeal* gushed, "It was like New Year's Eve and the Fourth of July rolled into one."

The next phase of bridge development and construction in the city began in 2016 with the Harahan Bridge Centennial. The two-mile pedestrian walkway, the Big River Crossing, was installed on the steel girders that once supported the original wooden vehicle crossing. Engineers also mounted an LED computer-controlled lighting system on the bridge. The Big River Crossing is part of a larger pedestrian trail known as the Main Street to Main Street Multi-Modal Project. During its first year, 250,000 folks walked, ran, or bicycled across the new walkway.

The nineteenth-century rail bridges in Memphis contributed to the city's metamorphosis from an antebellum river port to a transcontinental crossroads for commerce and travel. This shift might never have occurred were it not for a few influential citizens who understood the significance of post–Civil War opportunities for economic change and growth.

Today, that same public spirit and visionary thinking have transformed Memphis's riverfront into a contemporary urban-residential area and thriving tourist center. The Great River Walkway, along with the Tom Lee and Mud Island parks, entice folks to the Mississippi River. The dramatic lighting on the Harahan and de Soto bridges frames the stunning visual sweep of the new riverfront. Ongoing development in Memphis illustrates the importance of bridges, riverfront parks, green spaces, and historic preservation to the quality of life of its residents. Accordingly, the city serves as an example of what residents of riverfront communities along the Mississippi appreciate about restoration and development as invaluable economic and civic assets.

The Hernando de Soto Bridge in Memphis

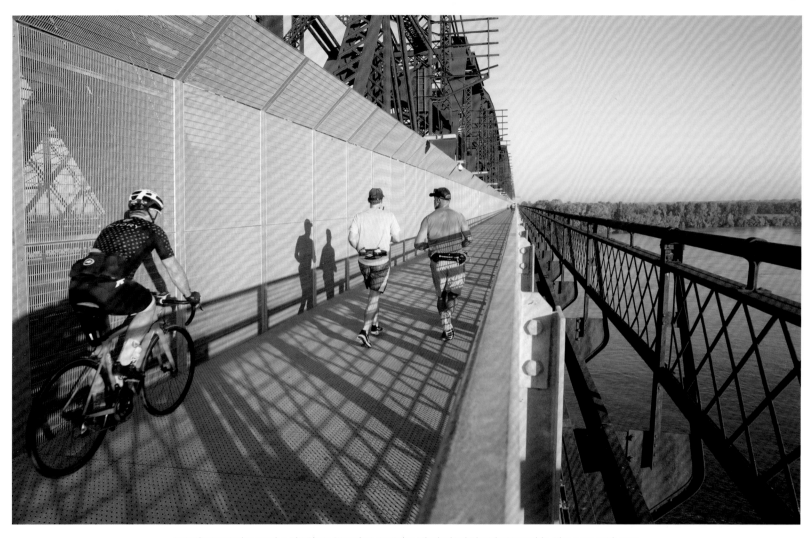

Morning exercise on the Big River Crossing over the Mississippi River in Memphis. The new path was built on the original Harahan Bridge vehicle-lane, supportive grid.

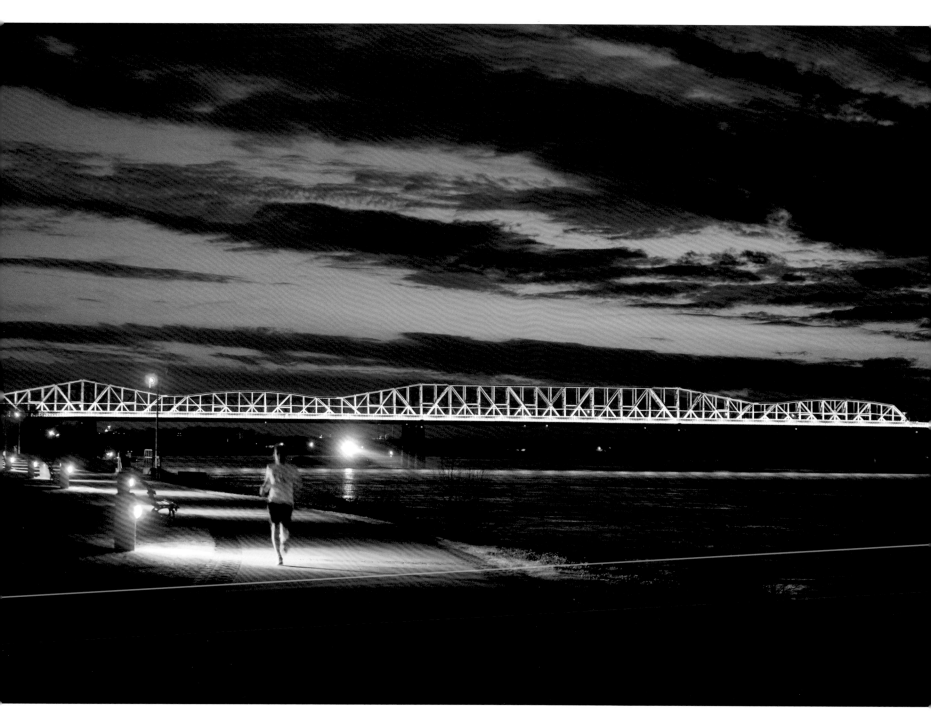

The vintage Harahan Bridge in Memphis is illuminated by new LED lights as a jogger runs along the Great River Walkway near downtown.

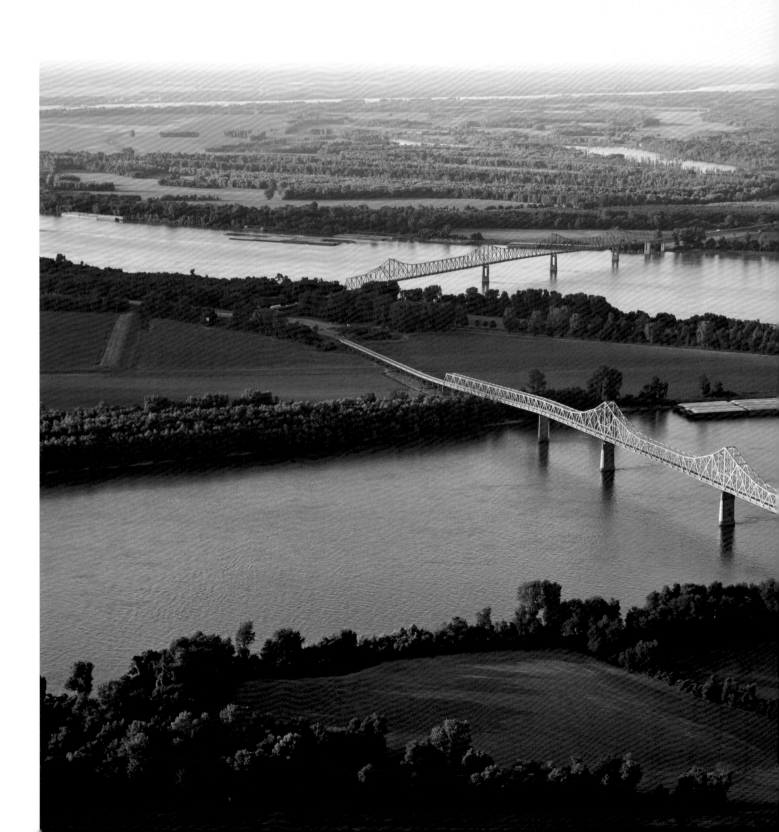

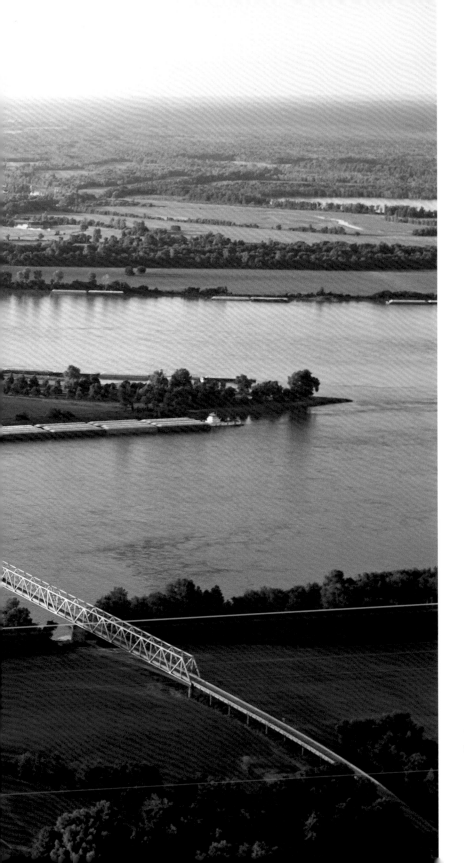

The Cairo Mississippi River Bridge crosses at the southern tip of Illinois, where the Ohio and Mississippi rivers meet.

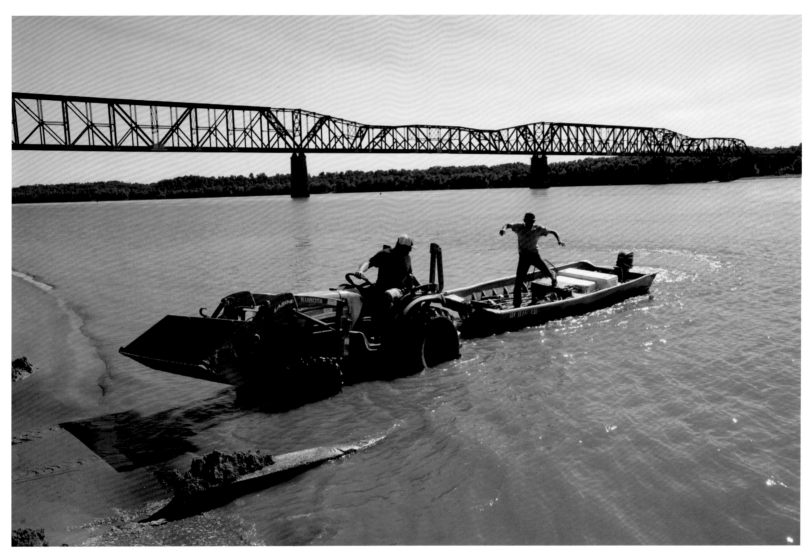

Two men use a tractor to launch a boat onto the Mississippi River adjacent to the Thebes Railroad Bridge. The bridge, built in 1905 and designed by Ralph Modjeski, is one of few double-track spans to cross the river.

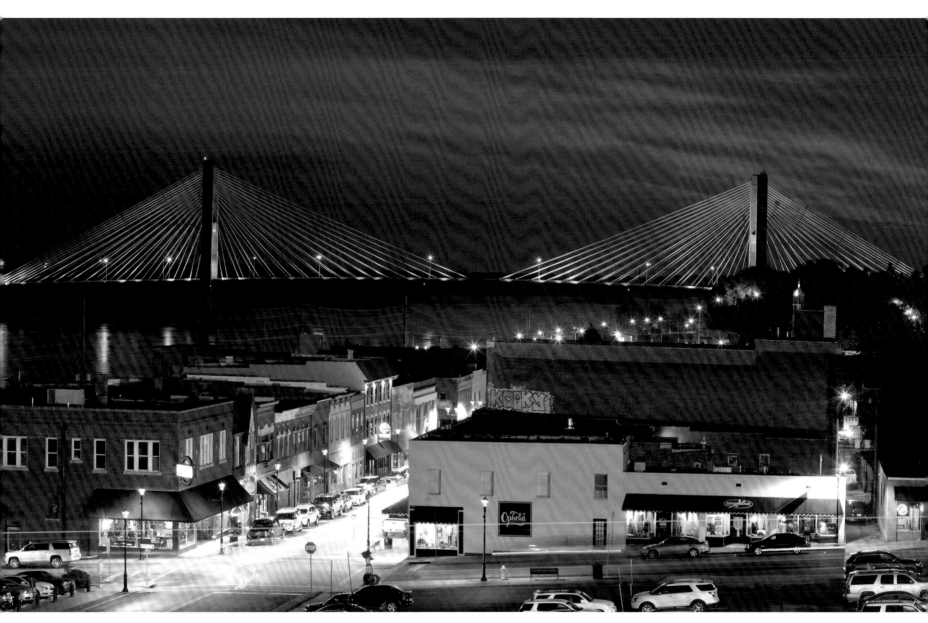

The Bill Emerson Memorial Bridge, built in 2003, rises above downtown Cape Girardeau, Missouri.

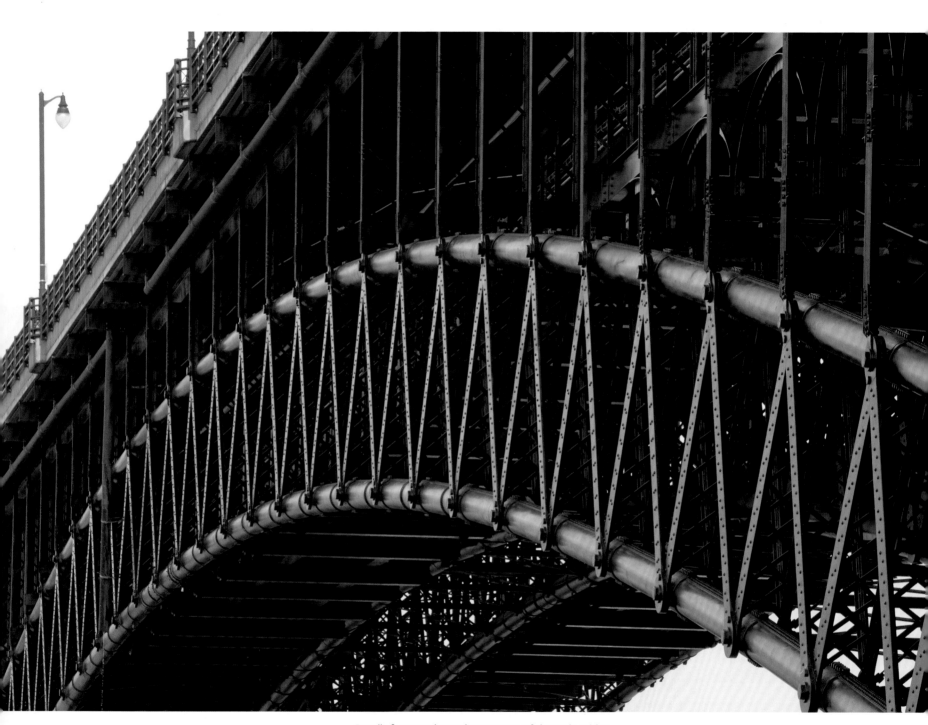

Detail of supportive understructure of the Eads Bridge

St. Louis, Missouri

Faith in Eads and Steel

St. Louis began as a trading post for fur trappers along the Missouri and Mississippi rivers. Founded on February 15, 1764, the outpost soon developed into a vital river port. Much of St. Louis's history is inextricably tied to the nation's own story. For example, the city served as the departure point in 1804 for Meriwether Lewis and William Clark, who set off to explore the westernmost regions acquired by the United States in the Louisiana Purchase. Two years later, the two men returned to St. Louis and reveled in a heroes' welcome.

During the early years of the nineteenth century, St. Louis grew as an important center for both river commerce and westward expansion. In 1817, the *Zebulon M. Pike,* a stern-wheel paddleboat designed exclusively for passenger travel, was the first self-powered vessel to arrive in St. Louis. Riverboat activity increased so dramatically that, by

Western abutment of the Eads Bridge in St. Louis

1860, an average of 100 steamers a day, carrying over one million passengers each year, lined the city's six miles of riverfront.

Simultaneously, the proliferation of railroad networks created increased competition for these slower river vessels for freight and passenger traffic. It was not long before St. Louis's dominant river-port status was losing ground to Chicago, the midwestern rail hub. Lacking a rail connection across the Mississippi River to the east, St. Louis was "stranded by the very river that had put it on the map" (Dupre 55). Building a bridge across the Mississippi proved the only reasonable solution to the city's economic problem.

St. Louis city fathers turned to James Eads, the one man they trusted above all others to successfully complete the task. Eads had no formal engineering education, but he was a builder at heart. He had firsthand knowledge of the Mississippi River,

having walked much of the river bottom in his diving bell searching for sunken vessels to salvage. Eads's credentials also included building ironclads, steam-propelled war vessels used by the Union during the Civil War.

Eads knew that building a bridge over the river in St. Louis would be challenging since the waterway was wider here than at points north. Arches necessarily had to be longer and taller than any built previously. Up to this point, iron was the primary material used in bridge construction. However, Eads considered the metal too soft for the proposed span. His solution was steel, an alloy he encountered when constructing ironclads for the Union. Steel technology had improved in the years since, but metallurgy on the scale required for his project was untested. Yet Eads wagered that what he needed could be manufactured in a factory setting, and he set off to design arches using two levels of tubular steel ribs to support the three spans, the largest of which would stretch 530 feet. As John Barry notes in *Rising Tide,* "At the time [Eads] made this recommendation, not a single steel bridge existed anywhere in the world; in addition, the proposed arches would be the longest in the world. But on April 8, 1866, his

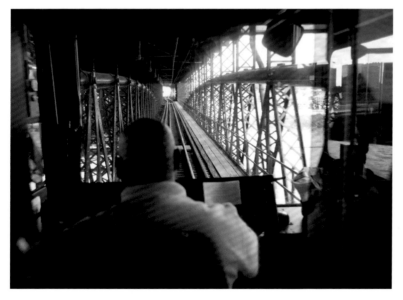

A MetroLink commuter train travels over the Eads Bridge in St. Louis.

subcommittee adopted his proposal unanimously. Such was the faith St. Louis businessmen had in Eads" (57).

Eads had observed bridge construction in Europe, becoming intrigued by a new triple-arch span in Koblenz, Germany. The cutting-edge design appealed to him, as did cultural considerations. "Given the heavily Germanic composition of his engineering staff and the dominance of German culture (population 40,000) in St. Louis," Howard Miller notes, "it was only appropriate that Eads was drawn to the Prussian bridge" (83–84). The foundations for the new bridge extended more than 100 feet into bedrock and were installed using pneumatic caissons for drilling. All load-carrying components were constructed of steel. Sadly, during the project, many workers suffered the ill effects of rapid decompression, or the bends, and died. They were some of the first people to understand the danger of the bends.

General Tecumseh Sherman drove the ceremonial spike for the Eads Bridge's opening on July 4, 1874, officially connecting the city to eastern rail networks. However, locals were skeptical about the span's safety, so Eads conducted two demonstrations to ease their fears. First, he marched an elephant across the bridge. The beast crossed without incident. Then Eads ran fourteen locomotives across the bridge, again with no problem. Public fears were calmed.

Unfortunately, the innovative Eads Bridge proved to be a financial disaster. A year after opening, the bridge went into bankruptcy due to overcapitalization and underuse. The Terminal Railroad Association (TRRA), a consortium of fourteen railroads operated by tycoon Jay Gould, then assumed control of the span. It charged exorbitant tolls, forcing heavy industry to locate on the river's eastern shore. In 1890, the Merchants Bridge opened downriver in an effort to break the TRRA monopoly. However, three years later, it too fell under TRRA control.

Relief for the beleaguered bridges seemed to arrive in 1909, when construction began on a toll-free span, the St. Louis Bridge. The city-owned bridge was designed with an upper deck for vehicles and lower deck for rail traffic. But money for the approaches ran out, and the vehicle bridge deck did not open until 1917. The railroad deck was not completed until 1928. In 1942, the span was renamed for military hero Douglas MacArthur.

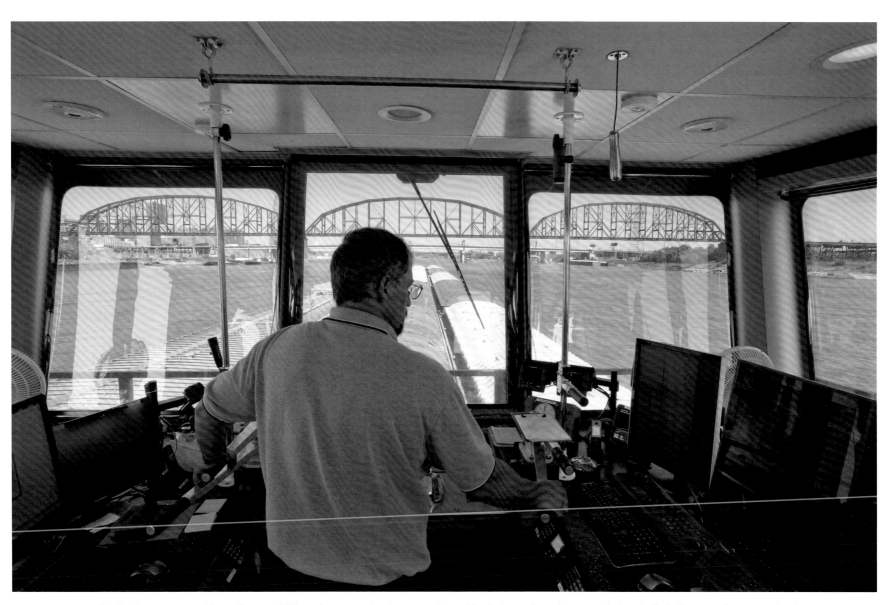

Claude Clemons steers his towboat and fifteen barges under the MacArthur Bridge in St. Louis. He is surrounded at the helm by several computerized navigational devices that, along with his years of experience, help him navigate safely on the river. "Any river pilot who says that they haven't had a close call with a bridge is lying to you," he notes. "It just happens."

Urban interstate traffic travels through St. Louis in front of the MacArthur Bridge.

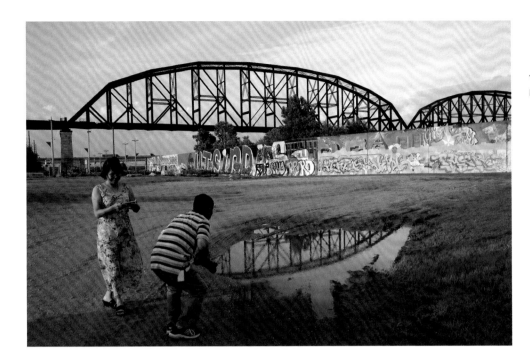

Visitors to St. Louis photograph the MacArthur Bridge behind graffiti-covered riverfront floodwalls.

The bridge deck, with its sharp turns, proved too dangerous for large automobiles and trucks, prompting officials to close the vehicle portion of the span in 1981, though rail lines remained operational.

In 1989, the city of St. Louis acquired the Eads Bridge by exchanging its MacArthur Bridge for the TRRA-owned Eads. The city renovated and reinforced the historic span. Four years later, the city began rerouting MetroLink commuter trains over the Eads Bridge into East St. Louis. In 2003, engineers installed a new highway deck, with additional renovations occurring three years later.

Located just north of the Eads Bridge, the Stan Musial Veterans Memorial Bridge opened in St. Louis in 2014. The cable-stayed span features diamond-shaped support piers at each end. The 2,803-foot bridge, along with the I-64 Bridge just south of downtown, carry the city's cross-river interstate traffic.

St. Louis has retained much of its historic grit and personality. Refurbished warehouses line the riverbanks, and towboats operate from floating piers near the intricate web of rail lines running along the riverbank.

In some places, graffitied floodwalls separate the industrial area along the river from St. Louis's historic neighborhoods.

This industrial stretch is interrupted by the ninety-one-acre Gateway Arch National Park, formerly the Jefferson National Expedition Memorial. Designed by Finnish American architect Eero Saarinen and engineer Hannskarl Bandel, the arch, known as the Gateway to the West, opened in 1965. Built near the starting point of Lewis and Clark's expedition, the arch symbolizes the city's role in westward expansion. The memorial honors Thomas Jefferson and the pioneers who realized his vision of opening the West, as well as former slave Dred Scott, who sued for his freedom in the nearby Old Courthouse. The park's boundaries are marked by the Eads Bridge to the north and Busch Stadium, which is nestled just south of the central business district.

Philip Gould: A Personal Reflection

To fully appreciate this remarkable city built adjacent to the Mississippi River, I wanted to experience it from the perspective of the river itself. On

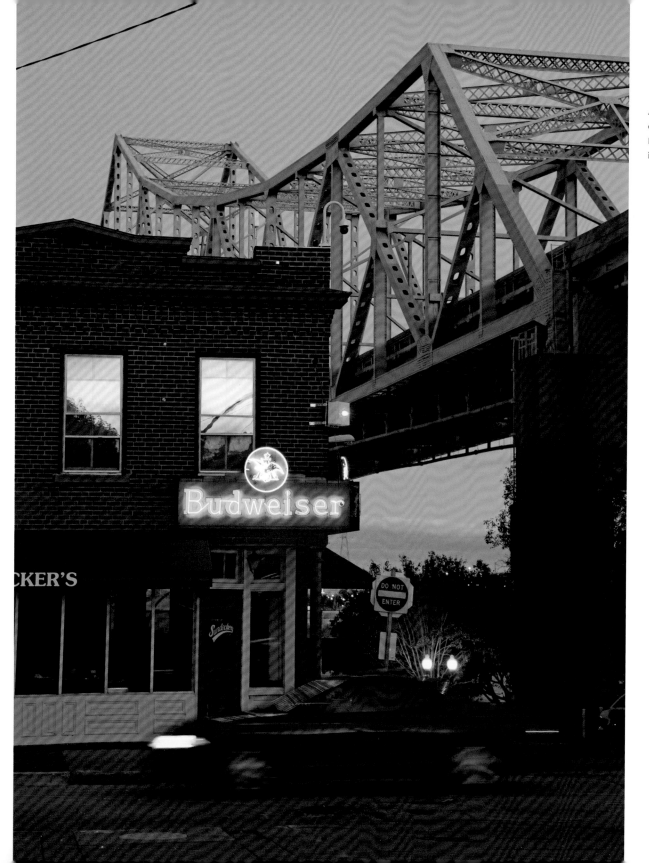

A car passes a riverfront bar in downtown St. Louis. The Martin Luther King Bridge, built in 1951, is in the background.

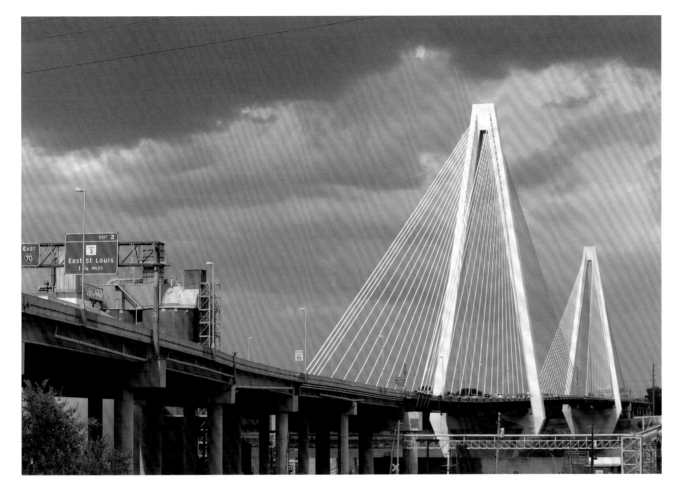

Stan Musial Veterans Memorial Bridge, also known as the "Stan Span," crosses the Mississippi just north of downtown St. Louis. Musial, one of the greatest hitters in Major League Baseball history, played for the St. Louis Cardinals from 1946 to 1963. The bridge opened in 2014 and was named in Musial's honor after he passed away the previous year.

an autumn day, I boarded the *L. J. Sullivan,* a quadruple-decker towboat operated by American Commercial Barge Lines. The vessel was docked at the Old Sage Facility in south St. Louis at the end of a long, narrow street that ran through an old blue-collar neighborhood. The no-frills facility consisted of an assortment of portable buildings, floating docks for towboats, and gravel parking lots.

The *L. J. Sullivan* usually runs barges up and down the Mississippi and Ohio rivers. On this particular day it was headed upstream, pushing fifteen barges containing iron ore and diammonium phosphate, a widely used fertilizer. After a safety briefing, I boarded the vessel and walked

along the narrow perimeter to a sealed doorway. From there, I climbed four levels of stairs to the bridge. There, I met Claude Clemons, chief pilot.

Clemons had an easygoing manner as he navigated the vessel while keeping a clear vision ahead and scanning the computer screens that showed obstacles in the river. By his standards, it was a typical day at the helm. As we passed beneath each bridge, he talked about his job. "Any river pilot who says they haven't had a close call with a bridge is lying to you. It just happens. If a barge hits a bridge pier and does damage, the pilot must notify Coast Guard and inform them 'we have landed'" (interview, Oct. 16, 2017).

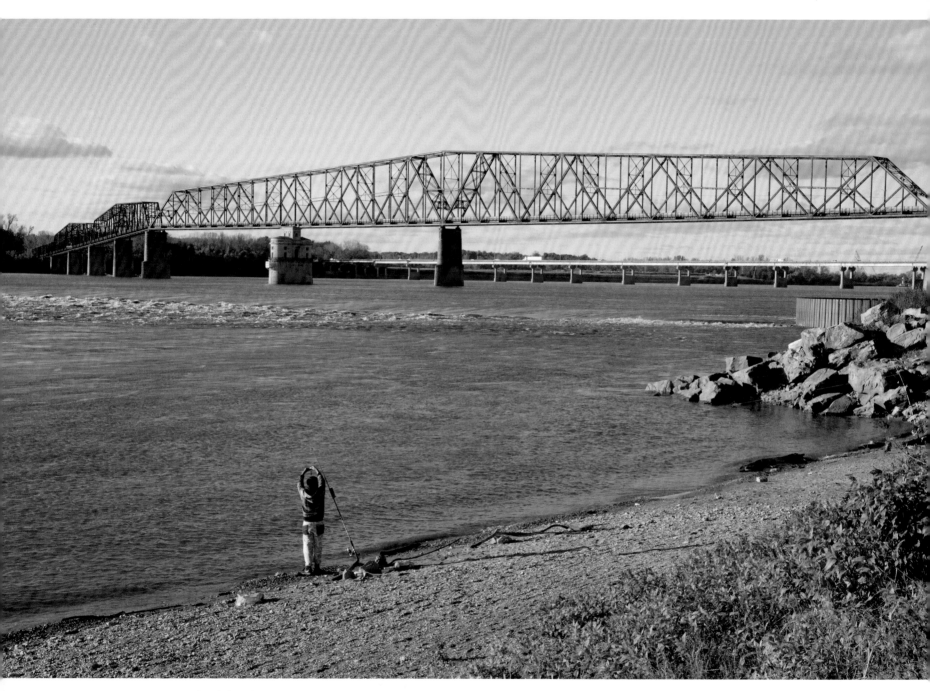

A young boy fishes downstream from the rapids at the Chain of Rocks Bridge north of St. Louis. The bridge features a twenty-four-degree bend over the river. In 1953, the U.S. Army built a bypass canal to the east that includes a lock and dam, the first on the river heading upstream. The bridge used to be part of the original U.S. Route 66.

Left to right, Alan Abbott, Amanda Hicks, and Samantha Hicks walk their dogs Sandman, Zoey, Kai, Kylie, and Lizzy on the Chain of Rocks Bridge.

From the pilot's deck, the panoramic view, including downtown St. Louis, the bridges, and river, was spectacular. We arrived at each span slowly, and their supportive substructures were in full view. Once we passed beneath St. Louis's seven bridges, we veered off the river just north of the city to take the Chain of Rocks Canal.

Chain of Rocks is a line of stones that cross the Mississippi River several miles upstream from downtown. Here the river's bedrock comes close to the surface and creates modest rapids over hard ground and small rocks. In the early days of riverboats, traversing the chain was tricky, if not downright hazardous. More often than not, specialized pilots were hired to navigate these shallows. In the early 1950s, the U.S. Army Corps of Engineers completed an eight-mile bypass canal east of the river past the rapids. They also built a set of locks, the first of twenty-nine on the Mississippi heading upstream.

Back in 1929, as a speculative venture, a group of investors decided to build a bridge at the Chain of Rocks site just upstream from the rapids. Their timing could not have been worse. Two years later, as America entered the Great Depression, the private venture went bankrupt from lack of traffic and high toll fees for the bridge. Starting in 1936, the bridge served as the Mississippi crossing for U.S. Route 66, and in 1939, the neighboring city of Madison, Illinois, took possession of the bridge. The oddly shaped trestle functioned as either a main highway or bypass until it was finally closed to traffic in 1970.

The antique warren-truss Chain of Rocks Bridge is noteworthy for its twenty-four-degree bend in the middle of the river. The distinctive span is currently part of a regional bicycle and hiking trail around St. Louis. Markers along the bridge feature Route 66 memorabilia, reminding pedestrians and bicyclists of the famed highway's history. For the Chain of Rocks Bridge, as well as for many of St. Louis's spans, the past is alive and well as these out-of-date relics remain steadfastly in the present.

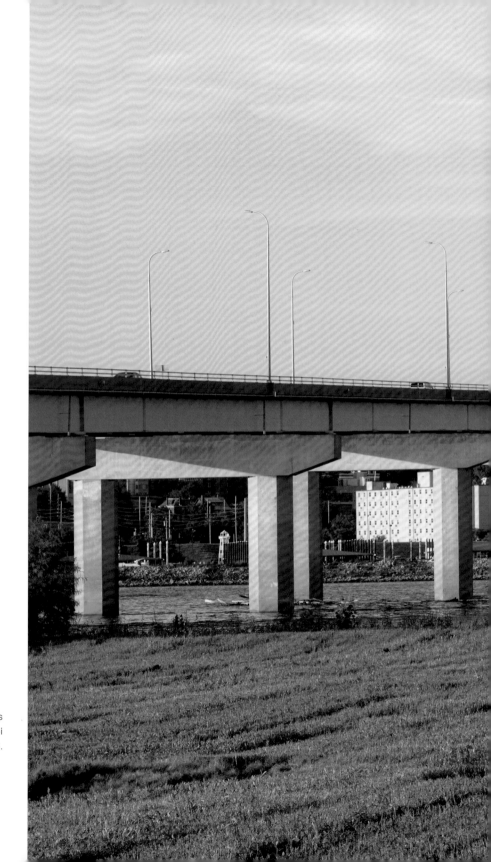

The Clark Bridge, also known as the "Super Bridge," in Alton, Illinois, was built in 1994 as one of the early cable-stay bridges on the Mississippi River. It is named after William Clark of the Lewis and Clark Expedition.

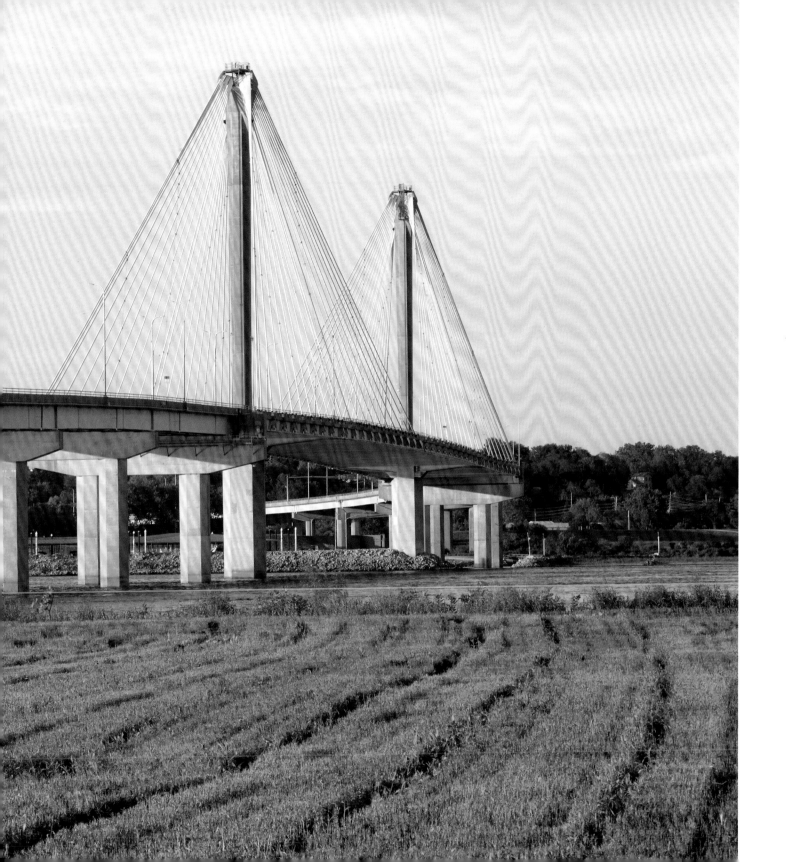

The old Champ Clark and the KCS Rail bridges as seen from the River View Cemetery in Louisiana, Missouri, a riverside hamlet north of St. Louis.

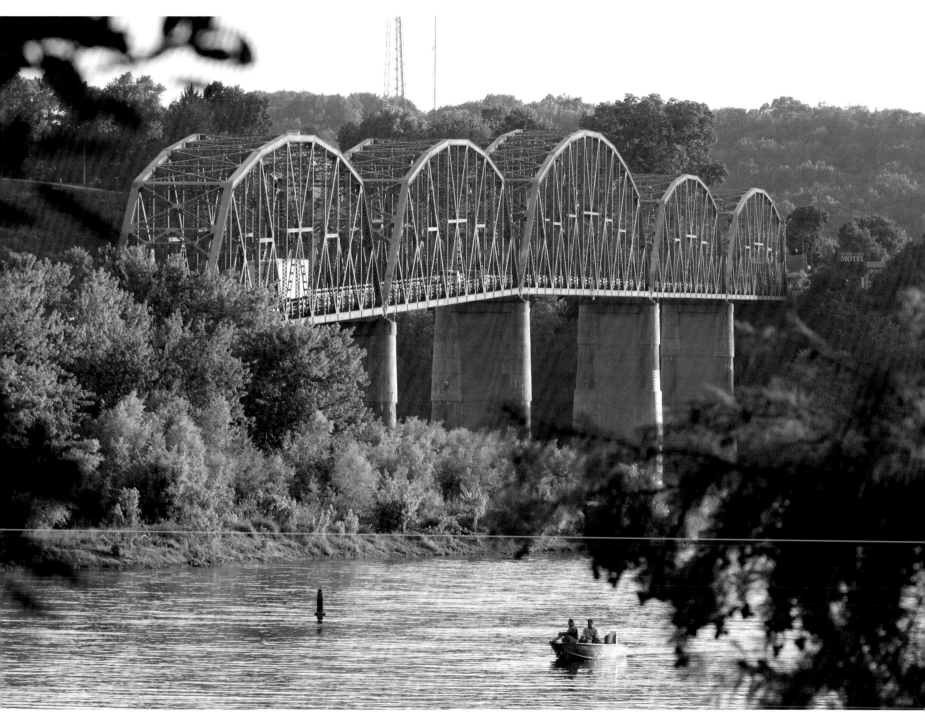

The old Champ Clark Bridge in Louisiana, Missouri has been replaced by newer span. Champ Clark served in the U.S. House of Representatives and was speaker for several years in the early twentieth century. Since the photograph was taken, the bridge has been demolished and replaced with a modern crossing.

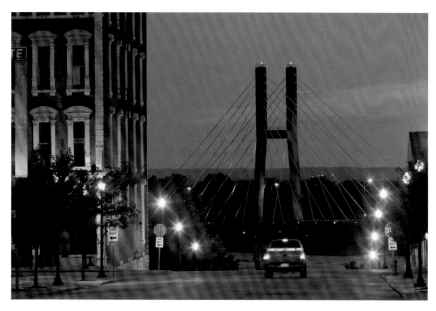

A tower of the Bayview Bridge is illuminated blue as seen here from downtown Quincy, Illinois.

Barbara Strieker and Joe Zimmerman walk along riverfront beneath the Bayview and Soldier's Memorial bridges in Quincy, Illinois. Constructed in 1930, the Soldier's Memorial Bridge now handles westbound traffic. The Bayview came on line in 1987 and handles eastbound traffic.

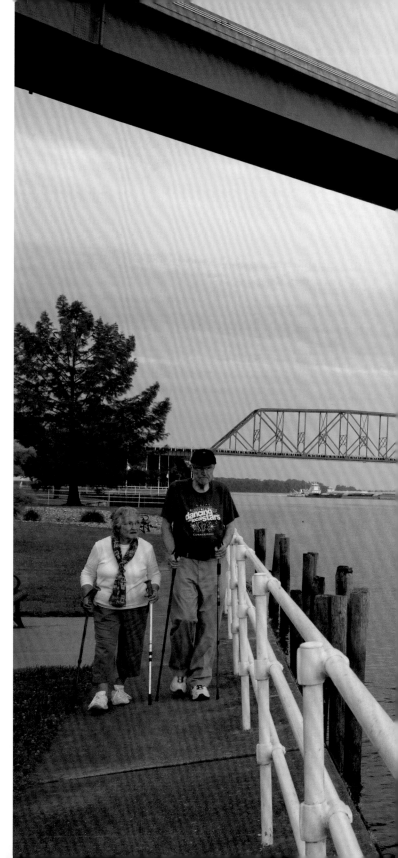

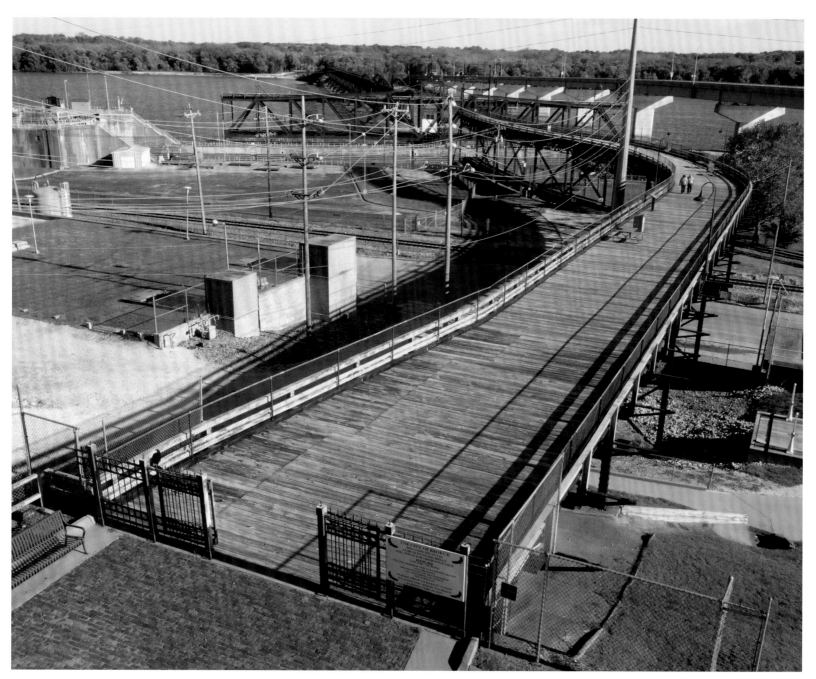

Overview of the Keokuk Municipal Bridge observation Deck located in Keokuk, Iowa. The upper bridge deck was originally part of the vehicle level for the bridge. It closed in 1985 after a new vehicle bridge *(top right)* was constructed. The city acquired the deck and turned it into a park. Rail traffic continues on the bridge's lower deck.

Love locks are placed on the end fence of the Keokuk Municipal Bridge observation deck in Keokuk, Iowa.

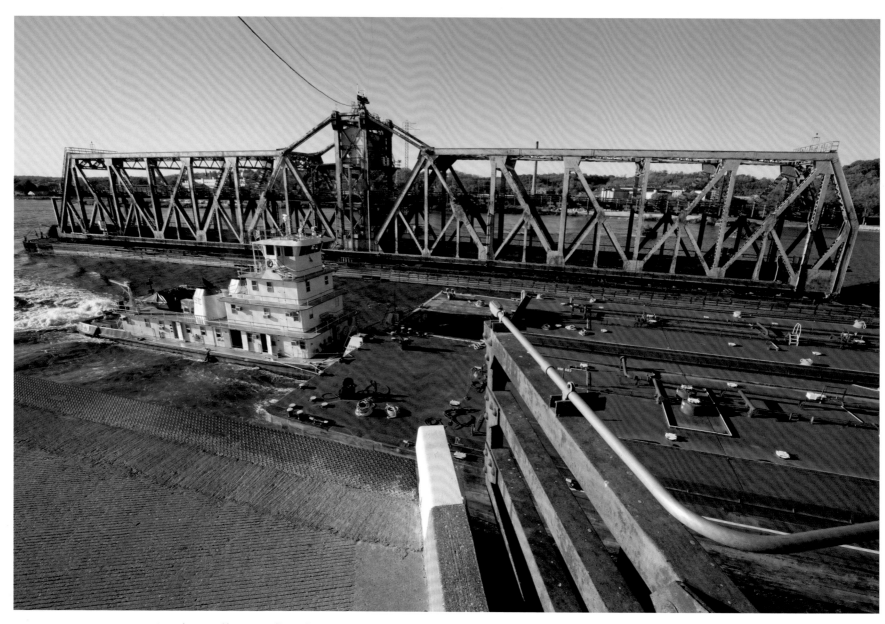

A towboat and barge configuration pass through the opening created by the swing deck of the Ft. Madison Toll Bridge in Ft. Madison, Iowa. At 525 feet, the swing deck is the longest double-decker swing span in the world. The BNSF—owned Railroad Bridge is the last crossing on the river still collecting vehicle tolls.

The Ft. Madison Toll Bridge, in Ft. Madison, Iowa, as seen from a distance

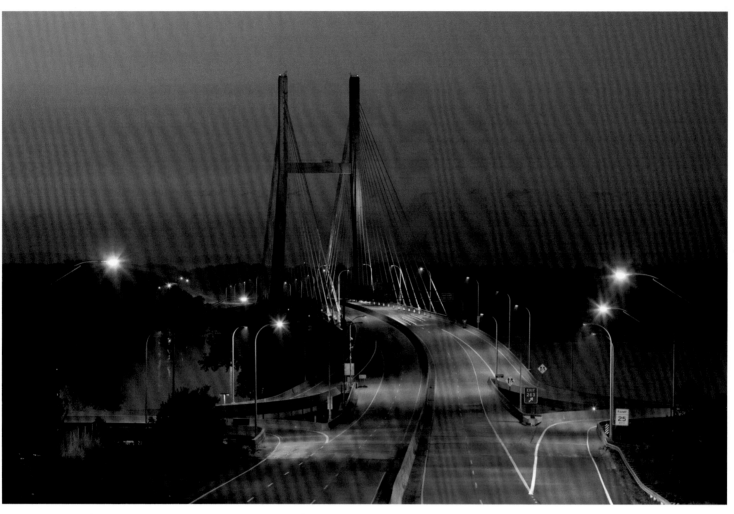

The Great River Bridge in Burlington, Iowa, at dawn. The span is an asymmetrical single tower cable-stay bridge that opened for traffic in 1993.

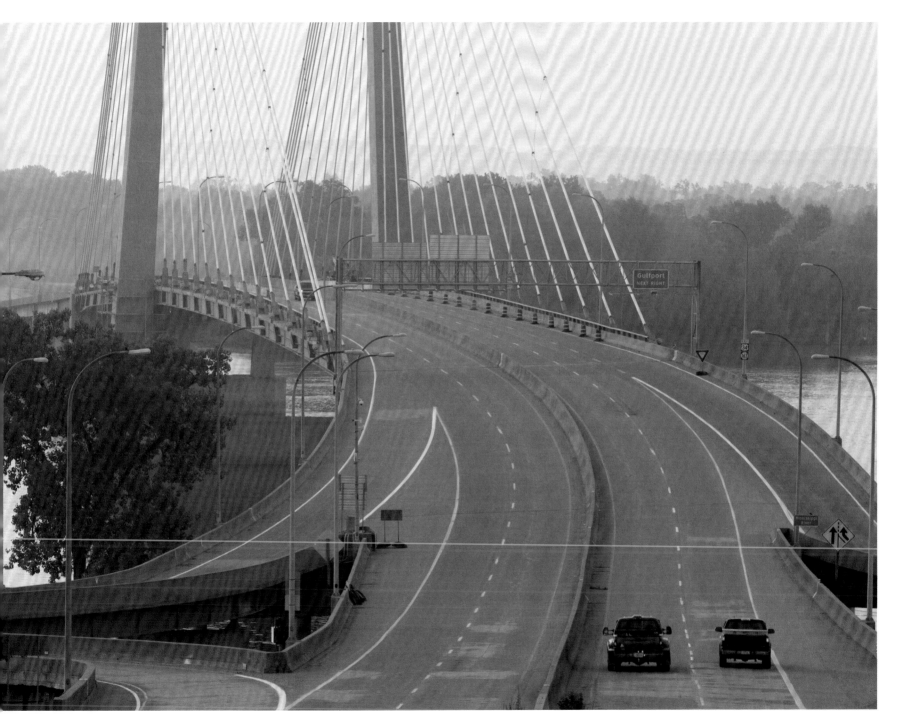

Two pickup trucks cross the Great River Bridge in Burlington, Iowa.

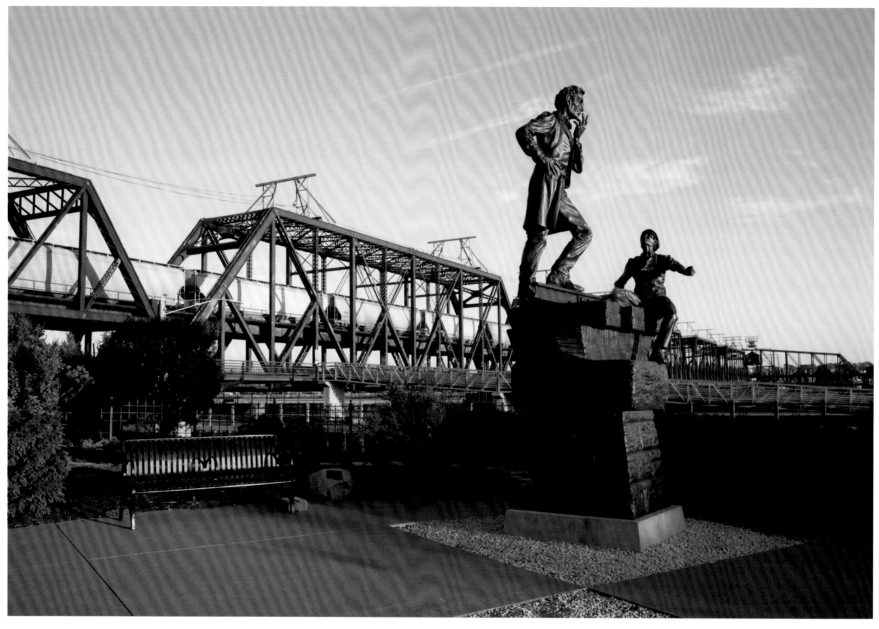

A statue in Davenport, Iowa's, Bechtel Park depicts Abraham Lincoln talking with a young boy near the Mississippi River in 1857. When asked by the boy what he was doing at the river, the future president is quoted as saying, "I am mighty glad I came out here, where I can get a little less opinion, a little more fact." Lincoln served as an attorney for the railroad in the case concerning the *Effie Afton*, a riverboat that lost control and crashed into the bridge in 1856. Lincoln is said to have visited the accident site to study the water flow. The case ultimately determined the right for railroads to build bridges across the Mississippi River as long as vessels could safely pass underneath.

The Quad Cities of Iowa and Illinois

"A Little Less Opinion, a Little More Fact"

On April 21, 1856, the Rock Island Bridge began rail operations connecting Rock Island, Illinois, to Davenport, Iowa. For two weeks, boats navigated beneath the new crossing without incident. On day fifteen, the tragedy involving the *Effie Afton,* a double side-wheel paddleboat, occurred, resulting in the collapse of the span. Enraged, Jacob Hurd, captain and co-owner of the boat, sued the Chicago and Rock Island Railroad, alleging that the rail bridge was a material obstruction to free river navigation. In suing the railroad, Hurd's purpose was to defend the primacy of navigable rivers as the natural trade route in the Mississippi River Valley. His attorneys argued the expanding rail system was as an "artificial means" of travel and commerce.

From the outset, the public took a strong interest in the lawsuit. Everyone understood the implications of a favorable verdict for either party. The *Chicago Daily Press* kept readers informed, assuring them that the newspaper would provide ample space for coverage of the trial.

As the story goes, Abraham Lincoln, then a young lawyer defending Chicago and Rock Island Railroad, spent countless hours studying every detail of the accident. He visited the wreckage site often and checked eddies and currents. In his final remarks to the jury, he was clear and concise: "A man has as good a right to cross a stream as another has the right to navigate it" (Pfeiffer 2004, 8).

Despite Lincoln's efforts, the jury failed to reach a verdict, and the case eventually made its way to the United States Supreme Court. It decided in favor of the railroad, stipulating that rail bridges were necessary for safe passage of both boats and trains. The issue of rail crossings was decided, accelerating westward expansion, particularly after Lincoln, as president, signed the Homestead and Pacific Railroad Acts in 1862. The next year, construction began on the transcontinental railroad.

In 1896, the U.S. Government Bridge opened in Davenport, Iowa, near the site of the first Rock Island Bridge. Celebrated engineer Ralph Modjeski designed the two-level structure to support rail traffic on the top tier and vehicles and pedestrians below. The bridge connected downtown Davenport to Arsenal Island, Rock Island, and Moline, Illinois, across the river.

Just downriver, past Lock and Dam No. 15 is Le Claire Park, which features a small amphitheater, the Woodmen of the World Minor League Baseball Park, and the Centennial Bridge, the only crossing on the Mississippi built with five tied arches. The American Bridge Company, the McCarthy Improvement Company, and the Priester Construction Company joined forces to erect the span, which opened in July 1940. Its arches symbolize the Quad Cities, the two largest representing Rock Island and Davenport. The three smaller arches honor Bettendorf, Moline, and East Moline. From the infield bleachers of the baseball park, the span appears to frame the outfield. Originally named the Galbraith Bridge, the crossing was was renamed in honor of the Rock Island Centennial in 1940.

Over half a million people live in the Quad Cities metropolitan area

today, and many manufacture farm equipment, the region's primary industry. The area faces the same challenges as many other American urban areas, such as maintaining infrastructure and keeping pace with rapid growth. Vehicle traffic in the region is handled by the Centennial, the U.S. Government, and the Iowa–Illinois Memorial (I-74) bridges, all of which are aging. The I-74 double span is currently being replaced. Completion is scheduled for 2021.

In Bechtel Park, downtown near the Mississippi River in Davenport, a statue of Abraham Lincoln as a fledgling railroad lawyer honors the late president and the role he played in railroad network expansion. Depicted as a young man gazing down at an adolescent boy, the statue can be seen by rail engineers crossing the U.S. Government Bridge just upriver. The boy, according to the inscription on the base, asks what the great man is doing near the river. Lincoln's response is a reference to the powerful emotions stirred during the trial: "I'm mighty glad I came out here where I can get a little less opinion, a little more fact."

Today, Davenport is a prosperous and culturally progressive city with much to offer its residents and visitors. For example, the Figge Art Museum contains works dating back to the fifteenth century. The Putnam, a natural history and science museum, includes local exhibits within its collection, and the River Music Experience is a performing arts venue. For those who love nature, Vander Veer Botanical Park is located just north of the busy city.

The Government Bridge in the background with Lock and Dam No. 15 just downstream in Davenport, Iowa. Twenty-nine lock and dams are located on the Mississippi between St. Louis and Minneapolis.

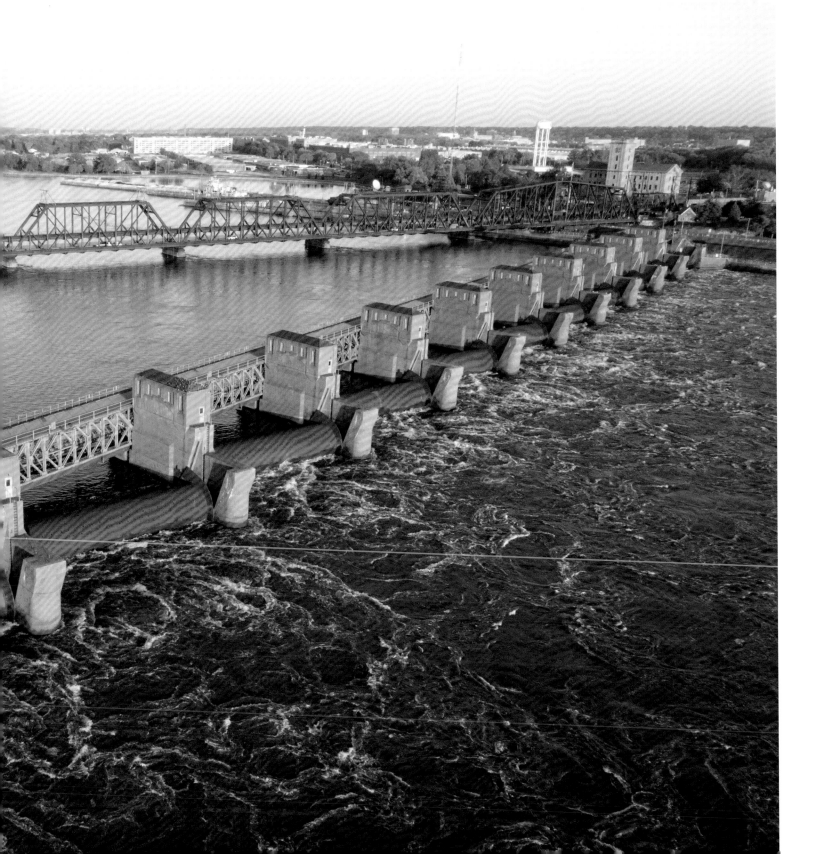

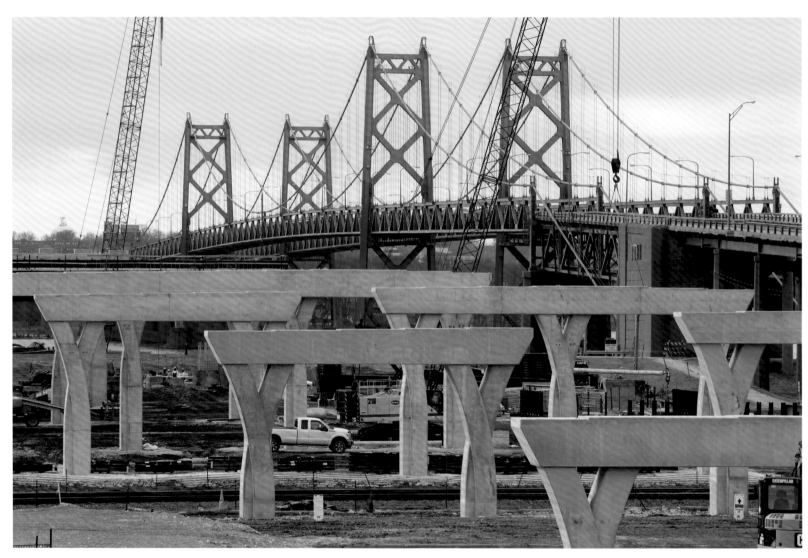

Approach supports are being constructed for the new I-74 Bridge being built in Davenport, Iowa. The bridge will replace the nearly identical Iowa–Illinois suspension bridges, the first of which was built in 1939. The second nearly identical span was constructed twenty-four years later.

Cassidy Peterson cheers for the Quad Cities River Bandits after Wander Franco hits a three-run homer. The River Bandits play in Woodmen of the World Baseball Park, which is located adjacent to the Centennial Bridge. The span opened in 1940, a century after the founding of the City of Rock Island.

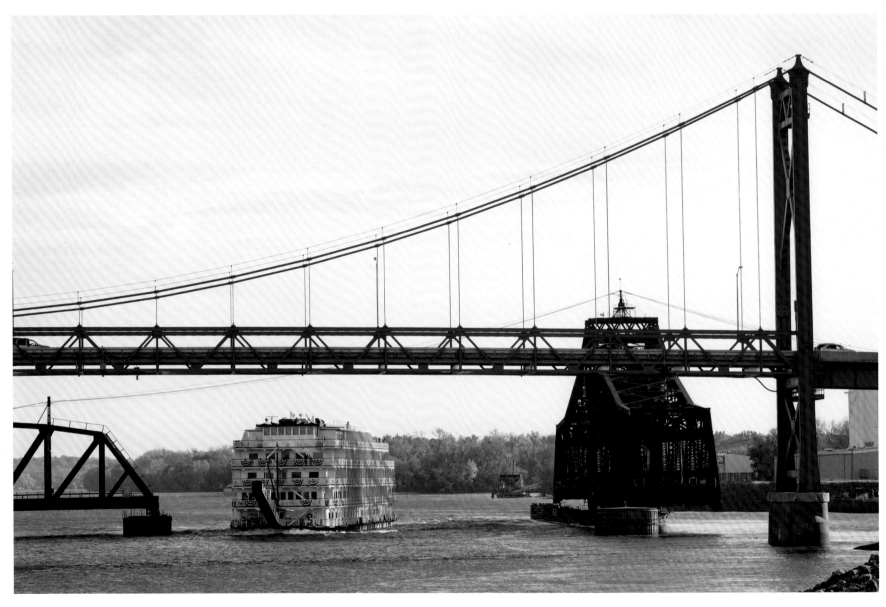

The riverboat *Americana* sails past the Chicago and North Western Rail and Gateway bridges in Clinton, Iowa. The rail span opened in 1909; the Gateway went on line in 1956.

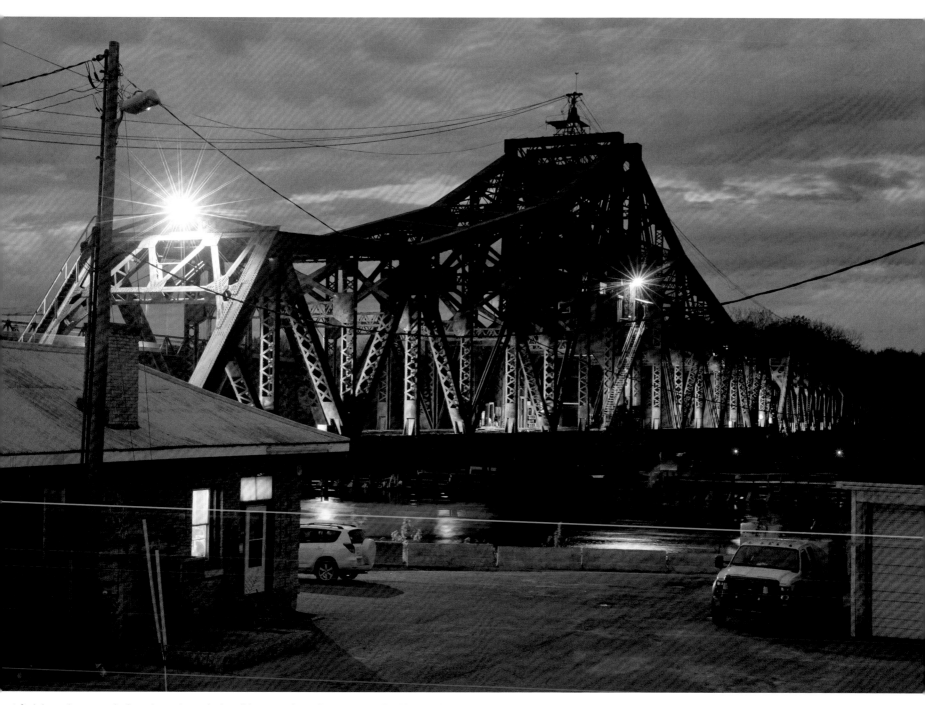

A freight train passes before dawn through the Chicago and North Western Rail Bridge in Clinton, Iowa. The bridge, which opened in 1909, features a double track and handles rail traffic to and from Chicago. According to Eric Vogel, an electrician at the bridge, the bridge components were manufactured in Pittsburg, where they were loosely assembled. The pieces were then transported individually to Clinton and reassembled on site. "In 1958 a fire almost burned up the bridge," Vogel noted. "As a result, the swing span has a slight warp. On a real hot day one side expands and the bridge can't close. People must then turn the bridge so the heated side can cool in the shade."

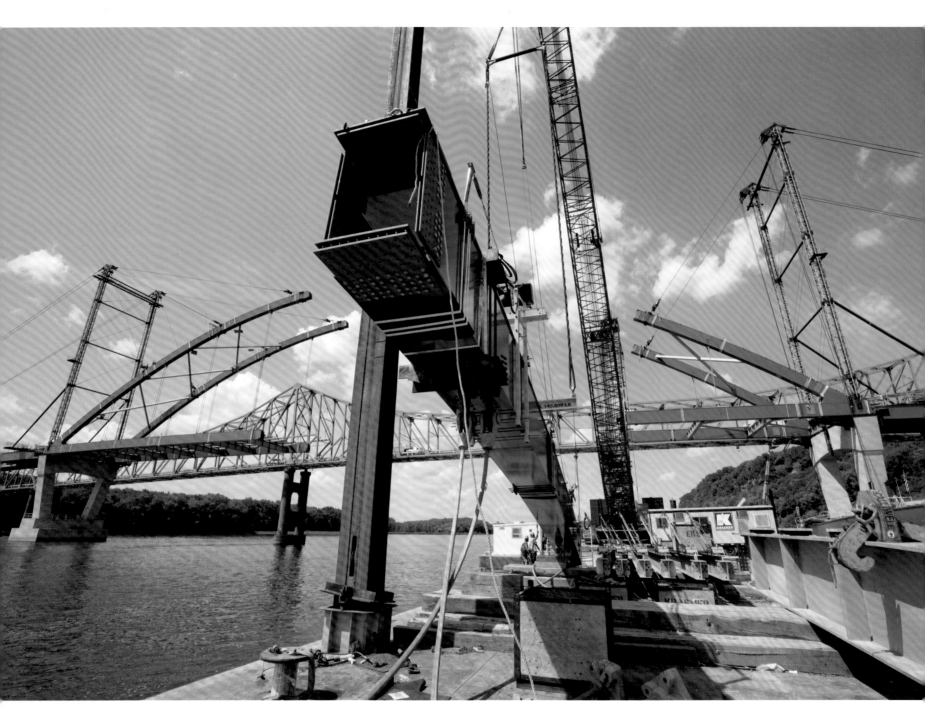

A section of the new Dale Gardner Veterans Memorial Bridge in Savanna, Illinois, is hoisted from a barge to be attached to the far right arch on the new span.

Savanna, Illinois

A Tale of Two Bridges

BNSF are your trains clear? Highway 84 northbound clear? Southbound clear? Nearby houses, are they clear? Retention pond clear?" Bridge project manager Pat Shea scans his checklist, then speaks clearly into his closed-circuit radio: "Gardner Park clear? Streets blocked and clear? Iowa approach clear? Barge and boat traffic up and downstream clear? Are drones in position? Okay, one-minute warning . . . 30 seconds . . . 10 seconds."

The roots of this moment date back to 1932, when the original Savanna–Sabula Memorial Bridge opened during the presidency of Herbert Hoover. Before that, ferries carried passengers across the Mississippi River between Sabula, Iowa, and Savanna, Illinois. The bridge ushered in a new transportation age to the tiny hamlets.

Savanna was settled in 1828 by explorers from Galena, Illinois, a bustling industrial city during the early twentieth century. Known for its well-preserved architecture, Ga-

Nick Place and Joe Meyer tighten a bolt to the crane rigging before lifting another section onto the Dale Gardner Veterans Memorial Bridge in Savanna, Illinois.

lena is also recognized for its citizens' donation of a home to Union general Ulysses S. Grant after he was elected President of the United States. Galena and Savanna, which began as steamboat stops to and from St. Louis, grew once logging and shipping were established in the area. The installation near Savanna of a United States Army weapons depot in 1917 expanded commerce and increased jobs.

Growth slowed over time. Congress closed the arms depot in 2000, compelling an economic downturn in the area. Between 2000 and 2016, the population declined from 3,500 to 3,000, a reduction of 15 percent, according to United States census data. Like so many small towns adjacent to the Mississippi River, Savanna has fought to stay viable. The town survives today primarily due to tourism. The scenic Mississippi River and its surroundings are inviting to weekend travelers and water-sport enthusiasts. A huge draw are the town's motorcycle-theme bars,

which display vintage Harley Davidson posters. Visitors love these watering holes whose names include the Iron Horse Social Club, Poopy's Pub 'n' Grub, and the Whiskey River Room.

Savanna mayor Chris Lain enjoys talking about the town's attractions. "We have beautiful hills and bluffs in the area. The motorcycle rides around here are gorgeous and the town is popular with weekend warriors. In fact, the Iron Horse even has a wedding chapel inside. I have watched people walk out of the bar wearing wedding dress and tux and leave on their motorcycles" (interview, Oct. 4, 2018).

During the decades following construction of the narrow Savanna–Sabula Bridge, vehicles increased in size and weight, and traffic multiplied. Crossing the bridge on the outdated lanes was dangerous. For example, two 18-wheelers approaching one another from opposite directions and meeting on the bridge's twenty-foot-wide deck would have only inches to spare between their drivers' side mirrors.

In 1985, the Savanna–Sabula Bridge was renovated, and in 1999 it was added to the National Register of Historic Places. Repairs made to the bridge nine years later were intended to extend its life, but a 2010 inspection by Illinois State Department of Transportation found accelerating deterioration. While the bridge remained open, IDOT initiated plans for its replacement.

During the planning phase for the new bridge, IDOT offered Savanna residents a choice between a cable-stayed crossing with two towers to support the bridge and roadbed or a tied-arch span. The townspeople opted for the latter design, and insisted that it, just like the old bridge, be painted blue.

Planning and design took years to complete. Kraemer North America secured the contract for construction, which began in January 2016. As many as sixty-five engineers, ironworkers, tugboat and crane operators, carpenters, electricians, and others worked on the bridge during its peak construction period. Located fifty feet downriver from the original Savanna–Sabula span, the new $80.6 million Dale Gardner Veterans Memorial Bridge was completed in 2018 and named for a hometown boy who became an astronaut. The new span featured a forty-foot-wide roadbed and a tall, graceful arch.

For two years, Savanna served as home away from home for project manager Patrick Shea, an easygoing, seasoned, and focused bridge builder. Shea and his experienced crew have worked together on a variety of bridge projects throughout the Midwest over the years. Over beers at Poopy's one evening, Shea and several workers provided insights into the personal side of bridge construction.

"For me, I like the challenge, the unpredictability of it," said Shea. "Working at Kraemer, we get the opportunity. I have been working with them for fifteen years. I went to Bradley [a university in Peoria, Illinois]," he continued. "When I graduated, most of my friends wanted to build buildings. I had no interest in buildings. I wanted to build bridges. One, they are more like a monument. Two, they are built to last. Three, it's the unknown, how do you do it?"

"When people look at bridges over water," said his coworker, "they'll ask how do you do that? Especially with the substructure stuff. How do you make that thing stand up in water? What's down there?"

Another crew member piped up, saying, "It's a curiosity, the need to know, especially here in small towns. They want to know everything. None of them have seen a new bridge being built up close."

"My dad was a crane operator," noted an engineer. "I first started running crane when I was eight. I had to sit on the old man's lap. I did the levers; he did the pedals. I would go with my dad and help in the yard and work on equipment. I have always been around it. One day he asks, 'So what do you want to do, go to school or get a job?' I saved myself a lot of time and money and just started to work. His boss told me, 'Stop by Monday and we'll talk about it.' All I had to do was sign the paper and turn it in."

"My dad was a river pilot," remembered Shea. "I was born on the river. Whenever there wasn't a deckhand, I was just across the hallway. He would wake me up two or three in the morning and say. 'You are going.' I thought it was great. It is what prompted my interest in rivers."

"My dad was a bridge builder although he switched to being in the yard," recalled a foreman. "When us kids came along, he had a choice to make: are you going to be gone a long time or be home every night?"

"There are well over 130 bridges on the Mississippi," Shea noted. "If you even build one of them, it is a chance of a lifetime" (interview, Mar. 18, 2018).

By October 2017, the new span was all but complete, and locals antici-

Bridge workers ready themselves to grasp a new hanging section of arch being positioned for the Savanna Bridge.

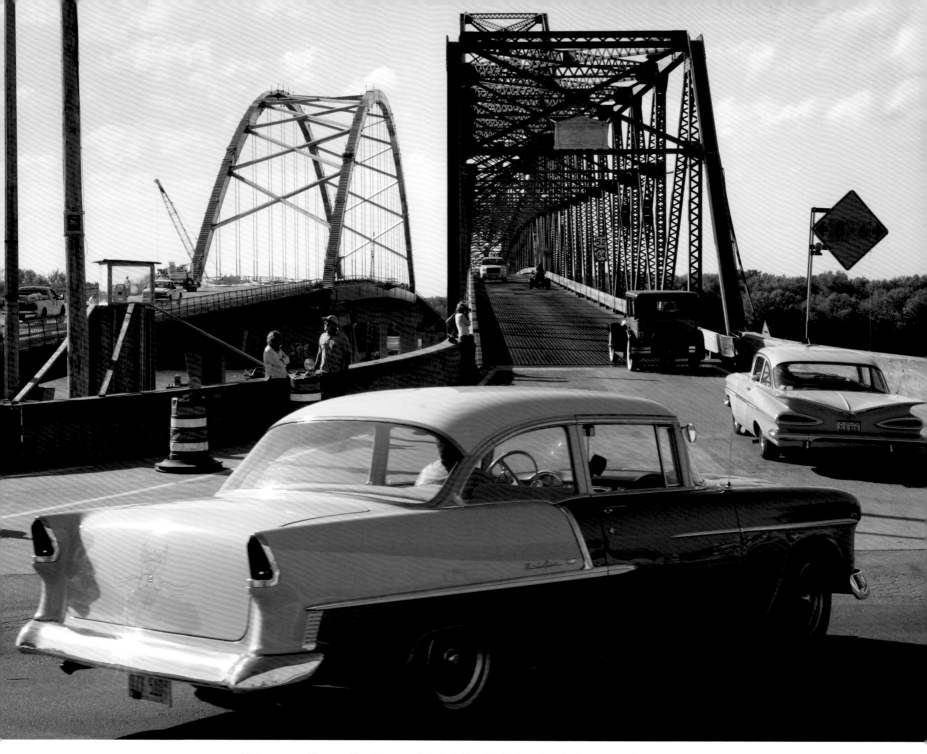

Vintage cars drive over the Savanna–Sabula Bridge for the last time during Savanna's Vintage Festival.

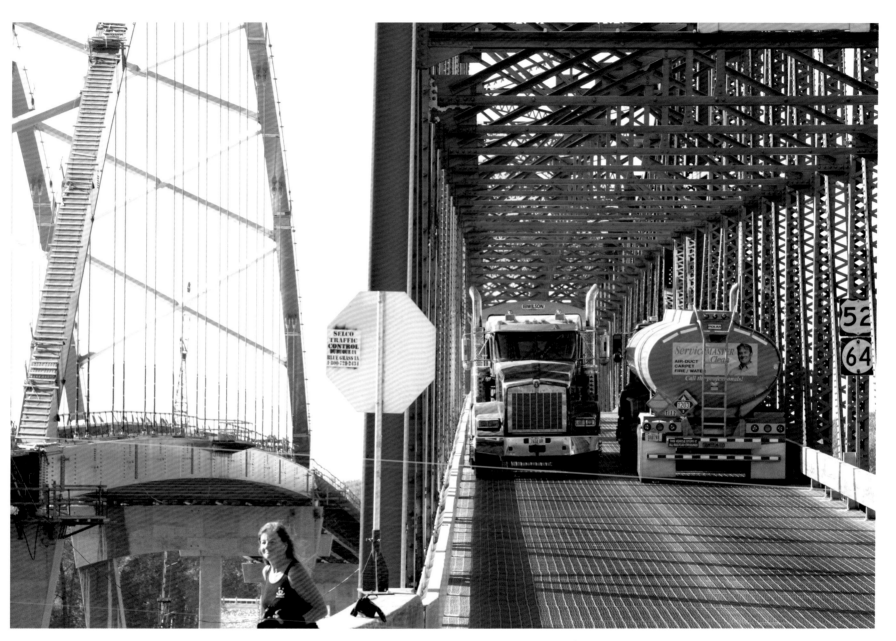

Eighteen-wheeler rigs inch past each other on the old Savanna–Sabula Bridge.

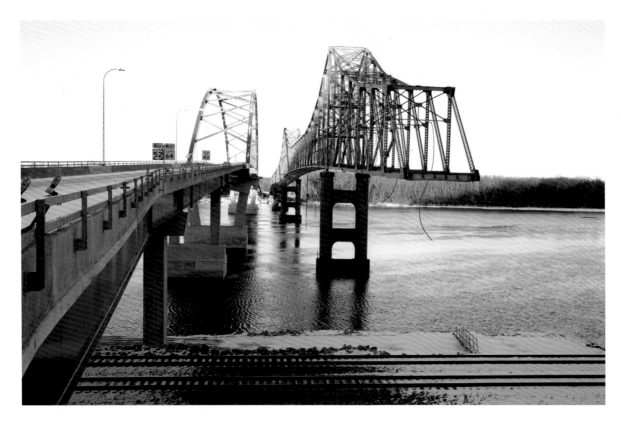

The old Savanna–Sabula Bridge, stripped of bridge decking and approaches, awaits demolition as it stands adjacent to the newly built Dale Gardner Veterans Memorial Bridge.

pated the demolition of the old Savanna–Sabula Bridge. That year during Bridge Fest, the annual fall food and music festival held on the riverbank, the antique cars featured in the celebrations crossed the old bridge for the last time.

Demolition preparations took months, as workers dismantled the approaches and removed the metal-grid bridge deck. Kraemer and the IDOT secured permits from the Army Corps of Engineers and the Coast Guard. They negotiated over the target demolition date with BNSF and Canadian Pacific Rail, companies that used the rail crossing beneath the span. It was essential that the bridge come down during the winter, when the river was closed to commercial barge traffic. Five days before the target date, workers carefully placed 386 explosive charges at critical support junctions along the bridge.

"Thirty seconds . . . Ten seconds . . . silence . . . KA-BOOM!"

On the morning of March 9, 2018, as hundreds of people watched, the string of charges on both sides of the roadbed exploded, instantly creating two broad lines of dark smoke along the bridge's frame. The force of the blast was felt 2,000 feet away. Within seconds the Savanna–Sabula Bridge collapsed into the Mississippi River. When the smoke cleared, only the metal skeleton remained, with debris breaking through the river's surface. In that moment, the scene was reminiscent of countless bridge demolitions across Europe during World War II.

Today, there is no sign of the Savanna–Sabula wreckage. First-time visitors to the area might never know that a vintage twentieth-century bridge once crossed the Mississippi between the two towns. However, with the new Dale Gardner Veterans Memorial Bridge open, after nearly ten years of planning, construction, and demolition, the quaint village has returned to the business of being Savanna.

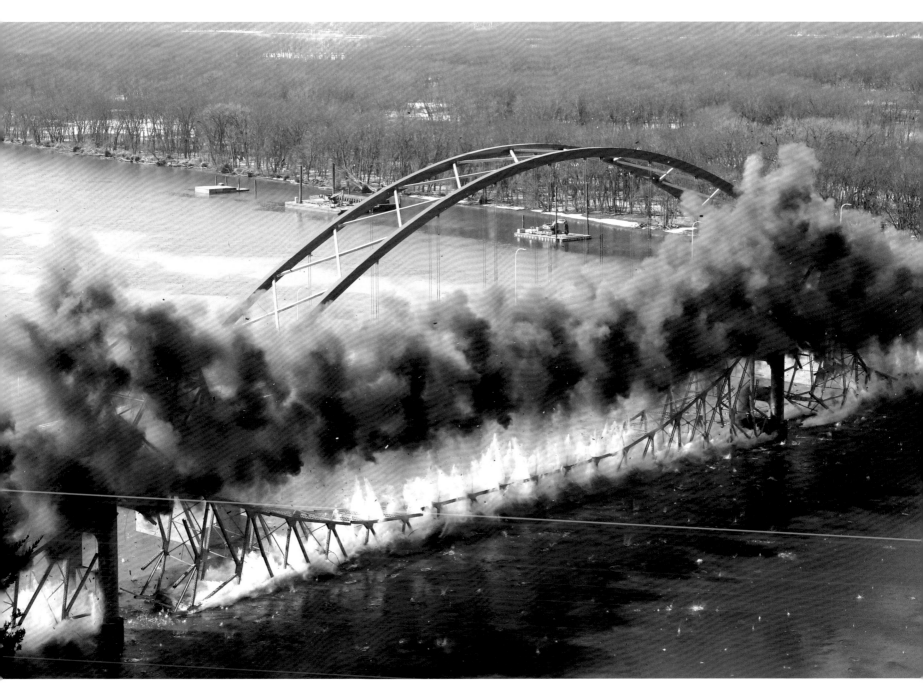

Three hundred and eighty-six explosive charges detonate in tandem causing the old Savanna–Sabula Bridge to drop into the Mississippi River.

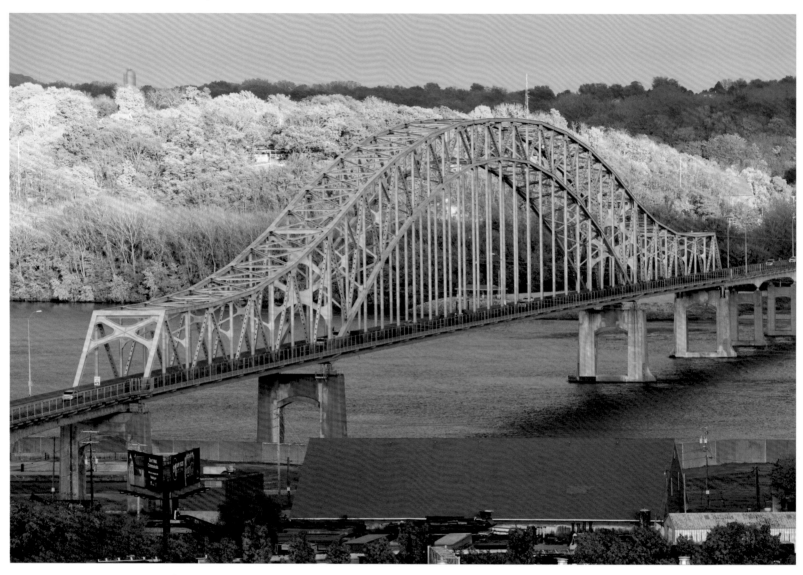

Afternoon sun illuminates fall foliage behind the Julien Dubuque Bridge in Dubuque, Iowa. The bridge, which opened in 1943, connects the city to East Dubuque and other Illinois towns.

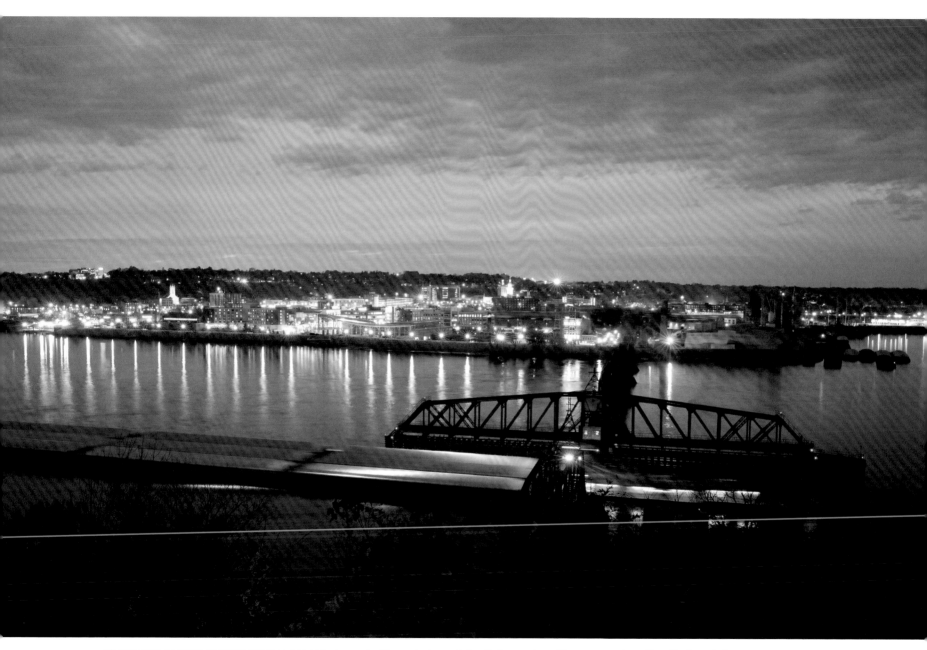

The Canadian National Railroad Bridge opens for barge traffic as dusk overtakes Dubuque, Iowa. The span carries rail traffic from Dubuque across the Mississippi River through a tunnel and to points east. The original span opened in 1869 and was rebuilt thirty years later.

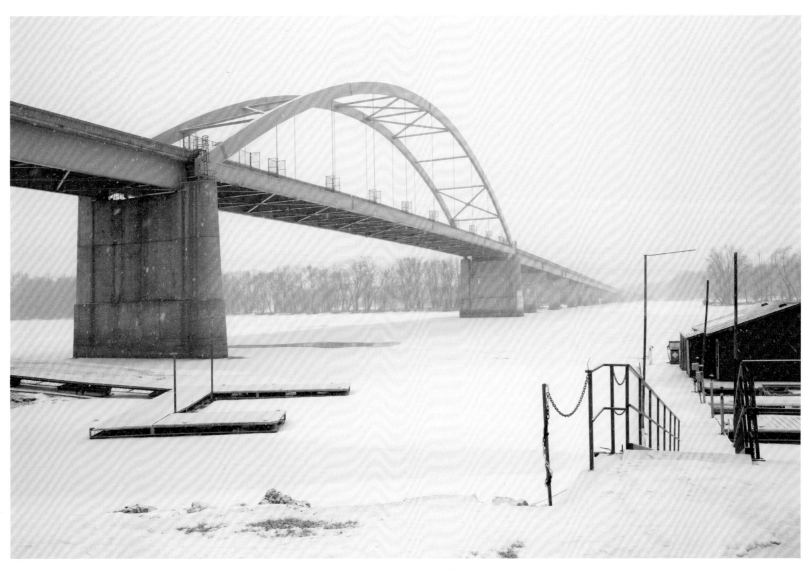

The Marquette–Joliet Bridge during a snowstorm in Marquette, Iowa. The bridge connects the hamlet to Prairie du Chien, Wisconsin.

Marquette, Iowa, during a snowstorm

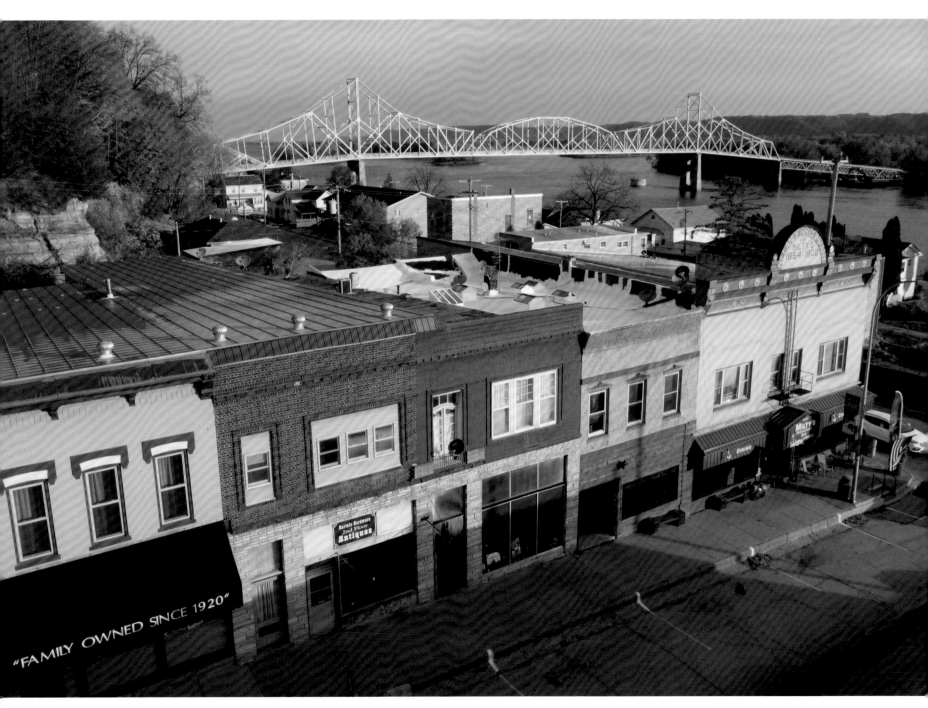

The Black Hawk Bridge crosses the Mississippi adjacent to downtown Lansing, Iowa.

Lansing, Iowa

A Town and its Bridge

Residents of towns and cities along the Mississippi River feel a strong connection to their bridges, as exemplified in stories about the Crescent City Connection in New Orleans, the Hernando de Soto Bridge in Memphis, the Eads Bridge in St. Louis, and the Stone Arch Bridge in Minneapolis. But few communities experience this bond the way folks in Lansing, Iowa, do for their beloved Black Hawk Bridge. In Lansing, a small town founded in 1848 and nestled along the Mississippi in Iowa's northeast corner, residents feel that their town's identity is inseparable from that of its bridge, which was named for the warrior Black Hawk, a famous regional Sauk American Indian chief.

"The bridge is everything to the town," noted John Rethwisch, a city employee and resident of Lansing since 1964. His home sits along the Mississippi adjacent to the Black Hawk. "It has had enormous economic and historical impact on Lansing," he explained. "For example, ten years ago they found a crack on a bridge beam and closed the span immediately for repairs. During the week it was closed, folks in Wisconsin could not cross the river to shop. Stores in town could feel it" (interview, Sept. 26, 2018).

The Black Hawk Bridge's architectural style is one important reason for its appeal to locals and visitors alike. Built in 1931, the cantilever-truss-style span hearkens back to an earlier generation of distinctive crossings. These early twentieth-century bridges were the first built exclusively for vehicle traffic, having lower weight-load requirements than rail crossings. In terms of engineering, the Black Hawk is a delightful anomaly, comprised of three distinct components. The bridge's two piers support a tower and structural grid of metal. Between them is a freestanding truss section connected to the bridge only at the base of the roadbed. There are no lateral connections providing reinforcements between the sections. A first-time view of the bridge can be startling, as the Black Hawk's center section seems to float in midair, the components on each end appearing unable to support themselves or the traffic on them.

While the Black Hawk Bridge is perhaps Lansing's preeminent attraction, there are other points of interest in town as well. One noteworthy establishment is Horsfall's Variety Store, affectionately known among local residents as Lansing's "Mall of America." A memorial to general stores from decades past, Horsfall's features narrow aisles and shelves stacked floor to ceiling with every imaginable item, drawing in both locals and out-of-towners.

Weekend visitors arrive in Lansing on their motorcycles, in cars, or even on bicycles to cross the Black Hawk Bridge and patronize local shops, restaurants, and bars. The town's residents welcome this weekend commerce by hanging promotional banners featuring images of the bridge on streetlight poles. Another Lansing attraction, the Main Channel Grill, features a large wooden replica of the Black Hawk Bridge over its picture window facing the street. Local banks and businesses proudly hang framed photographs of the bridge on every available wall in their lobbies and offices.

Over the years, the Black Hawk Bridge has served the region well, join-

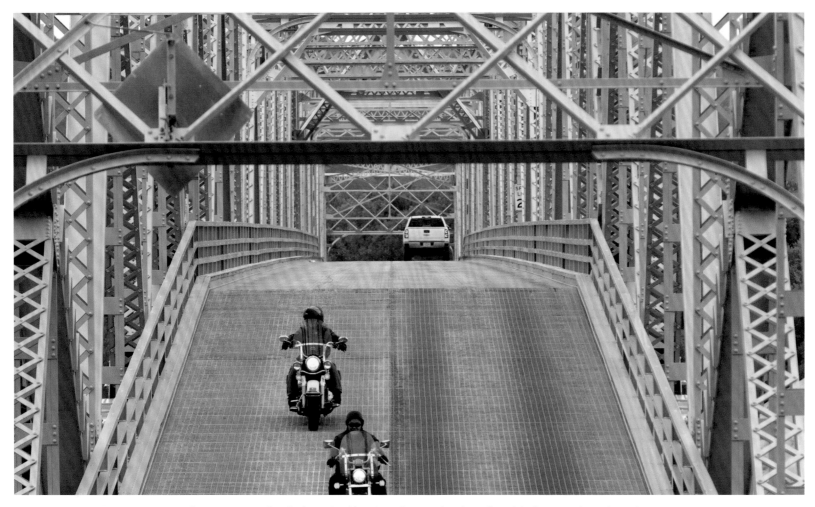

Motorcyclists cross over the Black Hawk Bridge. Countless weekend warriors visit the town throughout the year.

ing residents from both sides of the Mississippi River for everyone's benefit. At the dedication for the bridge in 1931, Lansing mayor R. G. Miller spoke proudly of the two towns' new connection. "We all must be happy in the knowledge that a magnificent steel bridge now spans the mighty old river that has, for so long, acted as a barrier to our social and commercial intercourse with the good people a short distance across the valley in Wisconsin, people who were removed in a practical way entirely by the border of our territory."

In spite of its cultural value to the area, the Black Hawk Bridge's fate has been in question for decades. The span is as "structurally as sound as the day it was built," boasts Rethwisch, but its location is problematic. The bridge crosses the Mississippi immediately after the river veers left heading downstream past Lansing. Towboats pushing barge groups must finesse this approach at just the right moment. Once the barges are safely positioned perpendicular to the bridge, the towboats can safely navigate the river.

The Black Hawk Bridge is protected by two massive, concrete cylindrical dolphins, each roughly twenty feet in diameter and surrounded by

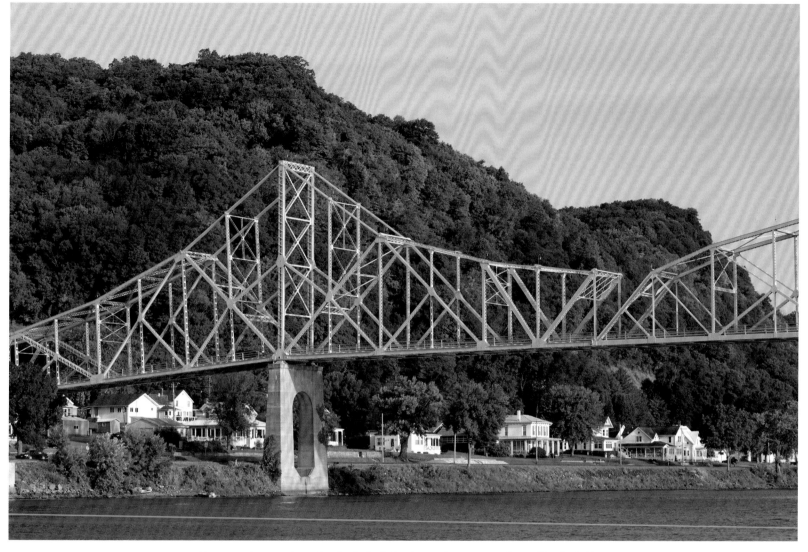

Numerous homes along the Mississippi River in Lansing, Iowa, are framed by the bridge.

large wooden planks wrapped with one-foot-wide steel plating. The dolphins are man-made marine structures that extend above water level but do not connect to the riverbank. They were installed to provide a fixed edifice where it was impractical to extend the shore to provide dry access. It is noteworthy that the dolphins bear the scars of towboats and barges.

Why not straighten the river to facilitate easier navigation, just as engineers did in Memphis? The answer is fraught with complications. The entire river area is part of the Upper Mississippi Wildlife refuge, a 240,000-acre, 261-mile-long wetland preserve that stretches from Wabasha, Minnesota, to Rock Island, Illinois. Home to a vast array of lakes,

A group poses along the riverbank in Lansing, Iowa, before heading out to party on the river for July 4th celebrations.

sloughs, and hardwood forests, the refuge also protects numerous wildlife species, including bald eagles. These emblematic birds have finally returned to the area following near eradication by DDT poisoning during the mid-twentieth century. Altering this protective ecosystem in any way would be unthinkable.

Iowa Department of Transportation noted that it is "currently conducting an Environmental Assessment, or NEPA Study, on the IA-9 river crossing at Lansing. The Environmental Assessment is looking at many alternatives at this time, including replacement, major rehabilitation, or 'do nothing.' There are currently four new location alternatives, however, all will be researched further as more data is available. Studies are underway to examine the historical and cultural assets, as well as the natural environment. We hope to wrap up the Environmental Assessment . . . with a preferred alternative" (interview Sept. 21, 2018).

Folks in Lansing have heard this talk before—that the bridge is too old, narrow, and outdated; that it is a navigational hazard; that another span needs to be built in its place to ease river navigation. Residents young and old simply shrug their shoulders at this talk, just as they have done for decades. Nothing has changed yet, and their responses signify a confident attitude of "It just won't happen in my lifetime."

Bill Fitzgerald, a local fixture and longtime resident stated, "The Black Hawk Bridge means as much to people in Lansing as a living great-grandparent. They know they will lose their loved one at some point, so they just cherish their relation as long as they can" (interview, Sept. 19, 2018).

As beautiful, distinctive, and beloved as it is, the Black Hawk Bridge poses problems with no good solutions. Until the dreaded moment of change arrives, folks in town will continue to enjoy their cultural icon, knowing its value as one of the last old-style, architecturally distinctive bridges on the Mississippi River. Quite possibly, it is key to the unspoiled life of this charming hillside hamlet.

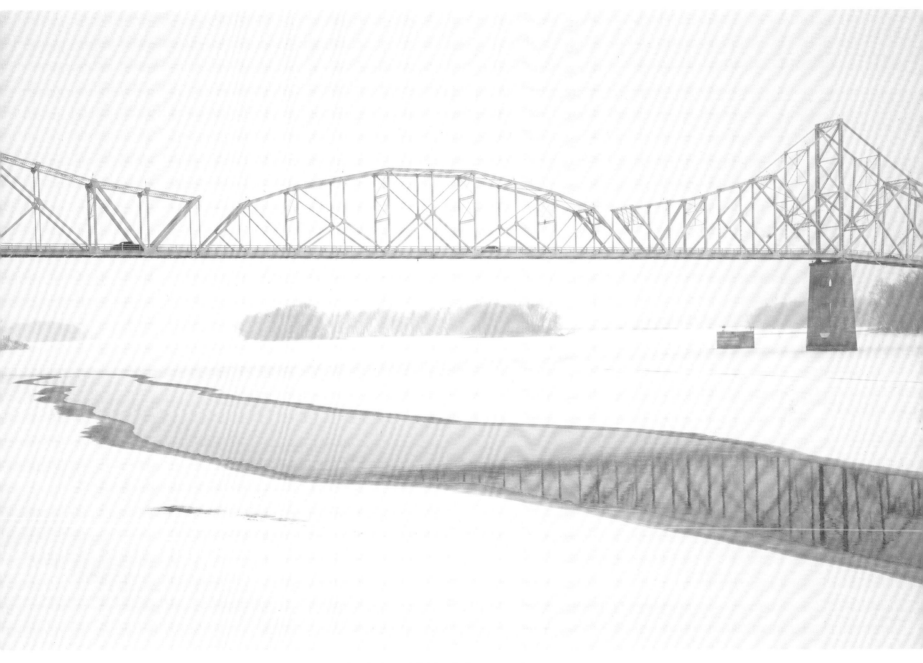

The Black Hawk Bridge during a snowstorm

Rotating platform of the Canadian Pacific Rail Bridge's swing span during a snowstorm in La Crosse, Wisconsin.

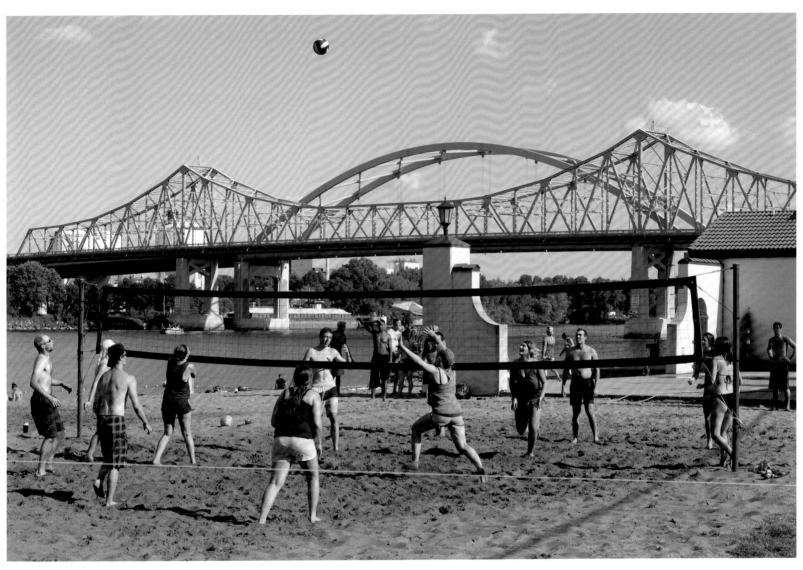

Volleyball players compete in a match along the river at Pettibone Beach in La Crosse, Wisconsin. In the background are the two bridges that carry cross-river traffic.

One section is all that remains of the Chicago and Northwestern Rail Bridge in Winona, Minnesota. The bridge was originally built in 1871 and underwent several renovations before closing in 1977. Much of the span was removed afterwards to make way for river traffic.

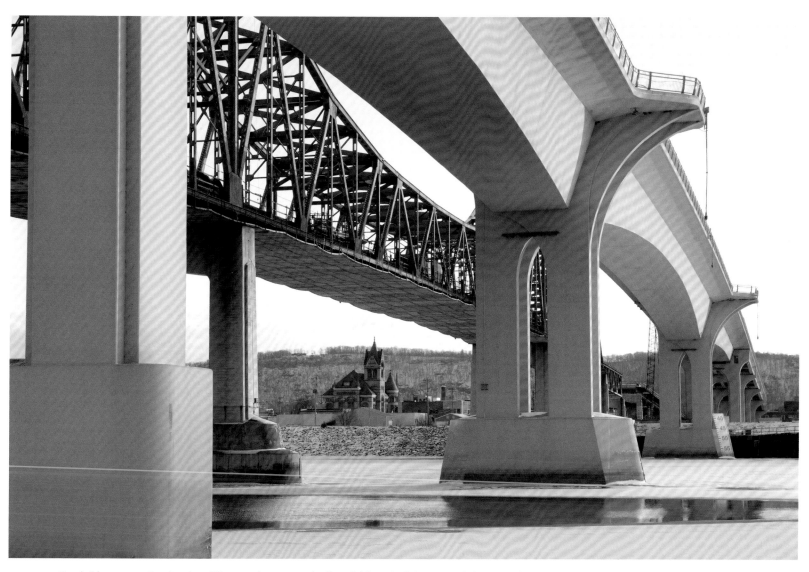

Two bridges cross the river into Winona, Minnesota. The first *(left)* was built in 1942 and the second in 2016. The older bridge was condemned by the Minnesota Department of Transportation in 2007 after the I-35 bridge collapse in Minneapolis. After the new bridge was built, workers began refurbishing the older span. The bridges frame the old Winona County Courthouse.

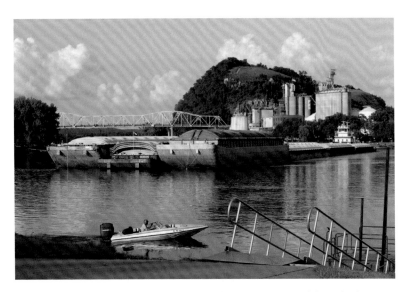

The Dwight D. Eisenhower Bridge seen from Bay Point Park in Red Wing, Minnesota. A towboat-barge configuration is pictured here as it inches its way along the narrow river adjacent to the town.

The city of Red Wing, Minnesota, shown in panorama, includes a down-town, a riverside, and the Dwight D. Eisenhower Bridge. The span opened in fall of 1960. Former president Eisenhower, campaigning in the state for Republican presidential nominee Richard Nixon, was a guest at the inaugural ceremony. The span was named in his honor.

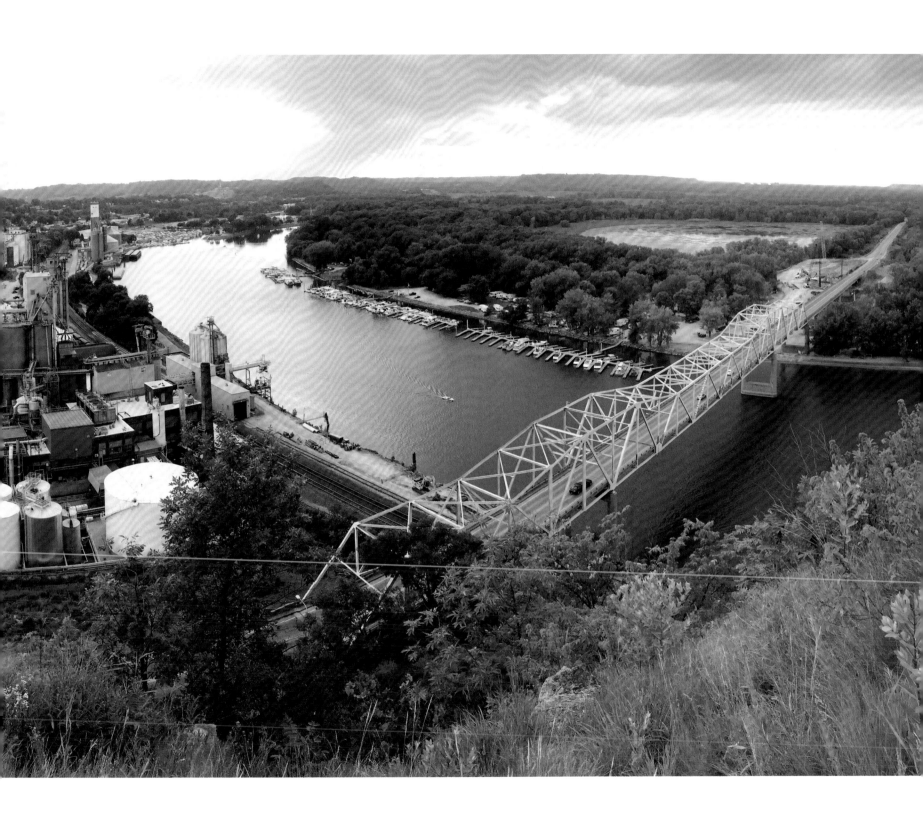

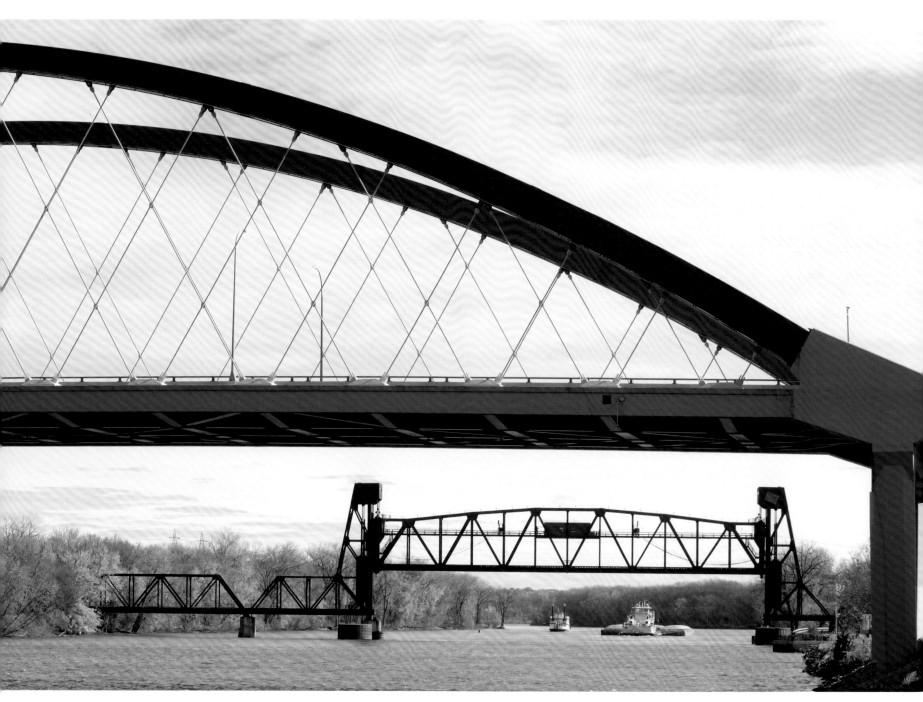

The Hastings Bridge frames the Mississippi River in Hastings, Minnesota. The Milwaukee Road CP Railroad Bridge is in the background.

A replica of the Spiral Bridge can be found at Little Log House Pioneer Village south of Hastings, Minnesota.

A metal artwork rendition in the town's riverfront park fence shows the original Hastings Spiral Bridge that once crossed the river in the town. The bridge was unique as a span but fell into disrepair in the 1940s. Unable to maintain the span, the city demolished it 1951. According to locals, townspeople almost immediately regretted razing the distinctive crossing. For decades, "Remember the Hastings Spiral Bridge" served as the rallying cry for preservationists in the town and elsewhere.

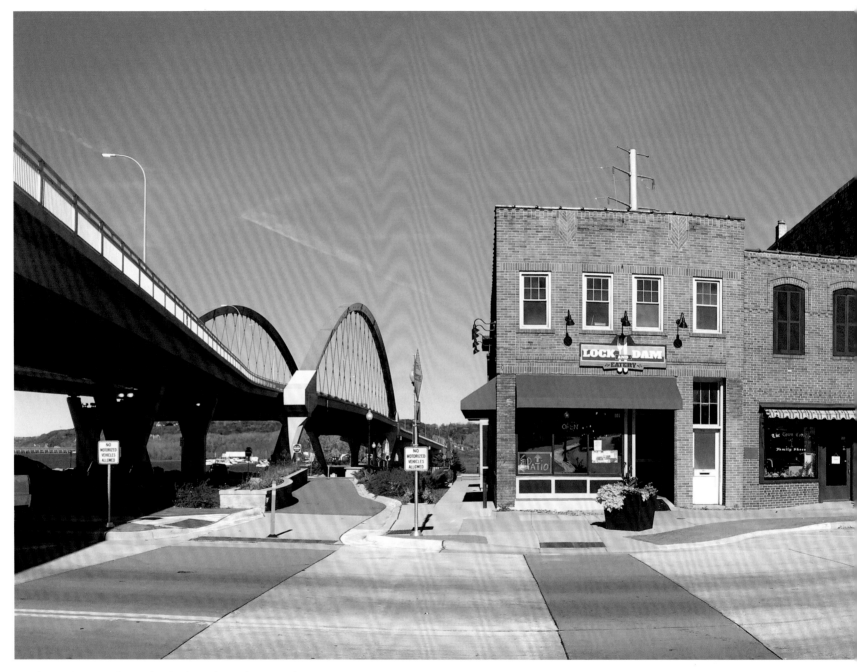

Hastings, Minnesota, has maintained its vibrant downtown historic district over the years. The demolition of the Spiral Bridge in 1951 created a great sense of loss in the community, encouraging citizens to zealously protect the town's numerous historic bridges. The current Hastings Bridge is in the background on the left.

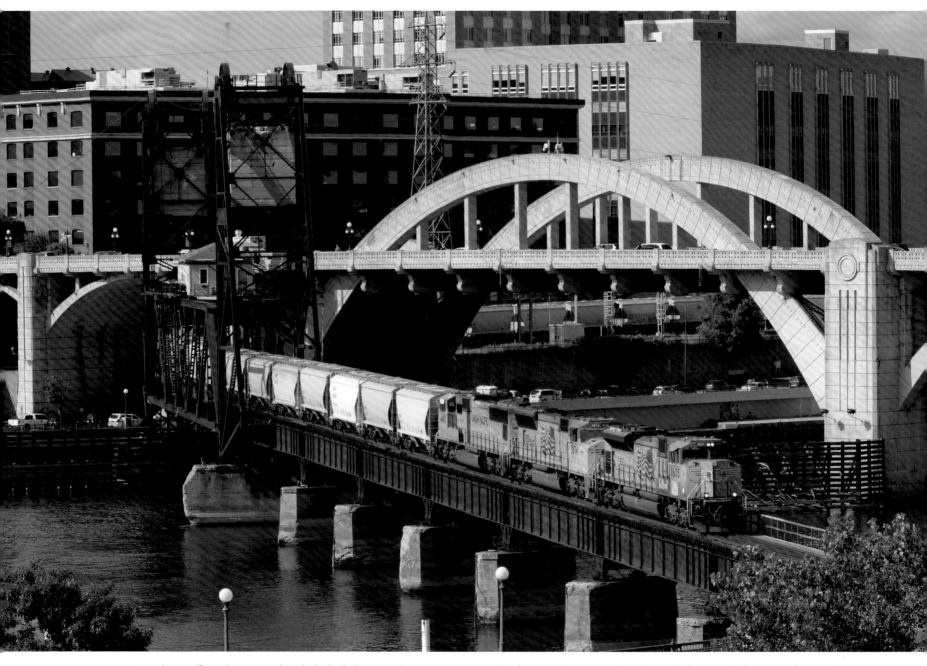

A Union Pacific train crosses the Mississippi River over the Great Western Bridge in St. Paul, Minnesota, which was built in 1913. Adjacent to the span is the Robert Street Bridge, an art deco rainbow arch–style crossing that opened in 1926. Bridge construction was difficult as the span had to accommodate both rail and river traffic while being built.

St. Paul, Minnesota

St. Paul and the Mississippi River Gorge

The city of St. Paul, Minnesota, is blessed with several spectacular and distinctive bridges. Possibly the most unique and eye-catching span in the city is the Wabasha Street Bridge, which opened in 1998, replacing a structure built in 1889. Renamed the Wabasha Street Freedom Bridge in 2002 to commemorate the first anniversary of the 9/11 attacks on the United States, the span extends uphill from the riverbank on the west side of the Mississippi, then turns gracefully before reaching downtown St. Paul.

The Wabasha was designed by Toltz, King, Duvall, Anderson, & Associates, Inc., and is noted for its artistry and detail. Over the years, it has won numerous awards, including the Federal Highway Administration's Excellence in Highway Design Award in 1998. The unique color scheme of the span was intended to reflect the architectural heritage of St. Paul. Sandstone, the color chosen for the main structure, mimics the hue of most downtown buildings. The bridge railings were painted terracotta, an homage to the city's roofs. The six overlooks feature the green patina shared by the St. Paul Cathedral facade. The bridge's color scheme is both grand and festive, especially on windy days when the line of American flags perched atop the towers flap wildly. New Orleans natives viewing the bridge for the first time might easily imagine a celebratory Mardi Gras parade processing across the span. For ancient history buffs, the Wabasha evokes images of Roman soldiers returning victorious from war to shouts and cheers from the adoring crowd standing along the banks of the river.

The Wabasha was designed with pedestrians in mind, and eleven-foot-wide sidewalks were built on the outer bridge decks to provide safety from vehicles. An overlook was constructed on each of the six piers, and there is a stairway leading down to Raspberry Island below. Walkers, joggers, and bicyclists frequent the bridge, enjoying the views of the river from downtown St. Paul, which sits on bluffs atop the east bank. Upriver from the Wabasha is the gorge where St. Paul was first settled.

The Hopewell Indians were the first known inhabitants in the area 2,000 years ago. During the Middle Woodland period, they built burial mounds and held important religious ceremonies here. The Dakota and Ojibwa tribes arrived around 1600, and they established communities near the mounds, which lasted until 1837. Today, six of the oldest Hopewell Indian mounds in Minnesota are included in the St. Paul Mounds Park.

Fort Snelling, originally Fort Anthony, was built between 1820 and 1824 under the supervision of Colonel Josiah Snelling, commander of the United States 5th Infantry Regiment. Located upriver from St. Paul at the confluence of the Mississippi and Minnesota rivers, the fort primarily functioned as a trading post for trappers. One trapper, Pierre "Pig's Eye" Parrant, developed an interest in bootlegging, much to the chagrin of fort officials. Forced to leave, he settled downriver on the bluffs overlooking the Mississippi at present-day St. Paul. The settlement adopted his nickname and became known as Pig's Eye Landing, or L'Oeil du Cochon. The Pig's

Eye Tavern became the principle gathering place for French Canadian trappers who lived there. Over time, other predominantly Catholic immigrants settled, slowly establishing a town, followed by German, Swedish, and eastern European immigrants who helped to enlarge the community.

In 1841, the territory was officially renamed when Father Lucien Galtier, a French Canadian priest, built St. Paul's Chapel on the bluff overlooking the river. As a gesture of respect for the church, townspeople changed the settlement's name from L'Oeil du Cochon to St. Paul.

As the northernmost navigable city on the Mississippi, St. Paul was the final river port heading upstream during the mid-nineteenth century. At St. Paul, travelers disembarked from a riverboat and traveled north or west on foot, on horseback, or by wagon. In 1849, St. Paul became the capitol of the Minnesota Territory, and upon statehood in 1858, it became the capital. That year, over 1,000 riverboats unloaded cargo and passengers in St. Paul. Between 1849 and 1860 the population increased from 900 to 10,000.

The city of St. Paul is located at the southernmost point of the Mississippi River Gorge, a canyon varying in width from one to six miles and in depth from 100 to 650 feet. The gorge extends upriver to Minneapolis. It was formed when water rushing from St. Anthony Falls slowly eroded the river basin as it backed up and flowed upriver.

Dr. Raphael Gottardi, professor of geography at the University of Louisiana at Lafayette and former St. Paul resident noted, "As area glaciers retreated, melted glacial runoff swelled rivers and began carving into the rocks creating the waterfalls. The turbulent waters eroded the soft Saint Peter sandstone beneath the harder limestone and shale surface. Top layers would break down, which caused the falls to retreat upstream at an estimated rate of roughly four feet per year or fifteen miles over 12,000 years" (interview Oct. 21, 2018).

The St. Paul Bridge, built in 1859, was the first span across the Mississippi in the city. Constructed of wood as a Howe truss span, it featured supportive diagonal beams pointing to the bridge's center. The St. Paul

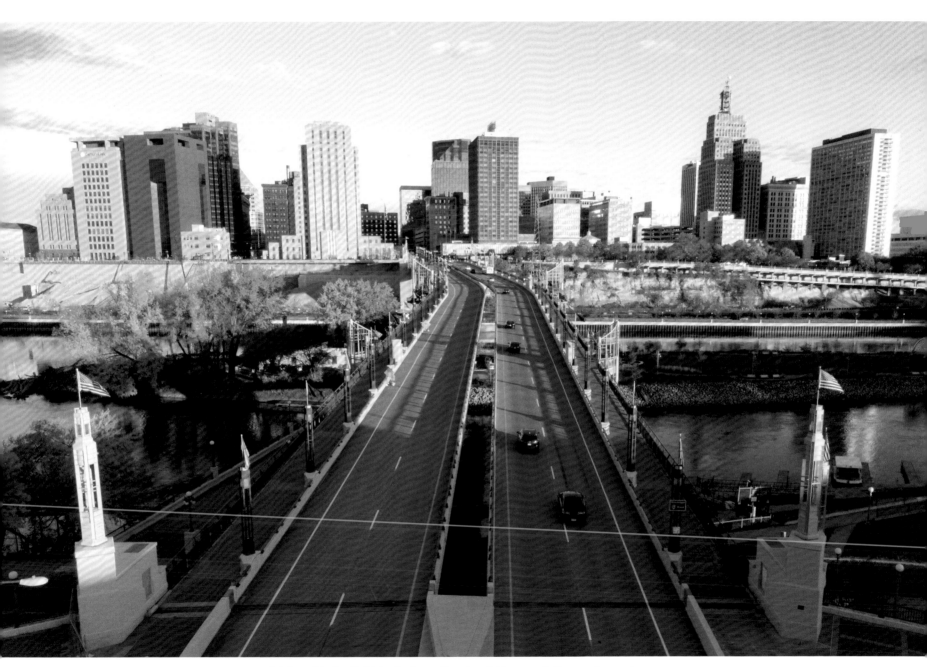

An aerial view of St. Paul's Wabasha Street Freedom Bridge reveals the span's grandeur.

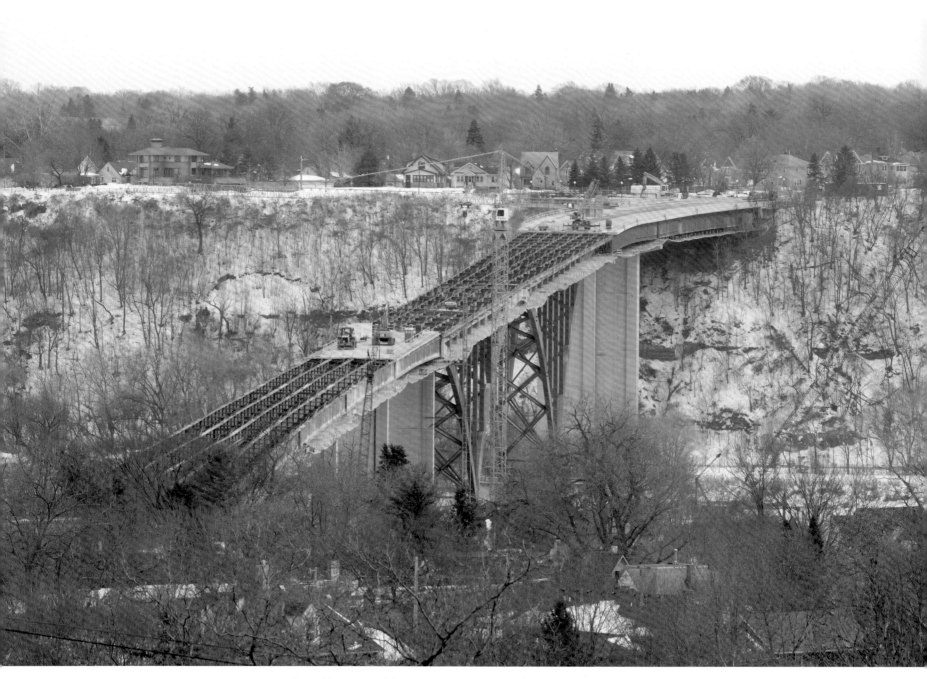

The Smith Avenue Bridge undergoes installation of a new deck in the winter of 2018.

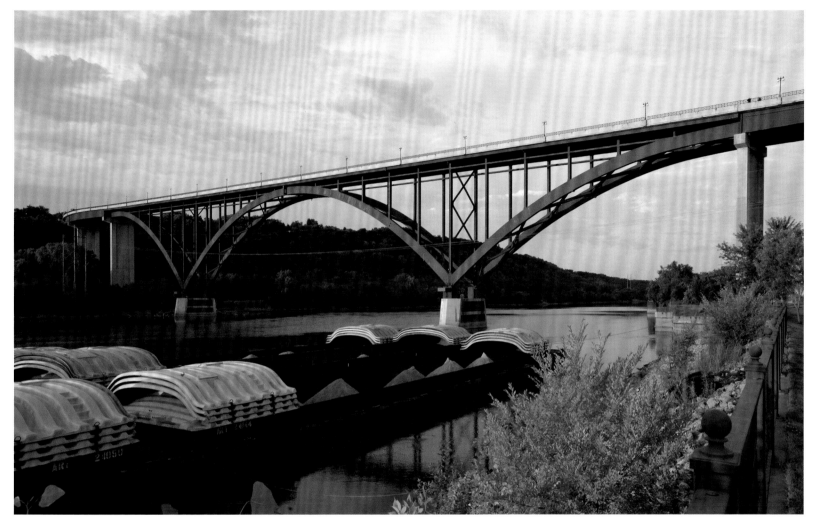

A water-level view of the Smith Avenue Bridge shows the bluffs on the river's banks. The bridge is the first, heading upstream, to span the Mississippi River Gorge.

span, which was renamed the Wabasha Bridge, functioned as a toll crossing until 1874. A replacement for the Wabasha was completed in 1876 and incorporated iron in the structure to add strength. Twenty years later, a third span was built, and with improvements made in 1900, it lasted another hundred years until the newest Wabasha Street Bridge was completed in 1998.

The first railroad bridge built in St. Paul was completed in 1885 and carried the Chicago and Northwestern Railroad, known today as BNSF. The span crossed the Mississippi River diagonally just beneath the bluffs at the center of town. In 1913, a stronger lift span that could serve both rail and riverboat traffic replaced the structure. It is one of just a few such rail crossings operating on the Mississippi. Other early twentieth-century rail bridges were constructed with ninety-degree rotating spans to allow riverboats to travel up and downriver.

The substructure of the Intercity Bridge in Minneapolis

Vehicle traffic in St. Paul increased so dramatically by the early twentieth century that a new Mississippi River bridge was needed. It would be constructed at the bluffs near Robert Street on the city's west side and would replace the existing wrought-iron bridge built in 1885. Toltz, King, and Day designed the span, which was tall enough to allow through-riverboat traffic beneath. To accommodate necessary height requirements, the Robert Street Bridge featured a dramatic rainbow arch.

Just upriver from the Robert Street span is the Smith Avenue Bridge, or High Bridge, the first crossing straddling the gorge. Completed in 1987, the crossing was named after Robert Smith, mayor of St. Paul during the late nineteenth century. In 2018, the bridge deck was replaced to add strength to the span.

Upriver from St. Paul is Minneapolis. Between the two cities, bluffs flank both the Mississippi River and gorge. Much of this section of the riverfront is undeveloped. However, several bridges built during the 1920s and 1930s cross the gorge. Many were designed with concrete arches, including the Intercity Bridge, the F. W. Cappelin Memorial Bridge (also known as the Franklin Avenue MR Crossing), the Tenth Avenue and Third Avenue bridges in Minneapolis, and the Ferry Street Bridge in Anoka. The Lake Street-Marshall Avenue Bridge was completed during the early 1990s.

Residents of St. Paul are proud of their city's extraordinary past, and they zealously guard its fine old buildings, beautiful churches, stately homes, capitol grounds, and stunning bridges. All of St. Paul's spans are evocative, but none more than the Wabasha Street Memorial Bridge, from the deck of which provides a spectacular view of historic St. Paul.

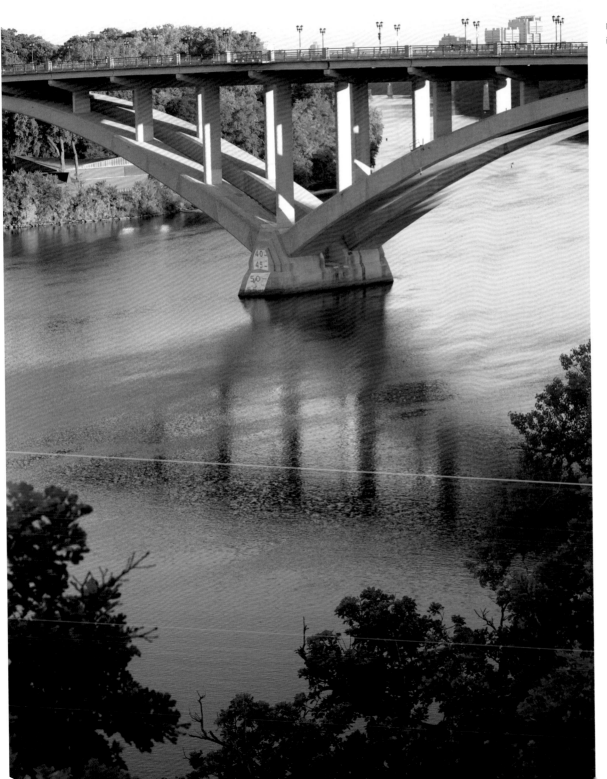

Reflection of the Lake Street Bridge
in Minneapolis

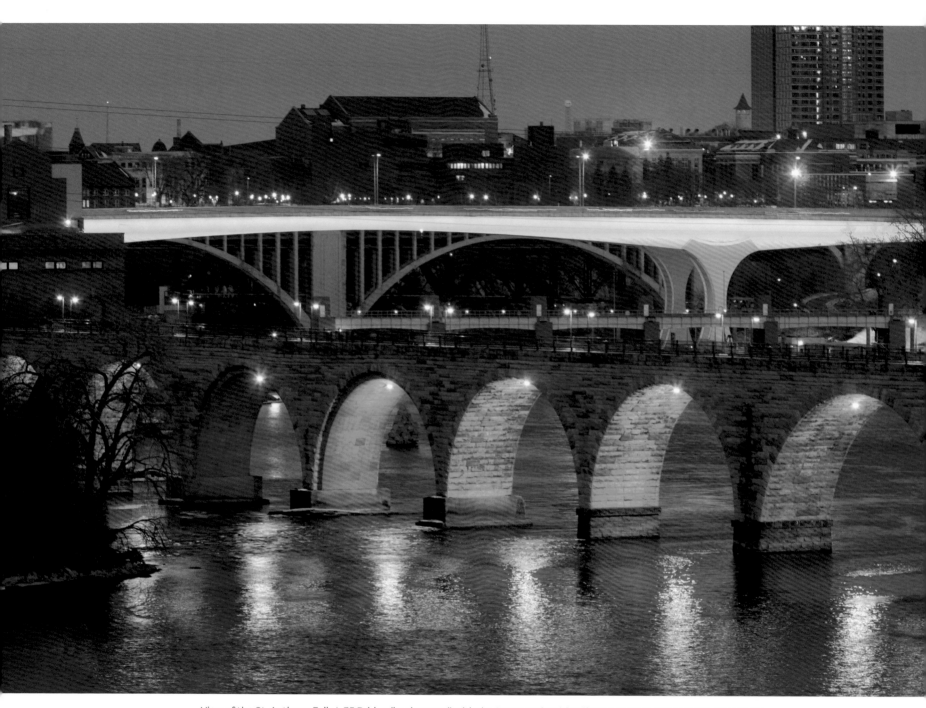

View of the St. Anthony Falls I-35 Bridge (background) with the Stone Arch Bridge (foreground) in Minneapolis, Minnesota

Minneapolis, Minnesota

Calamity, Beauty, and Innovation

The Stone Arch Bridge offers the best view of Minneapolis along the Mississippi River. The scene includes towering new apartment buildings, the Guthrie Theater, a performing arts venue, and St. Anthony Falls just upriver. All are within easy walking distance from the city's downtown hustle and bustle.

James J. Hill was commissioned to build the Stone Arch Bridge, which he completed in 1883. An engineering tour de force in its day, the crossing now reminds us of the importance of nineteenth-century railroad operations. As the oldest bridge in Minneapolis, the Stone Arch carried both freight and passengers, and connected the city to eastern manufacturing interests and northern lumber and coal industries. The bridge was constructed diagonally over the river, with a slight six-degree curve to avoid exist-

One of the two blue wave sculptures on the St. Anthony Falls I-35 Bridge, which honor those who died when the older span collapsed into the river in 2007

ing buildings, fragile stone, and St. Anthony Falls. Referred to as Hill's Folly until its completion, the Stone Arch Bridge is 2,100 feet long and features twenty-three arches and two railroad tracks.

Minneapolis developed into a strong manufacturing base during the latter half of the nineteenth century largely due to the Stone Arch Bridge. At first, flour mills and lumber industries were powered by water wheels. St. Anthony Falls, which at the time caused four feet of riverbank erosion annually, required engineers control the flow of water. Once dams were constructed upriver, the falls began generating hydroelectric energy, benefitting industry growth. Geologist Raphael Gottardi of the University of Louisiana at Lafayette noted, "What is interesting is that the geology along the river completely changes north of Minneapolis. Seden-

Pedestrians cross the Washington Avenue Bridge that connects the University of Minnesota's east-bank and west-bank campuses. The covering protects pedestrians from the winter cold and winds.

tary rocks change to hard crystalline basement. In other words, a few more miles upstream and the falls would have stopped migrating anyway" (interview Oct. 22, 2018). By 1900, the population of Minneapolis had grown to 200,000 from 6,000 forty years earlier.

Today, the Stone Arch Bridge railroad tracks are gone, along with much of the surrounding industry that fueled Minneapolis's economic and population growth. However, reminders of the city's industrial legacy are everywhere—most in the form of advertisements for Grain Belt beer, Pillsbury's Best flour, and North Star blankets—painted on facades of old warehouses-turned-apartment buildings.

Just upriver from the downtown district are the Third Avenue Bridge and Father Louis Hennepin Suspension Bridge, the latter of which is named for the French explorer who discovered St. Anthony Falls in 1680. The original Hennepin Avenue Bridge, which opened in January 1855, was the first bridge built across the Mississippi River. Intended for horse and buggy rigs as well as pedestrian traffic, the wire suspension span measured 620 feet in length. It featured wood-covered towers flanking the entrances

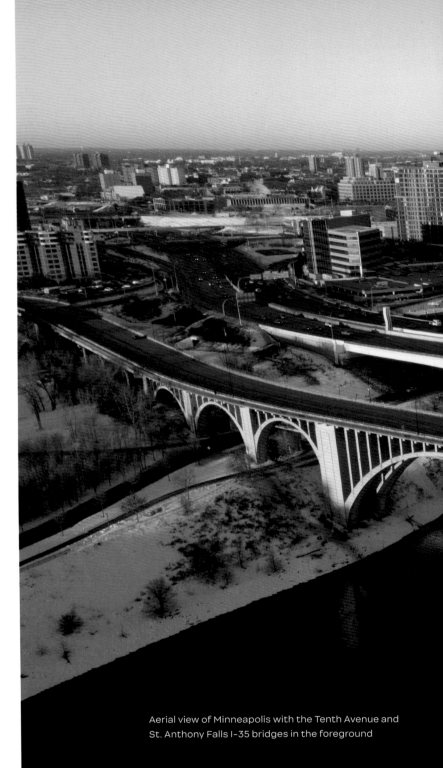

Aerial view of Minneapolis with the Tenth Avenue and St. Anthony Falls I-35 bridges in the foreground

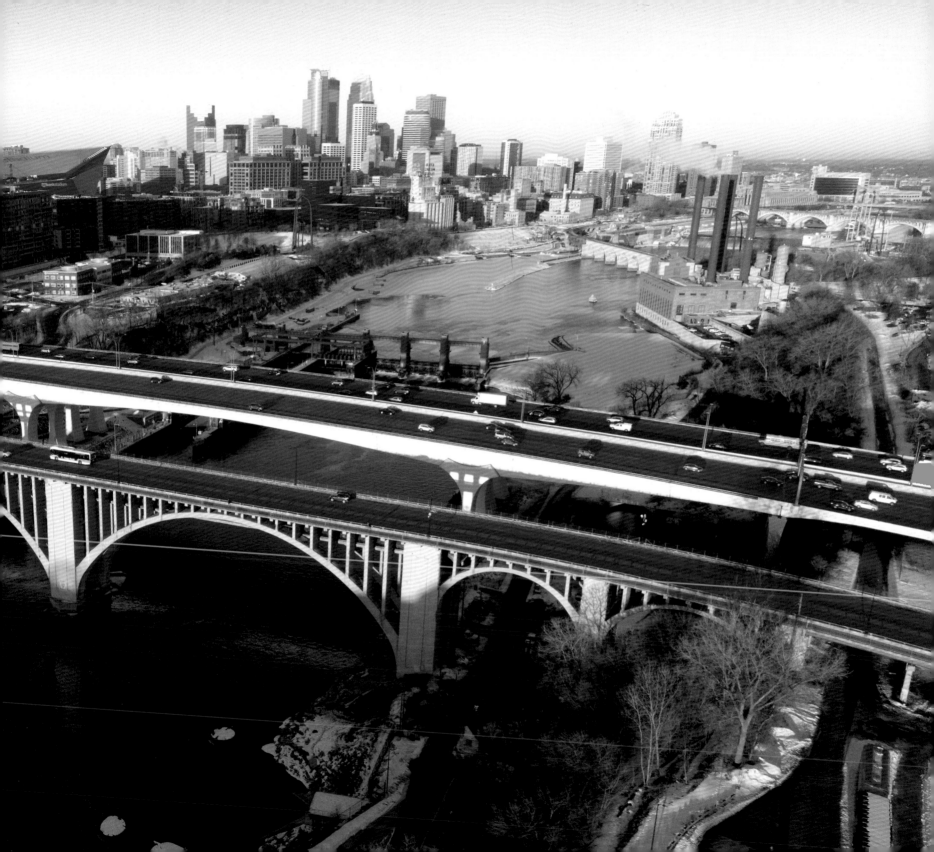

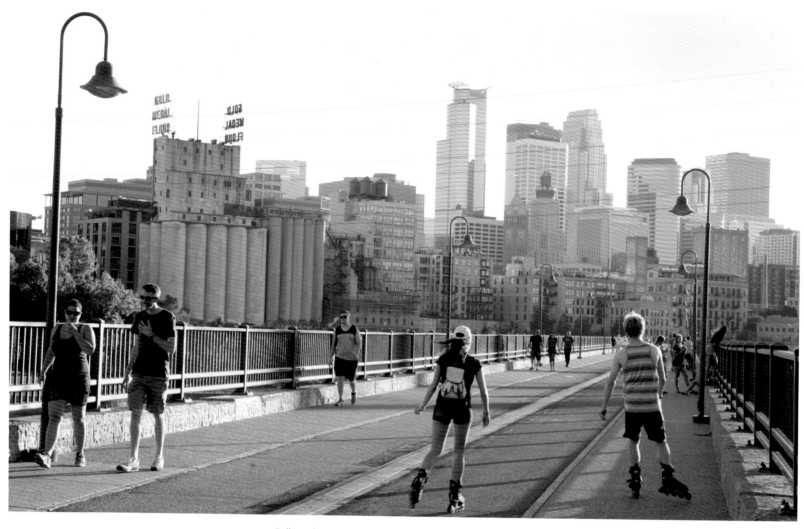

Folks enjoy crossing the Stone Arch Bridge in summer.

on both ends. The Hennepin was fraught with safety issues, and in March 1855 a tornado destroyed it. The second Hennepin crossing, completed in 1877, was designed as a suspension bridge featuring stone towers, wire cables, and decorative ornamentation. For the most recent rendition of the Hennepin Bridge, completed in 1990, designers remained faithful to the suspension model, in spite of its added expense.

The St. Anthony I-35W and the Lowry Avenue bridges are the newest in Minneapolis and both employ computerized lighting systems to enhance safety while honoring the city's design tradition. Together, the bridges frame the downtown Mississippi River basin.

In 2008, the St. Anthony Falls I-35 Bridge opened, replacing the I-35W Mississippi River Bridge, which collapsed from structural fatigue in August 2007, killing thirteen and injuring 145. The new ten-lane span is maintained by MDOT and features state-of-the art support piers loaded with

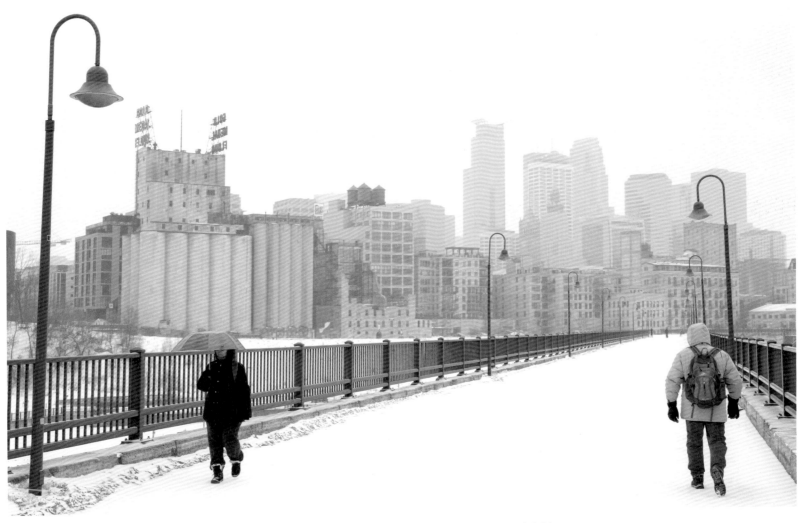

Pedestrians walk through winter snow across the Stone Arch Bridge.

structural stress-detecting sensors. The bridge piers appear stylized and physically powerful.

At nightfall, the entire structure is bathed in either solid blue or purple light. On holidays or other special occasions, bridge operators program a color scheme to honor the event. For residents, the purple light shines as a tribute to world-renowned pop star and favorite son, Prince.

In contrast to the bridge piers, the roadbed of the St. Anthony Falls

I-35 Bridge seems austere. Soon after the span opened, Steve Berg of the *Minnesota Post* wrote, "One hardly notices they are crossing on the bridge. It seems instead to fit the pragmatic Minnesota character" (Sept. 16, 2008).

The only ornamentation are two wavelike sculptures placed at either end of the crossing as a memorial to those who died in the 2007 bridge disaster. During the ribbon-cutting ceremony in 2008, the United States

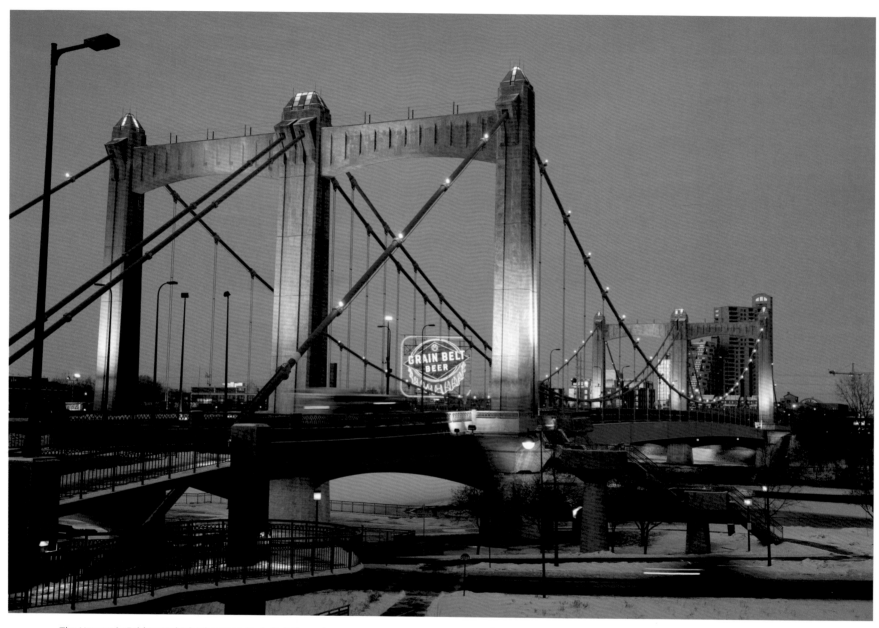

The Hennepin Bridge at dusk. The neon Grain Belt Beer sign, synonymous with the bridge and downtown Minneapolis, was installed in 1940 and refurbished in 2017.

transportation secretary, Mary Peters, addressed the crowd stating, "It shouldn't take a tragedy to build a bridge this fast in America, but it has. And it would be a travesty if we didn't share the secrets that this state, and this community brought together to make the project happen so quickly. Lessons were learned and the right remedies taken to ensure that no one has to worry or wonder when they cross a bridge in America ever again."

The Lowry Avenue Bridge, located just upriver from downtown Minneapolis, opened in 2012. This elegant span features a steel basket-handle, tied-arch design. Lights within the arches are programmed to display a numerous combination of colors. Usually, the crossing glows with ambient light, similar to that shone on the I-35 W Hennepin Bridge downriver.

During Christmas holidays, though, the bridge glows red and green, while on New Year's Day and national holidays the span is bathed in red, white, and blue. Former Hennepin County commissioner Mark Tenglein said of the new bridge on opening day, "This is truly a great day, a long time coming. If we liked the old bridge, we'll love this one. The old bridge stood for fifty years. This one will stand for a thousand" (*Minnesota Star Tribune,* Oct. 13, 2012). Also in attendance was United States Senator Amy Klobuchar, who observed, "You know who will go over it? Me, on a bicycle. It's going to be an amazing thing. We didn't just rebuild it, we rebuilt it right."

During the nineteenth century, the Lowry Avenue spans connected north Minneapolis with the city's northeastern district across the Mis-

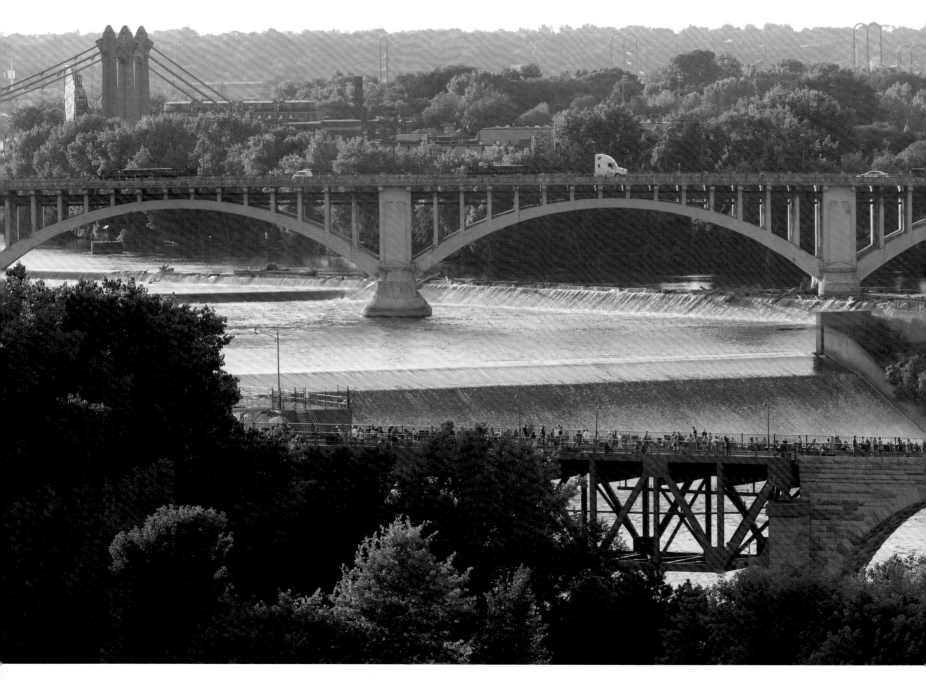

Crowds gather on the Stone Arch Bridge during the Minneapolis's Aquatennial celebration. St. Anthony Falls is behind them as are the Third Avenue and Hennepin bridges.

sissippi, where German, Irish, Finnish, Polish, Russian, and Italian immigrants settled and worked in factories along the river. There, on the east side of the Mississippi, stands a tavern that first opened during the 1890s, serving Grain Belt Beer, a local favorite, to European immigrants. In 1960, Tony Jaros, a hometown boy who became a basketball star in the NBA, purchased the establishment and renamed it. Tony Jaros River Garden retained its original old world character. Historic photographs line the walls, reminders of the establishment's legendary beginnings.

Since 1940, each third full week in July, residents and visitors celebrate the Minneapolis Aquatennial, a celebration of the the city's famous waterways. Advertised as the "Best Days of Summer," and supported by the Minneapolis Downtown Council, the event also honors the city's founding in 1856. For the closing event each year, thousands of spectators gather along riverbanks and on bridges to witness the Target Fireworks display, one of the largest and most exciting in the United States.

Fireworks display during Minneapolis's Aquatennial celebration, an annual event to honor the city's waterways. The Stone Arch Bridge is in the foreground.

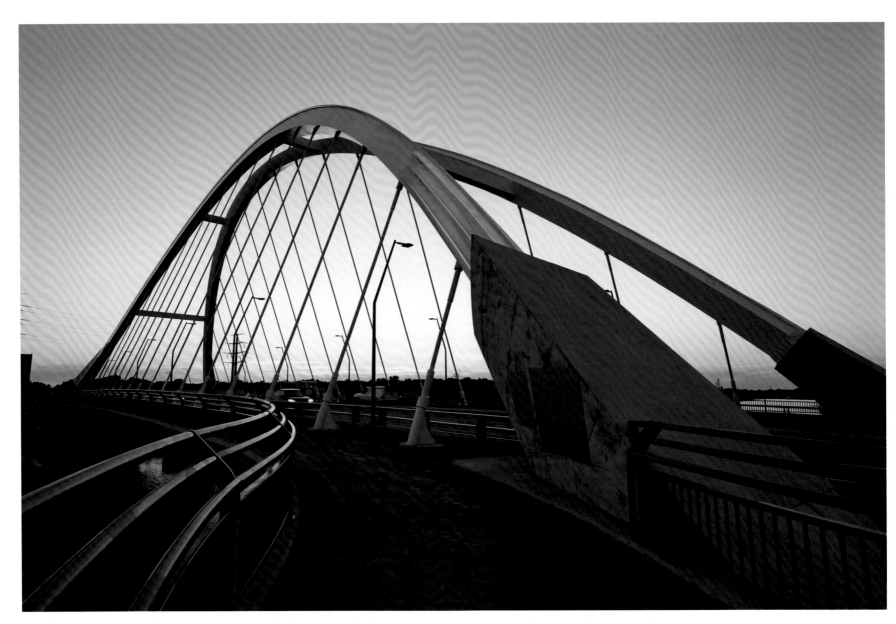

The Lowry Avenue Bridge is a marvel with its sleek and elegant design. Its arches can be illuminated with a variety colors.

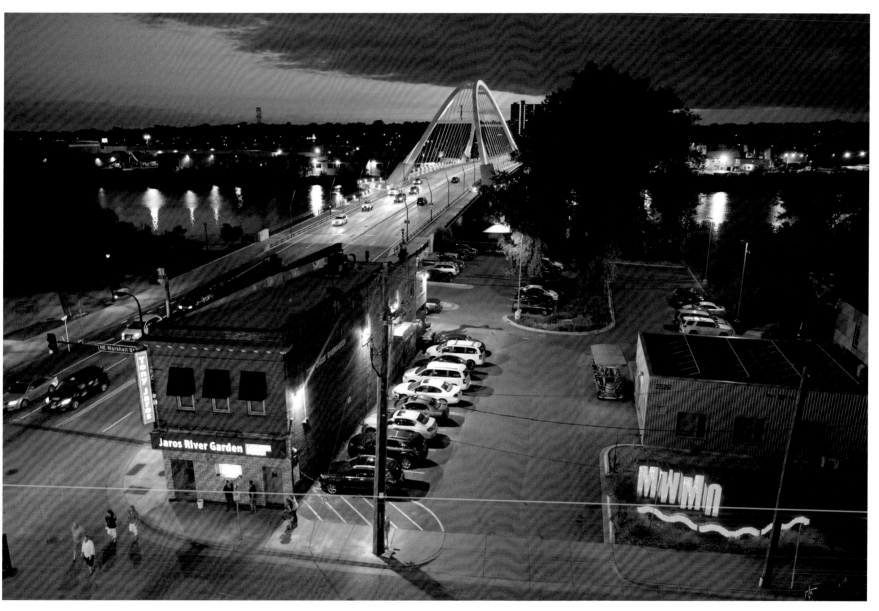

The Lowry Avenue Bridge crosses the Mississippi River just north of downtown Minneapolis. Opened in 2012, the breadbasket-arch span provides a crossing for traffic headed to one of the old immigrant neighborhoods to the northeast. Tony Jaros River Garden is a bar and restaurant established in the 1890s. It once was a taproom for a local brewery that catered to laborers living and working in the neighborhood.

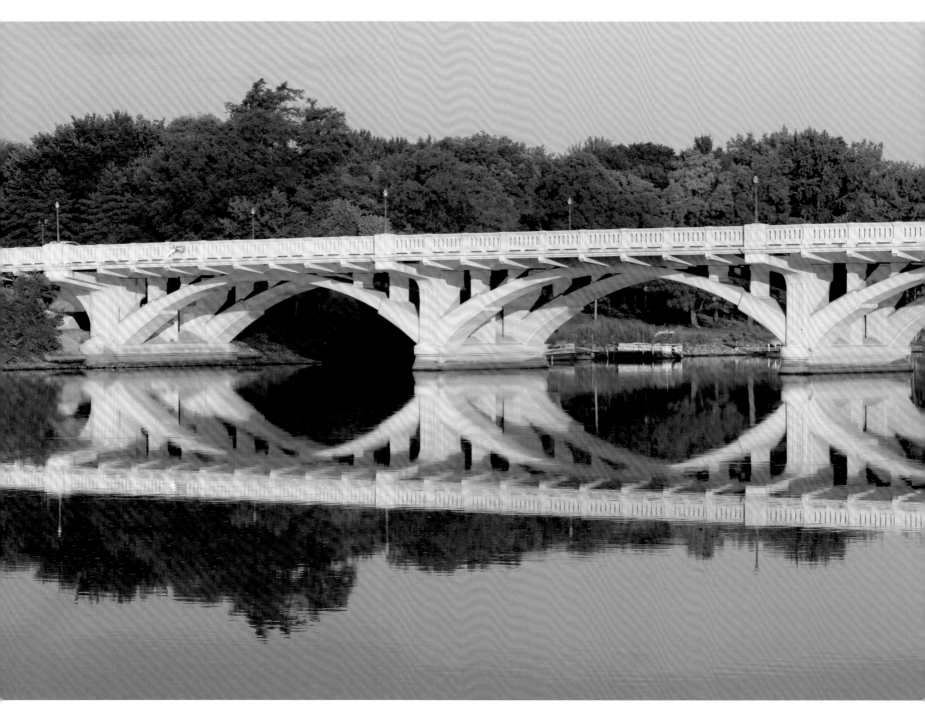

The Ferry Street Bridge in Anoka, Minnesota, is an excellent example of Art Deco architecture.

The BNSF Bridge in St. Cloud, Minnesota, opened in 1872 with the addition of extra structural bracing installed in 1922.
Shorter trains cross it a few times a day on average. Passing under it is a riverside walkway
built by the city. Directly overhead is the Veterans Bridge.

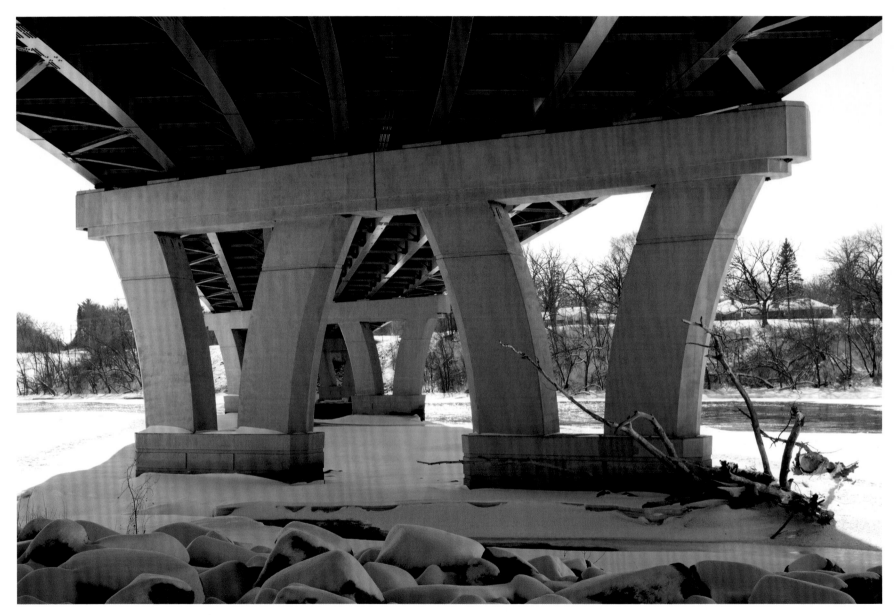

The Sauk Rapids Bridge opened for traffic in 2007. Located in the middle of downtown Sauk Rapids, Minnestoa, the span provides access to the city's downtown.

Military flags flap in the wind over the Broadway Bridge in Little Falls, Minnesota. In the distance is Our Lady of Lourdes Catholic Church, founded in 1917 by Polish immigrants.

The Bemidji Bridge crosses the Mississippi River near downtown Bemidji.

The Bemidji Bridge runs along the shore of Lake Bemidji, a large body of water located in north-central Minnesota. The pier and wharf are removed each winter due to excessive ice and snow.

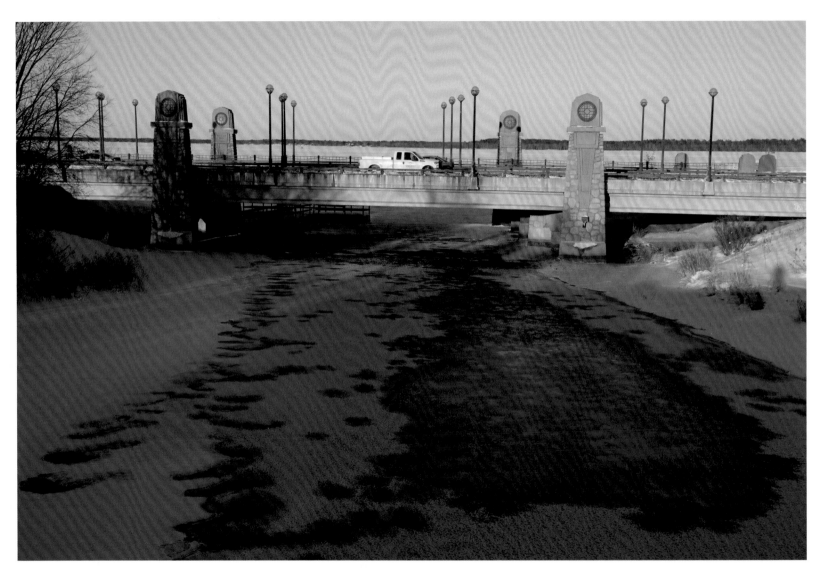

The frozen Mississippi River flows under the Bemidji Bridge as it makes it way to Lake Bemidji.

Campers spend winter months on ice-bound Lake Bemidji each winter. The ice's thickness ranges from twelve to eighteen inches during these months.

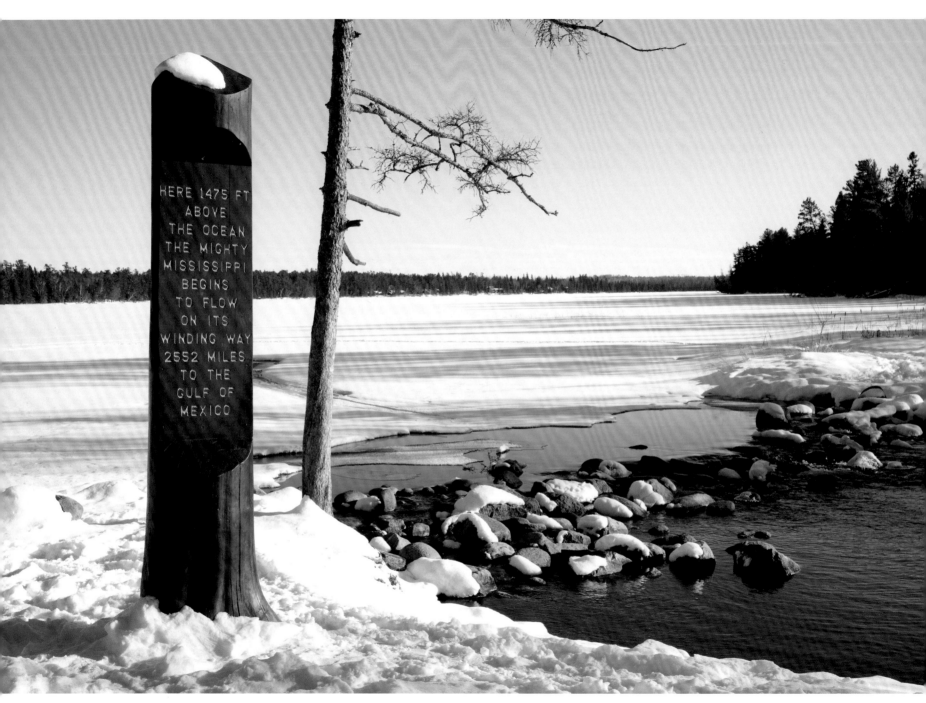

HERE 1475 FT
ABOVE
THE OCEAN
THE MIGHTY
MISSISSIPPI
BEGINS
TO FLOW
ON ITS
WINDING WAY
2552 MILES
TO THE
GULF OF
MEXICO

A carved totem pole marks the headwaters of the Mississippi River as it flows out of Lake Itasca.

Lake Itasca, Minnesota

The Mississippi River Headwaters

During the winter months, Lake Itasca, in north-central Minnesota, is quiet and still. Here, at the headwaters of the Mississippi River, the temperature is 10° Fahrenheit on a clear February day. Snow blankets the trees and shrubs, and the lake is a vast frozen plain.

On the northern side of Lake Itasca, a small steady stream flows from the lake and over a wall of ice-covered boulders to begin its long journey to the Gulf of Mexico. Inscribed on a nearby plaque is the message "Here, 1,475 ft. above the ocean the mighty Mississippi begins to flow on its winding way 2,552 miles to the Gulf of Mexico."

In contrast, warm summers at Lake Itasca entice as many as 500,000 vacationers from across the nation. They swim, hike, camp, and wade into the headwaters with their dogs and children. They pose for souvenir photos to prove to folks back home that this clear, shallow stream is the Mississippi River. One hundred feet downstream is the

Folks gather at the Mississippi River's headwaters in Lake Itasca in northern Minnesota. An estimated 500,000 people visit Itasca State Park each year.

first river crossing, a thirty-foot log. Farther north, as the stream widens as it flows through the park, wooden footbridges transport visitors from one bank to another. Itasca State Park is a fifty-square-mile preserve of forests and lakes. From here, the river flows farther north, gradually widening as it travels to its northernmost point in the town of Bemidji at Lake Bemidji.

The Mississippi then turns south toward St. Cloud, finally making its way to the twin cities of Minneapolis and St. Paul.

Declaring Lake Itasca the official Mississippi River headwaters was a complicated process. During the early nineteenth century, many people agreed that the river began somewhere in northern Minnesota within a vast network of small lakes formed by glacial drift thousands of years ago. A few explorers were determined to search for the river's true source.

Hundreds of years ago, natives of the Ojibwe tribe called the source Man-i-do-za'-gai-i-gun, or

Just downstream from the Mississippi's headwaters, people carefully walk across a thirty-foot log, the first object that spans the river from shore to shore.

the Spirit's Lake. Later, French explorers shortened the name to Lac La Biche, or Elk Lake. In 1832, Henry Schoolcraft, a noted geographer and ethnologist, explored the area with the help of local natives. He aimed to refute a claim made in 1820 by General Louis Cass that a smaller pond upstream from Lac La Biche was the river's true source. Schoolcraft traveled downriver to Lac La Biche, which he declared the true source of the river. To reinforce his assertion, Schoolcraft renamed the lake using parts of two Latin words—*veritas* (truth) and *caput* (head) to form Itasca, or true head.

In 1889, Jacob Brower, a land surveyor commissioned by the Minnesota Historical Society, confirmed Schoolcraft's proclamation. On April 20, 1891, the Minnesota legislature voted to set aside Itasca State Park for the public. The lawmakers also wished to protect the old-growth pine forests within the park from powerful logging interests. The bill passed by one vote, making Itasca the first state park in Minnesota and the second in the United States.

Even so, the Mississippi River headwaters at Itasca State Park are not solely nature's creation. In 1939, the Civilian Conservation Corps drained the surrounding swamp, dug a clearer channel from the lake, and installed a series of boulders at the site, creating a dramatic setting that annually entices hundreds of thousands of curious visitors to the source of the mightiest river in the United States.

Visitors to Itasca State Park make their way across the boulders marking the Mississippi River's headwaters.

Youngsters hop from boulder to boulder at the Mississippi River's headwaters at Lake Itasca.

ACKNOWLEDGMENTS

This ambitious project would not have been possible without the financial support of numerous benefactors who provided funding when the book project was merely an idea. I wish to thank Randy and Daynese Haynie, John Chappuis and Colleen McDaniel, Ralph and Cherie Kraft, Ed and Elaine Abell, Walter (deceased) and Ann Dobie, Patrick and Elizabeth Little, Jay and Therese Herrig Culotta, Jon Gross, and BBR Creative in Lafayette, Louisiana, for their generosity and support.

The process of creating a book, especially on a subject so geographically vast, is made much easier by those who, during the project, were helpful. I also wish to thank LouAnne Greenwald and Benjamin Hickey of the Hilliard University Art Museum in Lafayette who were instrumental in making the book possible.

During our travels, countless people provided access, hospitality, and local knowledge. In New Orleans, Steve and Haydee Lafaye Ellis were more than hospitable and supportive. Ben Sandmel's feedback helped tremendously. Dean Giroir and Carl Kucor with the New Orleans Public Belt Railroad provided valuable information and granted me access to the Huey P. Long Bridge to photograph on its deck. Jenny Fu of the Louisiana Department of Transportation and Development granted me access and provided essential data. Zachary Pyle patienty drove me numerous times across the Horace Wilkinson Bridge in Baton Rouge while I photographed rush-hour traffic. In Memphis, Jimmy Ogle, noted historian, helped with information and guidance. In Savanna, Illinois, Patrick Shea, Dale Gardner Bridge project manager for Kraemer North America, provided critical access, local knowledge, and a basic tutorial on bridge construction. In Dubuque, Iowa, Kristie and Jerry Arthofer welcomed me into their home and helped me find amazing locations for viewing their city's bridges. In Lansing, Iowa, Bill and Kate Fitzgerald helped me with local contacts and took Margot and me out on the river to see water-level views of the town's amazing Black Hawk Bridge. In LaCrosse, Wisconsin, Drake Holkanson led me to great remote spots. He and his wife, Carol, were also wonderful hosts and offered constructive guidance and critique. In Minneapolis, Stuart Klipper and Kathleen Richert shared their homes and offered encouragement regarding my efforts. In Alexandria, Minnesota, Marilyn Tisserand and Denny Becker were generously hospitable and also offered helpful advice and information about the area. I thank these folks and countless others who, in small ways and large, helped make this project a success.

Above all though, I want to thank my wife and creative partner, Margot Hasha, for all her efforts to see it to fruition, with her research, her writing, critical insight, as well as logistical and moral support. She provided key elements to render this dream project to into being.

Philip Gould

Danielle Swanson and Noah Bennett relax after a bike ride in Hastings's Lake Rebecca Park.

SELECTED BIBLIOGRAPHY

SECONDARY SOURCES

Agnew, D. L. (1949). "Jefferson Davis and the Rock Island Bridge." *Iowa Journal of History,* Vol. 47 (1) p. 3–14.

Andrist, R. K. (2016). *Life on the Mississippi.* Rockville, MD: New Word City, Inc.

Anfinson, J. O. (2003). *The River We Have Wrought: A History of the Upper Mississippi.* Minneapolis: University of Minnesota Press.

Barry, J. M. (1997). *Rising Tide: The Great Mississippi Flood of 1927 and How it Changed America.* New York: Touchstone.

Bissell, R. (1973). *Life on the Mississippi: or Why I Am Not Mark Twain.* New York: Little Brown & Company.

Bright, W. (2004). *Native American Place Names of the United States.* Norman, OK: University of Oklahoma Press.

Burke, W. J. (2000). *The Upper Mississippi Valley: How the Landscape Shaped Our Heritage.* Waukon, Iowa: Mississippi Valley Press.

Campanella, R. (November 1, 2018). "The Social Impact of New Orleans Geography." *Gambit* (online edition).

———. (November 11, 2018). "Bridging Decisions: How New Orleans River Bridged Had Lasting Effects on Region's Urban Geography," (online issue). *The Advocate.*

Cook, R. J. (1987). *The Beauty of Railroad Bridges in North America—Then and Now.* San Marino, CA: Golden West Books.

Coppock, P. (February 27, 1972). "1892 Kansas City and Memphis Railroad Bridge," *Memphis Commercial Appeal.*

Costello, M. C. A. (1995). *Climbing the Mississippi River Bridge by Bridge, Vol 1: From Louisiana to Minnesota.* Self-published.

———. (2002). *Climbing the Mississippi River Bridge by Bridge, Vol 2: Minnesota.* Self-published.

Dupre, J. (2017). *Bridges: A History of the World's Most Spectacular Spans.* New York: Black Dog and Leventhal Publishers.

Englebert, R. and Teasdale, G. (Eds.) (2013). *French and Indians in the Heart of North America, 1630–1815.* East Lansing: Michigan State University Press.

Feldman, J. (2005). *When the Mississippi Ran Backwards: Empire, Intrigue, Murder, and the New Madrid Earthquakes.* New York: Free Press.

Fremling, C. R. (2005). *Immortal River: The Upper Mississippi in Ancient and Modern Times.* Madison: University of Wisconsin Press.

Gardner, D. P. (2008). *Wood + Concrete + Stone + Steel: Minnesota's Historic Bridges.* Minneapolis: University of Minnesota Press.

Gilman, R. R. (1989). *The Story of Minnesota's Past.* St. Paul: Minnesota Historical Society Press.

Havighurst, W. (1964). *Voices on the River: The Story of the Mississippi Waterways.* Minneapolis, MN: University of Minnesota Press.

Huber, M. (2015). *Stone Arch Bridge, Minneapolis.* Retrieved from http://www.mnopedia.org/structure/stone-arch-bridge-minneapolis.

Huxtable, Ada Louise. (1974). "A Momentous Event in Engineering and Art." *New York Times.*

Jackson, R. W. (2001). *Rails Across the Mississippi: A History of the St. Louis Bridge.* Chicago,: University of Illinois.

Konwenhoven, J. A. (1982). "The Designing of the Eads Bridge." *Technology and Culture,* 23 (4) 535–568.

Magness, P. (January 22, 1998). "Harahan Built to Meet Traffic Needs." *Memphis Commercial Appeal, p. CC2.*

Marking, T. K. and Snape, J. (2013). *Images of America: The Huey P. Long Bridge.* Charleston, SC: Arcadia Press.

Miller, H. S. and Scott, Q. (1979). *The Eads Bridge.* St. Louis: Missouri Historical Society Press.

Morison, S. (1974). *The European Discovery of America: The Southern Voyages, 1492–1616.* New York: Oxford University Press.

Morsman, J. (July 2006). "Collision of Interests." *Common Place,* 6 (4). Retrieved from http://common-place.org/book/collision-of-interests.

Nelson, P. (2016) "St. Paul's Indian Burial Mounds are among the State's Oldest Human-made Structures." Retrieved from *MNopedia,* Minnesota Historical Society. http://www.mnopedia.org/place/indian-mounds-park-st-paul.

Northstein, I. O. (April 1956). "The First Bridge to Cross the Mississippi." *Museum Quarterly,* Vol. 1 (2) (online edition).

Paskoff P. F. (2007). *Troubled Waters: Steamboat Disasters, River Improvements, and American Public Policy, 1821–1860.* Baton Rouge: Louisiana State University Press.

Pasquier, M. (Ed.) (2013). *Gods of the Mississippi.* Bloomington: Indiana University Press.

Pfeiffer, D. A. (2004). "Bridging the Mississippi: The Railroads and Steamboats Clash at the Rock Island Bridge." *Prologue Magazine,* 36 (2) (online edition).

Pfeiffer, D. A. (2009). "Lincoln for the Defense: Railroads, Steamboats, and the Rock Island Bridge." *Railroad History,* 200, pp. 48–55.

Reicher, M. (2014) *Father Louis Hennepin Suspension Bridge.* Retrieved from http://www.mnopedia.org/structure/father-louis-hennepin-suspension-bridge.

Riebe, W. (1982). "The Government Bridge." *Rock Island Digest,* Vol. 2, pp. 68–79.

Robbins, P. (1972). "The Great River Expedition: Marquette-Jolliet." *American History Illustrated,* 7 (1), pp. 4–12.

Sage, L. (1973). "European Contact with Iowa: Jolliet and Marquette." *Palimpsest,* 54 (3), pp. 2–8.

Schneider, P. (2014). *Old Man River: The Mississippi River in North American History.* New York: Picador.

Shaffer, J. L. and Tigges, J. T. (2000). *Images of America: The Mississippi River—Father of Waters.* Charleston, SC: Arcadia Press.

Shepley, C. J. (2008). *Tales from the Bellefontaine Cemetery: Movers, Shakers, Scalawags and Suffragettes.* St. Louis: University of Missouri Press.

Sonderman, J. (2010). *Images of America: St. Louis Bridges, Highways, and Roads.* Charleston, SC: Arcadia Press.

Terminal Railroad Association of St. Louis. "TRRA History." Retrieved from the *Wayback Machine.*

Tinker, G. P. (Ed.) (2004). *Port Engine Security.* New York: John Wiley & Sons.

Walters, B. (May 7, 2013). *Art in Plain Sight: The Centennial Bridge, River Cities' Reader* (online edition).

Welky, D. (2016). "Backwater Blues: The Mississippi River Flood of 1927 in the African-American Imagination." *Journal of Southern History,* 82 (4), pp. 965–66.

Whittelsey, C. B. (1902). *The Roosevelt Geneology, 1649–1902.* Hartford, CT: J. B. Burr & Company Press.

Williams, T. H. (1981). *Huey Long.* New York: Vintage Press.

Zobrist, B. (1965). "Steamboat Men vs. Railroad Men: The First Bridging of the Mississippi River." *Missouri Historical Review,* 59 (2), pp. 159–72.

INTERVIEWS

Clemons, C. (October, 16, 2017)

Craiglow, J. (September 24, 2018)

Fitzgerald, W. (September 19, 2018)

Giroir, D. (November 15, 2018)

Gottardi, R. (October 17, 2017)

Lain, C. (October 4, 2018)

Peterson, M. (March 5, 2018)

Rethwisch, J. (September 26, 2018)

Shea, P. (March 8, 2018)

Thomas, T. (October 29, 2018)